# Abandoned USSR

Terence Abela

JONGLEZ PUBLISHING

# Content

# Introduction

The Union of Soviet Socialist Republics (USSR) came into being in 1922, founded in the determination to expand communist ideology after the overthrow of the Russian Empire, whilst at the same time retaining the influence which the Empire had exerted over many neighbouring territories. Originally it brought together the Russian Soviet Federative Socialist Republic (RSFSR), Transcaucasia (comprising Georgia, Armenia and Azerbaijan, dissolved in 1936), and the Ukrainian and Byelorussian Soviet Socialist Republics. It formed the largest nation in the world, occupying a sixth of the earth's landmass, stretching across eleven time zones. As well as its founding states, the USSR included Kazakhstan, Uzbekistan, Turkmenistan, Kyrgyzstan, Tajikistan, Moldavia, Lithuania, Latvia and Estonia.

The Soviet bloc was a major player in the Cold War. It formed a common front under the authority of a central power that brutally repressed any claims to a separate identity, crushing any attempts at democratisation and, more generally, anything that resembled direct or indirect criticism of Soviet Communism. The history of how these populations were often maltreated, sometimes deported and invariably repressed, is repeated from country to country, but there sometimes seems to be a shortage of sufficiently impartial Western reading matter to provide an understanding of what lies concealed between the lines of the story. The heritage of places now abandoned in all the countries that made up the former USSR serves as an echo of a nuanced past. Here, situated between two armed camps with their aggressive propaganda, you can happily stumble upon arts centres that once hosted brilliant intellectuals, and other well-preserved mementoes that leave you in no doubt that a sense of nostalgia for the old days still lingers in the deserted streets of some villages. There are also the technical sites that filled millions of hearts with pride during the era of space conquest.

From behind his lens the photographer seeks to let all these people speak out, from those most oppressed by the system to those who most appreciated it. Through silent pictures he captures the joys, sorrows, hopes and fears once felt within these run-down walls, allowing them to play out discreetly again decades later. All that remains is for the readers to let themselves feel moved by these snippets of stories from the past, if they have a mind to.

# Russia

Mother Russia, the birthplace of Soviet Communism, witnessed a dramatic development in her history in 1917. In that year, the Red October Revolution, led by the Bolsheviks with Vladimir Lenin at their head, confirmed the collapse of the tsars. In 1929, five years after Lenin's death, another leader of great stature took power, Joseph Stalin. He extended the USSR's influence to its pinnacle, exerting an iron grip to which innumerable people fell victim. Successive leaders, from Nikita Khrushchev to Mikhail Gorbachev, added new chapters to the story that eventually led to the dissolution of the Soviet bloc in 1991.

In post-USSR Russia, places now abandoned bear witness to every aspect of the bloc's turbulent history: from the solemn grandeur of a ruined Orthodox church, to the propaganda, distinctly military in flavour, still visible in former Pioneer camps, via the frescos which still adorn the crumbling walls of former barracks, schools and factories, the many faces of patriotism have left their indelible mark on this vast country's heritage.

Visits: 2013 – 2018

A grand country house dating from the 18th century, built by Italian architects. Following the Bolshevik revolution, the manor house was brought into state ownership in 1918.

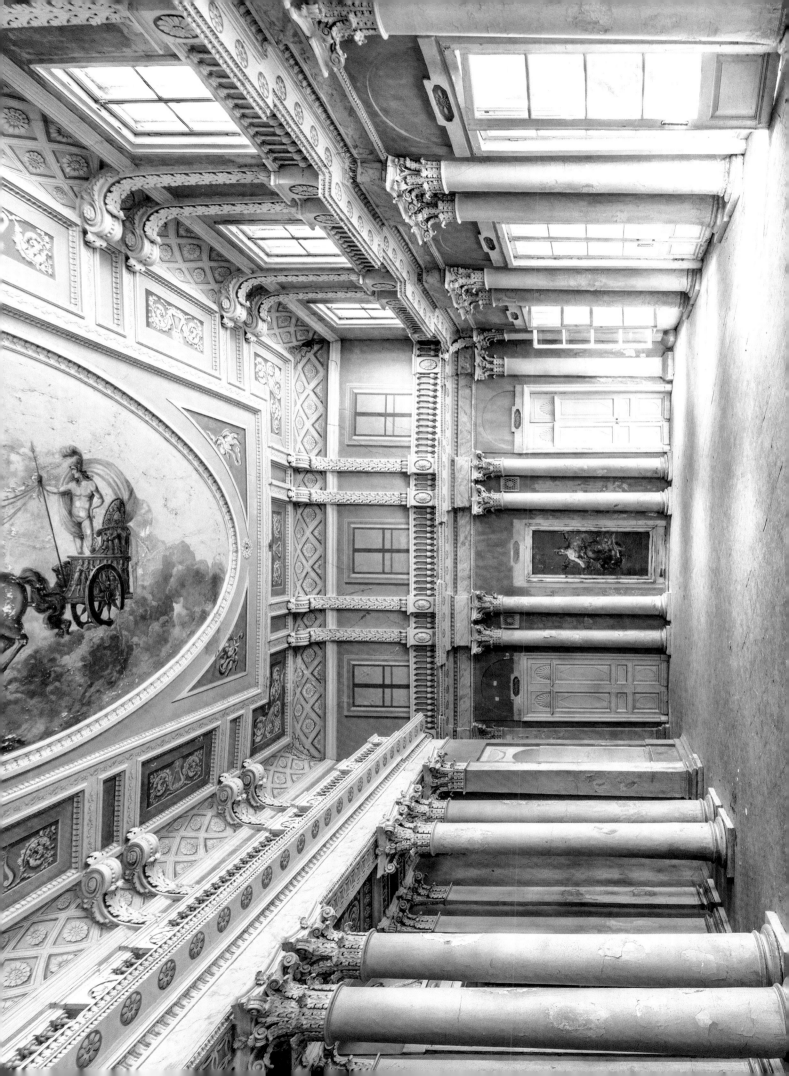

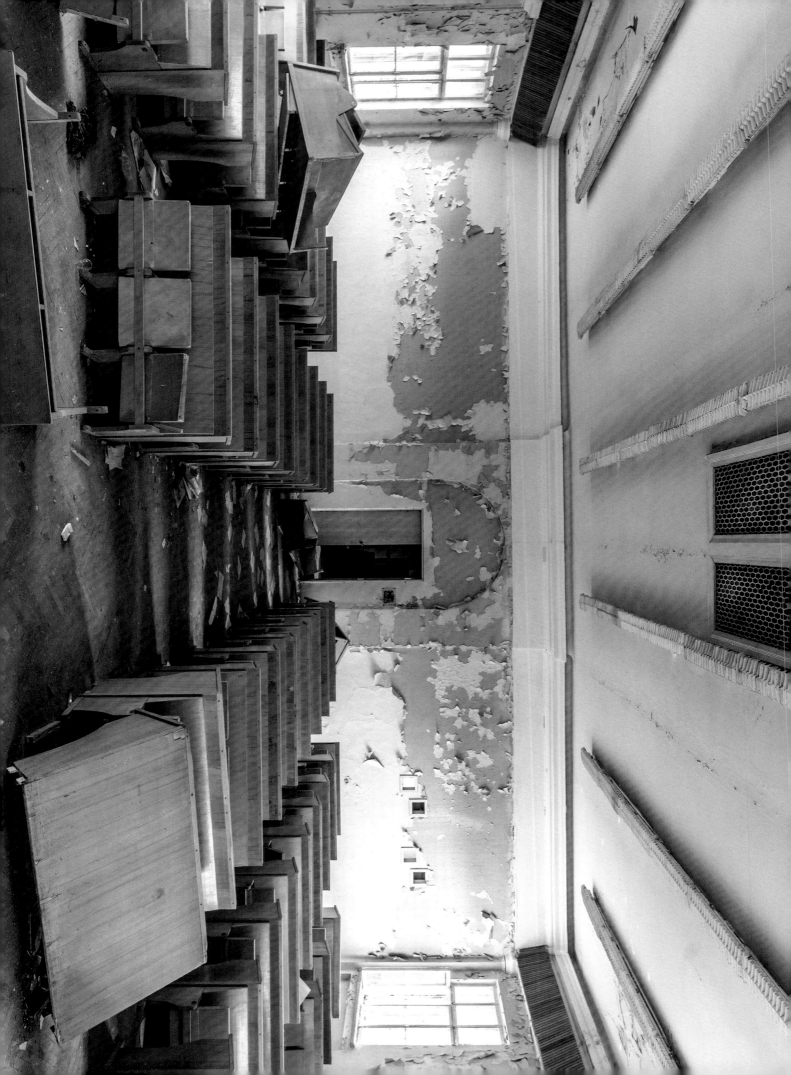

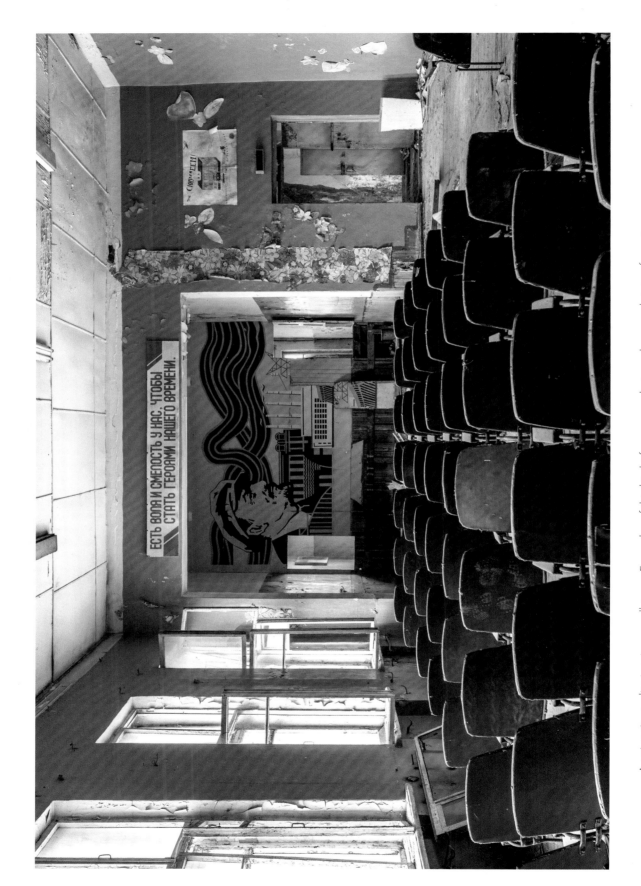

A university auditorium in a small town. Examples of this kind of propaganda in such a good state of repair are now very rare.

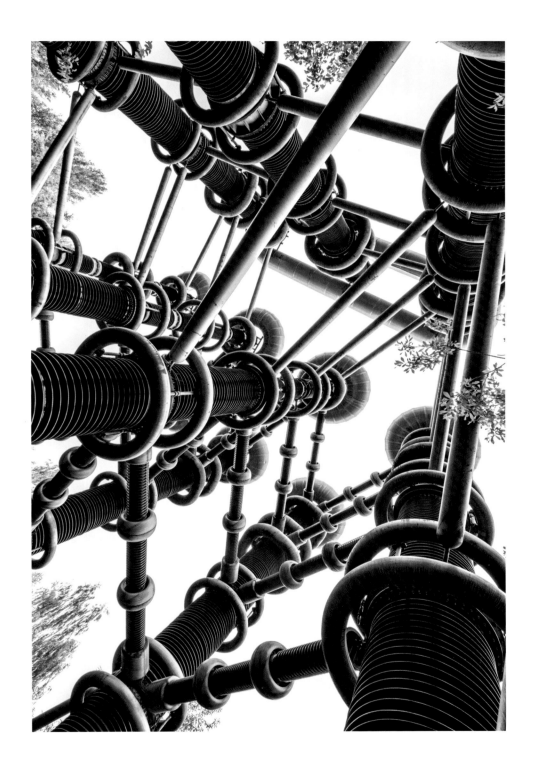

Prototype of a Tesla coil installed at the end of the 1970s in a research centre that was secret at the time. It was used to test insulators for the protection of vehicles, aeroplanes and electronic equipment against lightning.

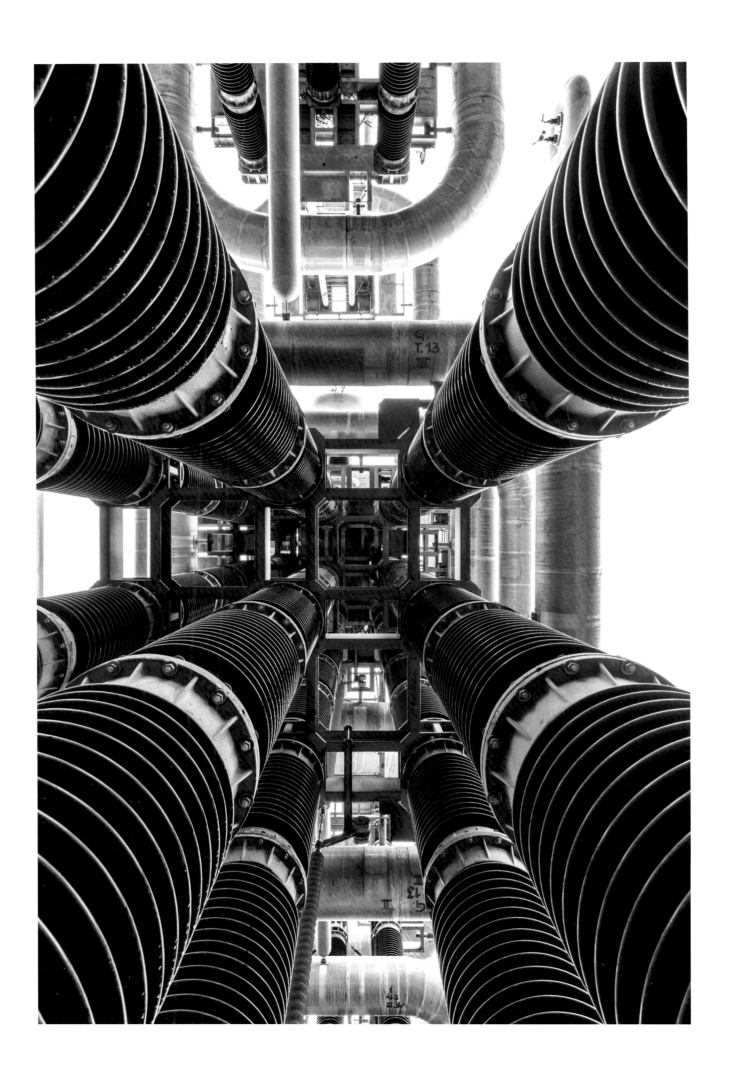

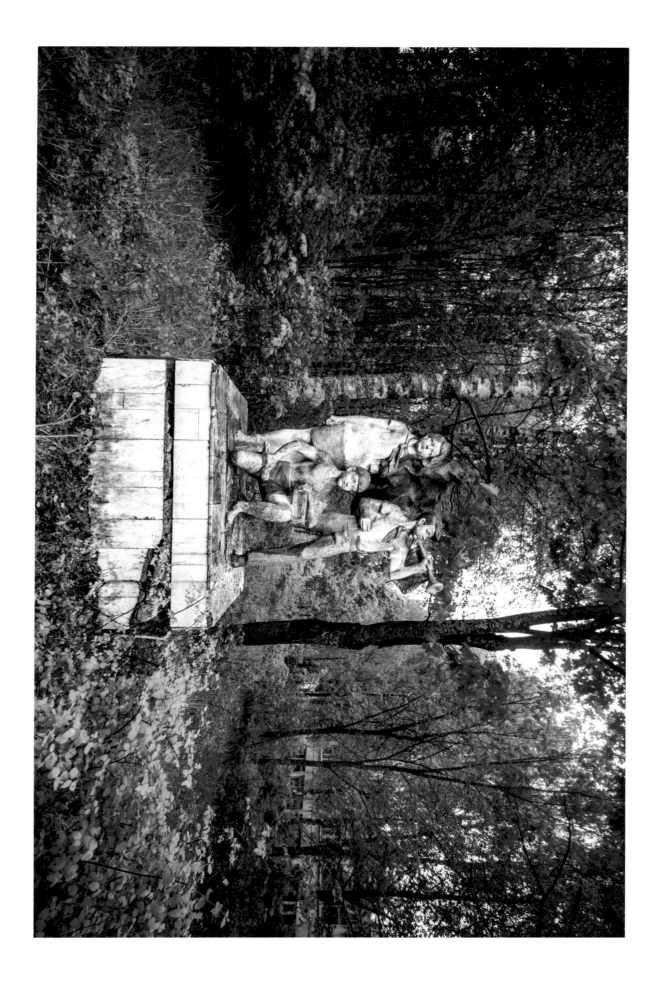

Statue showing a group of Pioneers inside one of Moscow's many camps.

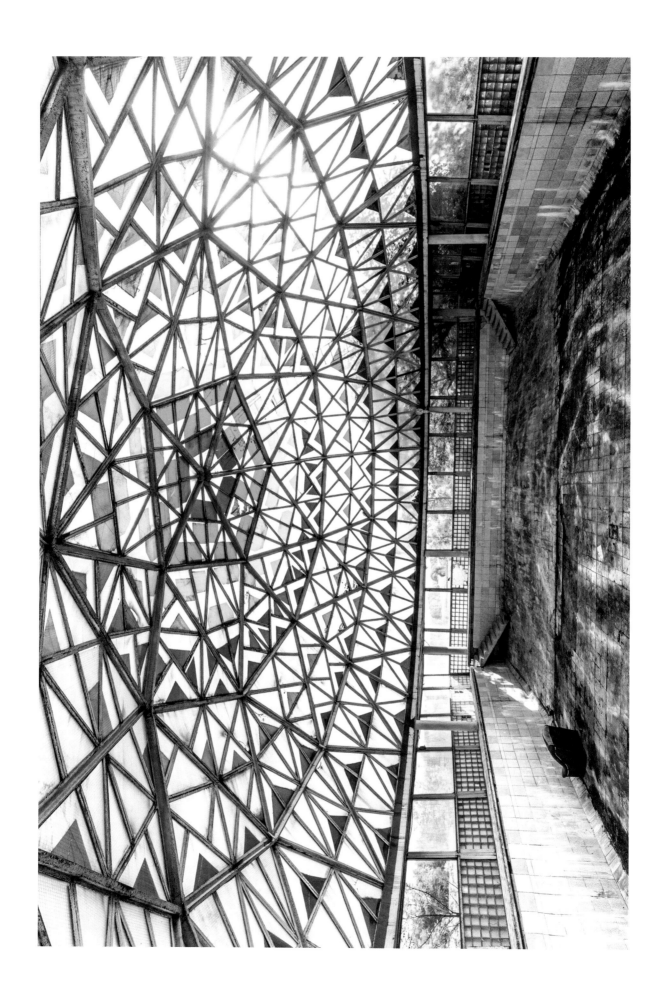

Swimming pool in a small village school in the Tula area.

The "Fairy Tale" Pioneer camp that became well known for its lavish decoration.

Dining hall at the "Fairy Tale" Pioneer camp.

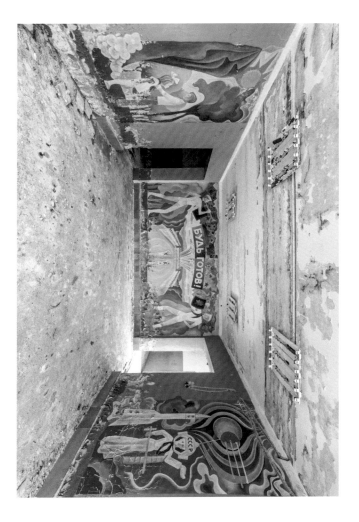

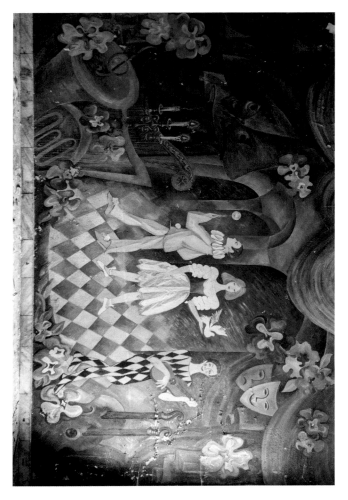

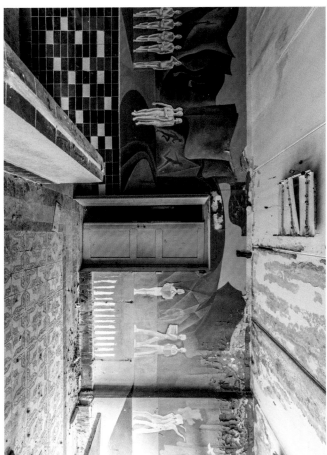

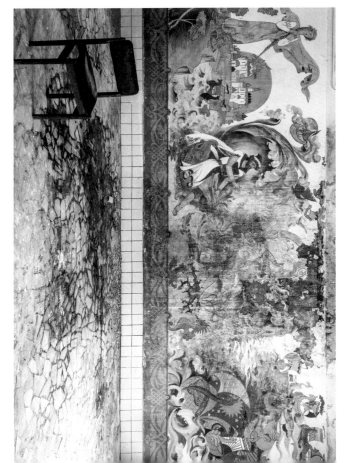

Six examples of wall decorations in an assortment of Pioneer camps located in the forests around Moscow. The pictures, in a style that appeals to children, mask unrelenting propaganda that encourages Pioneers to strive for the glory of the nation.

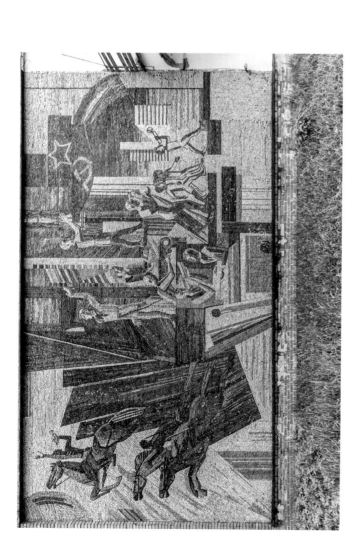

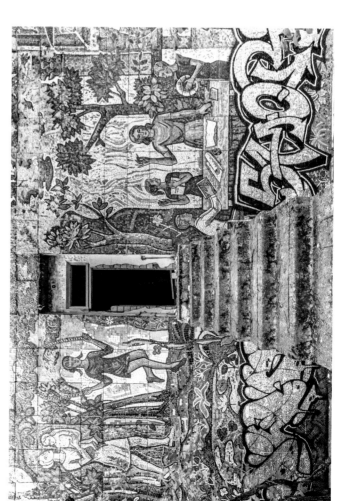

Statue of a cosmonaut in the conquest of space in the Kaluga area, not far from where Yuri Gagarin, the first man to travel into space, originated.

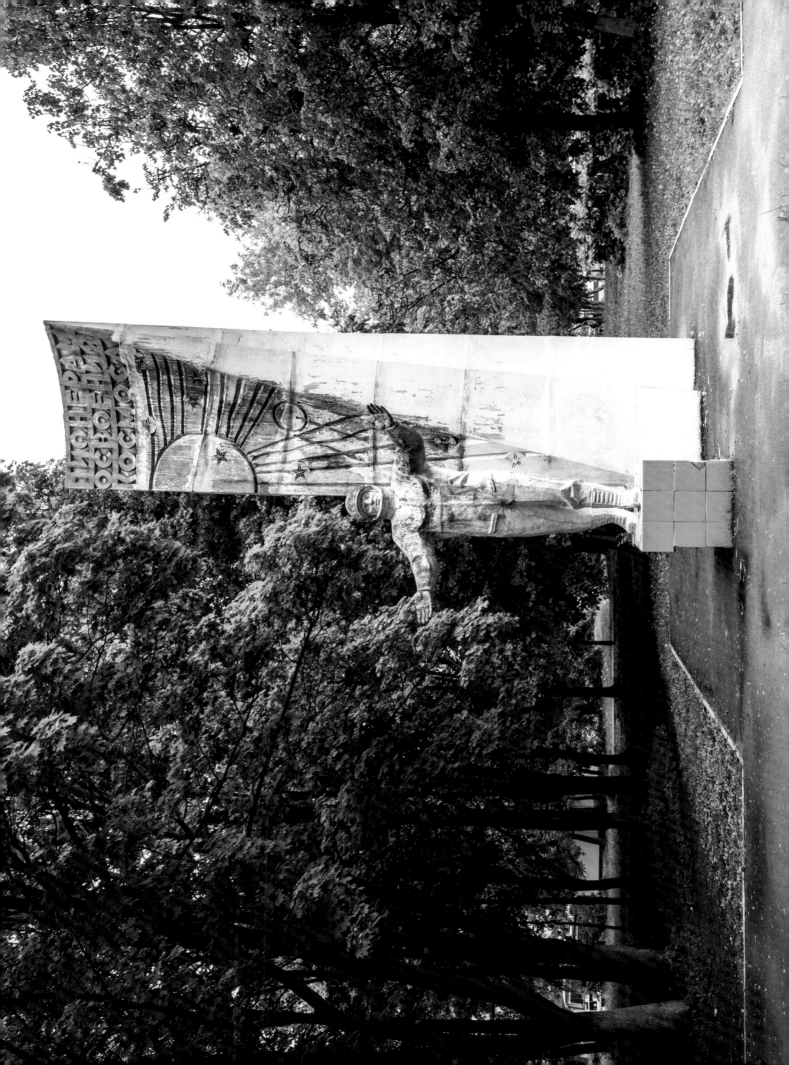

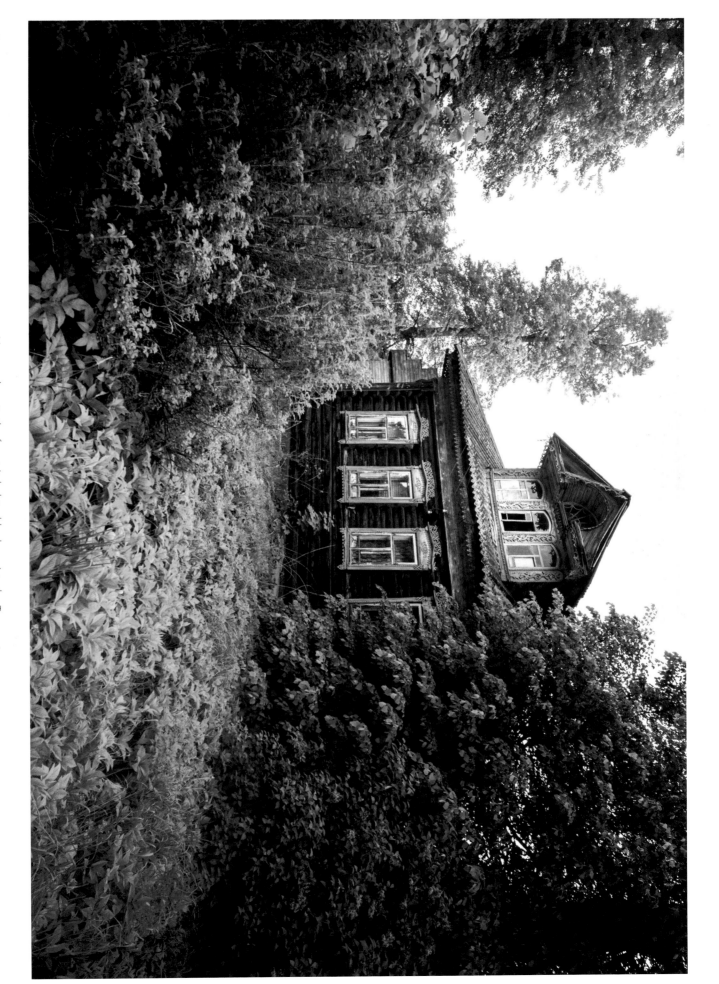

Houses deep in the forest (inhabited by bears) in the Tver region.

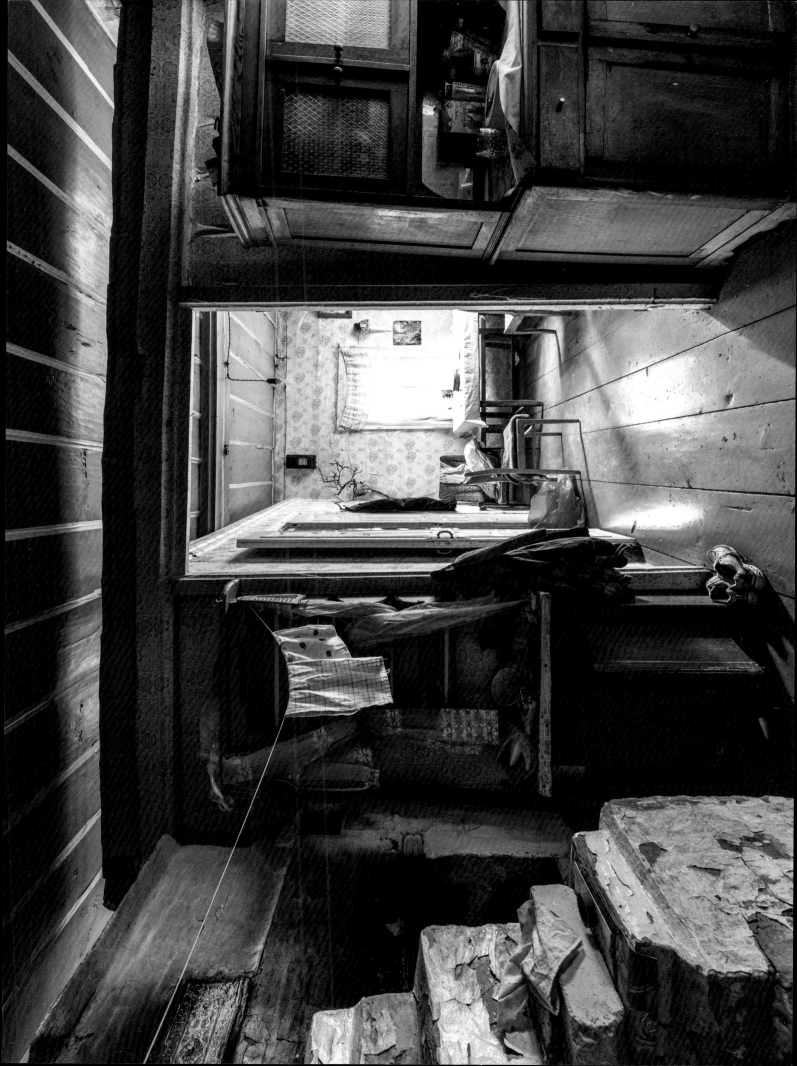

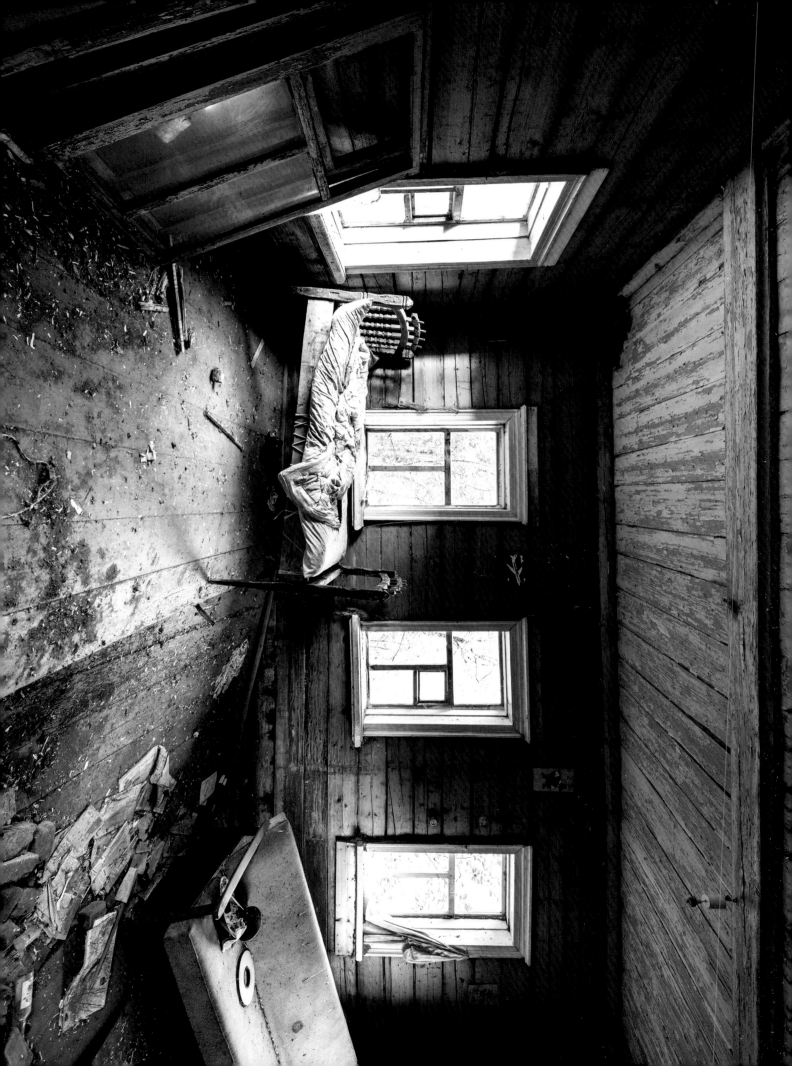

Food shop.

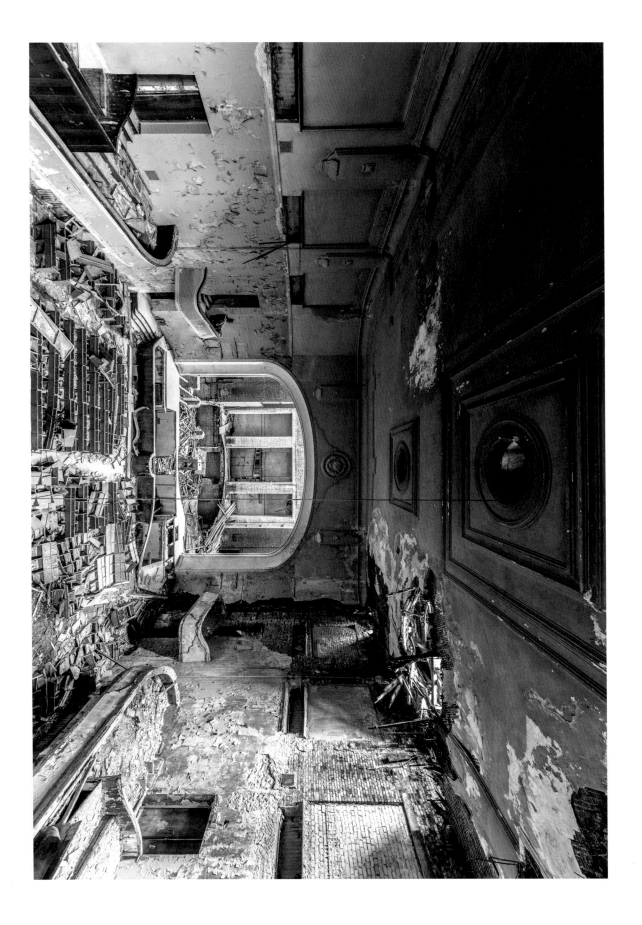

The Lenin Palace of Culture, built in 1917 in the city of Nizhny Novgorod, known during the Soviet period as Gorky. It was famous for manufacturing automobiles and armaments. This led to its being a "closed city" (where outsiders were forbidden access).

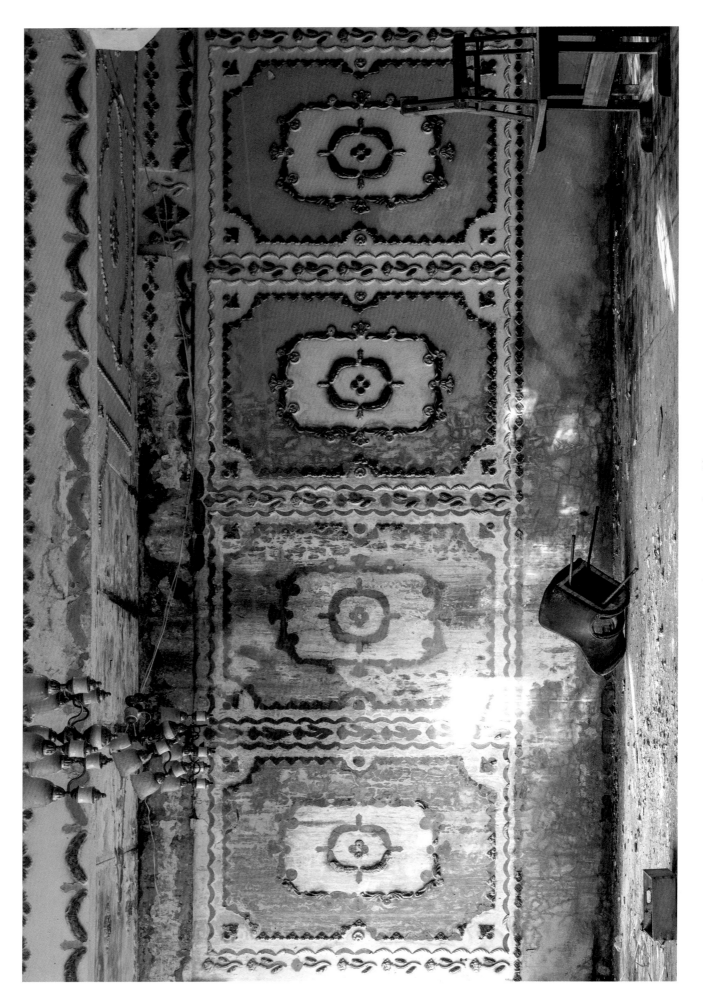

A canteen in a disused factory.

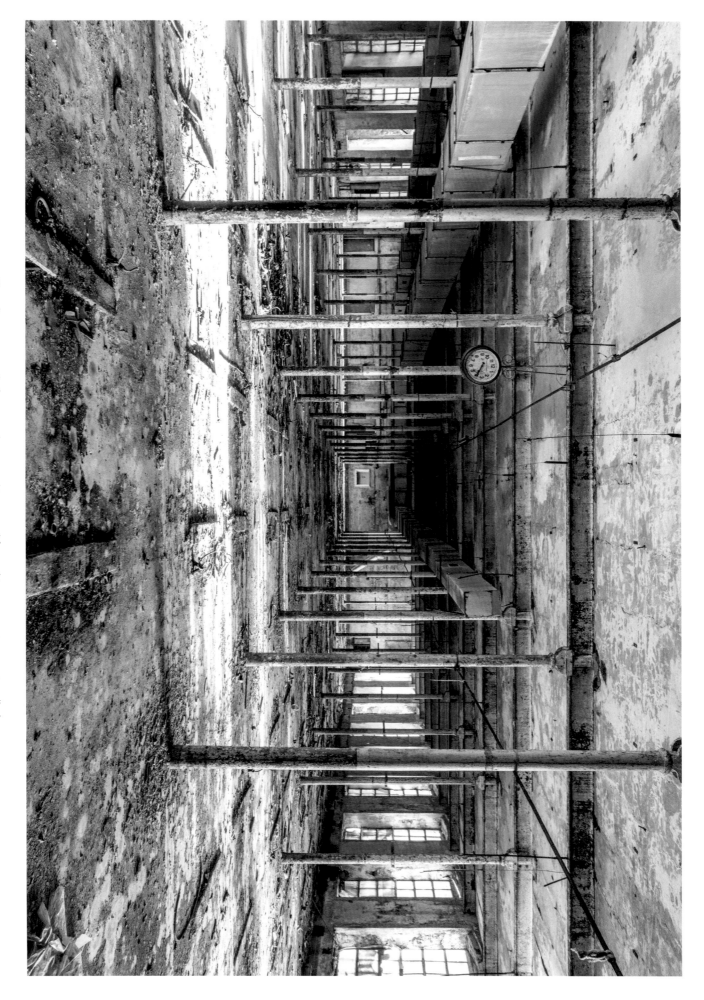

Shop floor in a textile factory where machines used for making garments were installed.

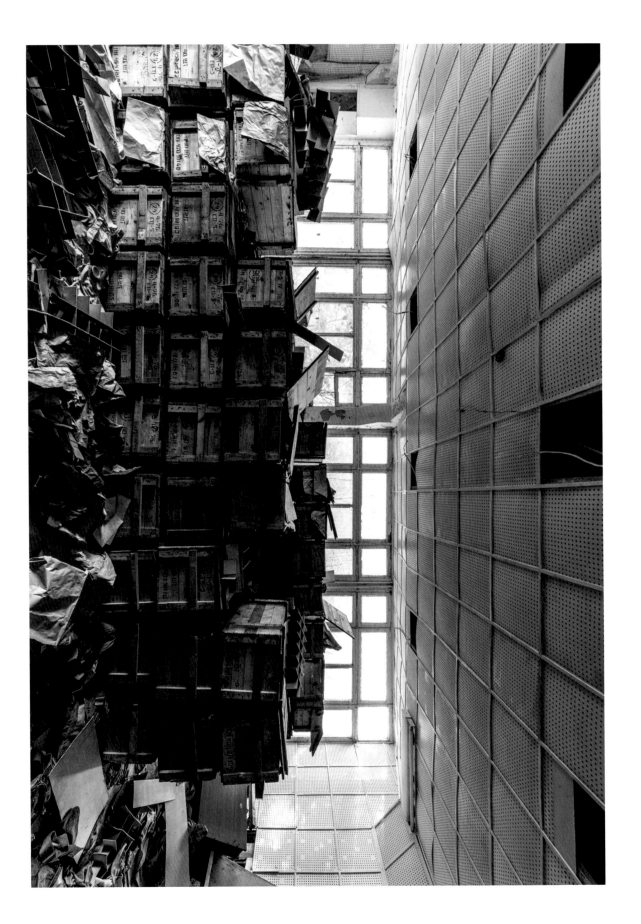

Areas used to store gas masks and military survival equipment in an abandoned factory. In the event of nuclear attack, workers had to be able to protect themselves long enough to reach a nuclear bunker.

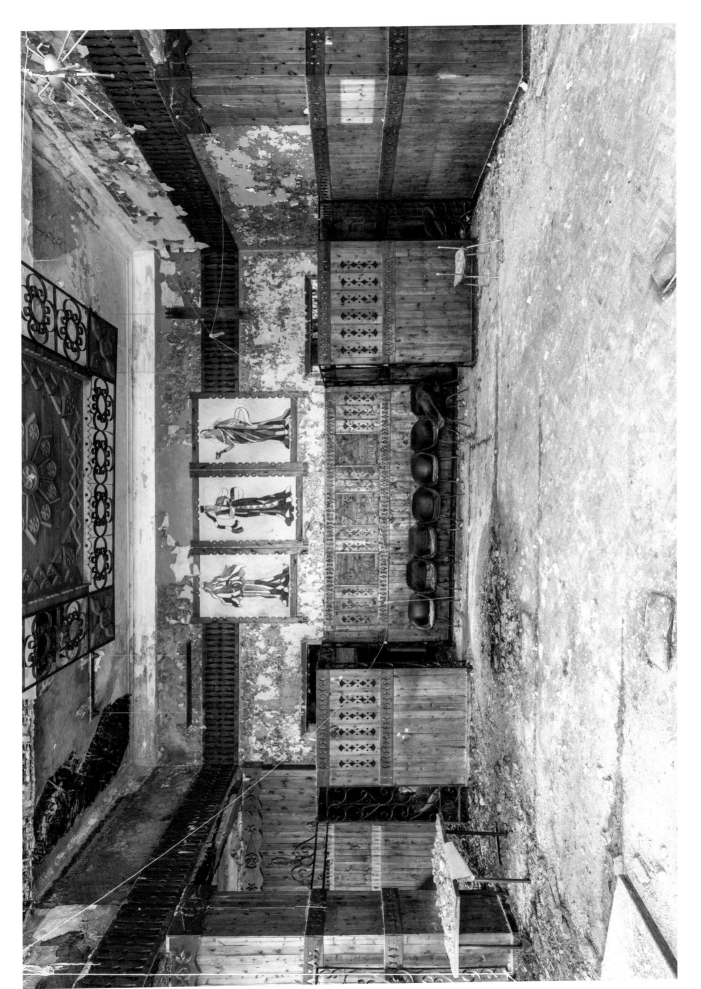

Dining room in the "Crane" factory, decorated with traditional Russian wood panelling in the region of Tula.

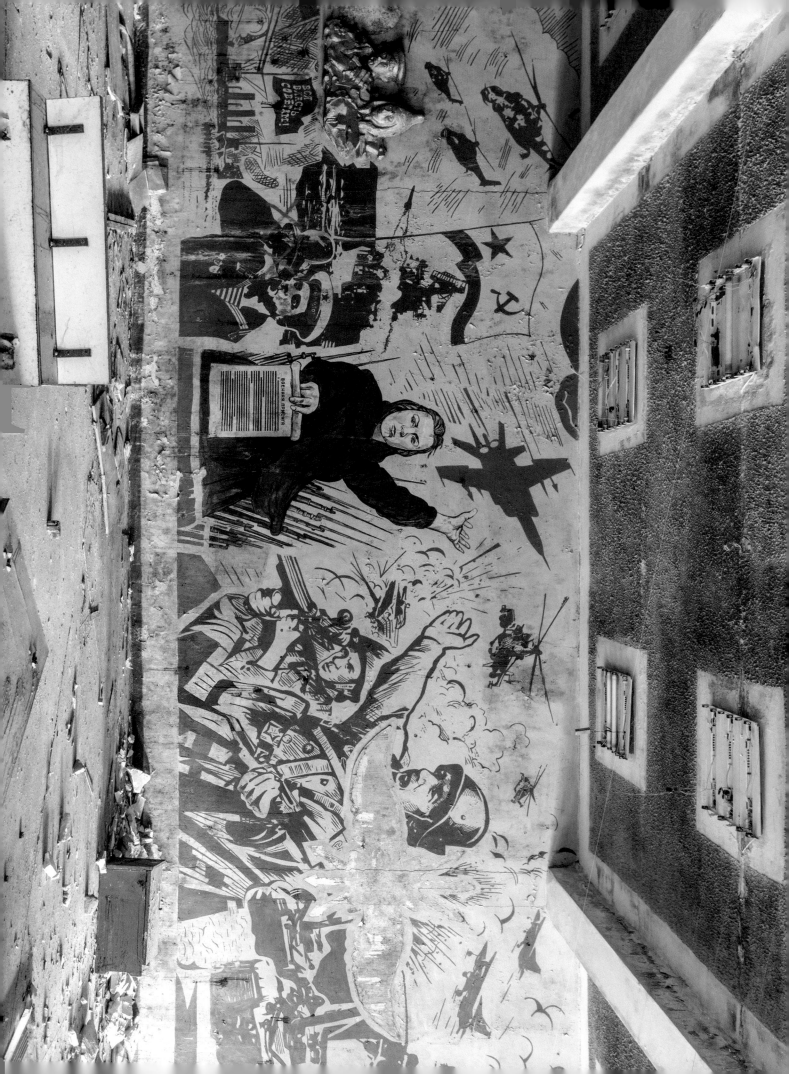

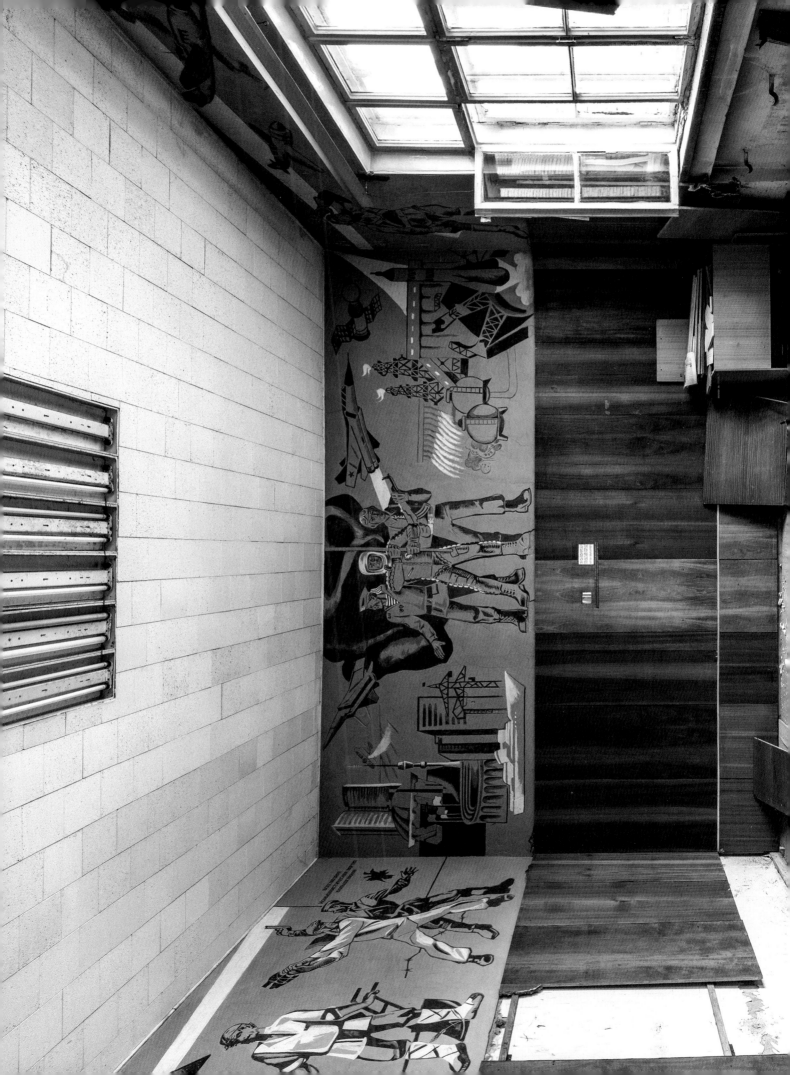

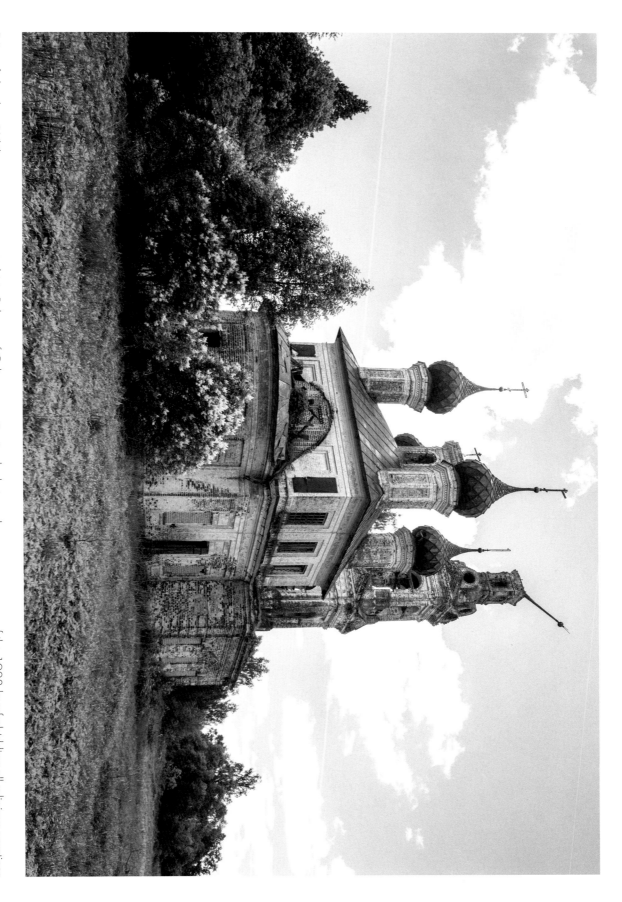

Ruins of churches. While some were converted into Palaces of Culture, or quite simply destroyed as a consequence of the 1928 law forbidding all religious practices within the Soviet Union, many others were simply abandoned. Some of the surviving buildings date from the 12th century, hanging on in the hope of being rescued by some initiative to save the nation's heritage.

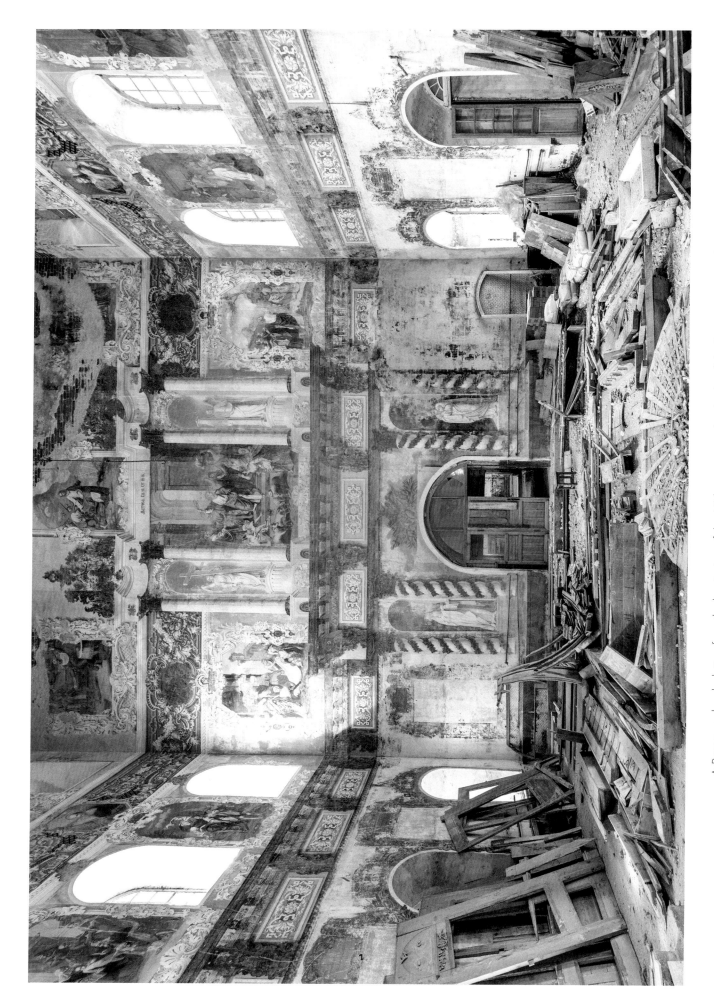

A Baroque church dating from the beginning of the 18th century, in the depths of the Russian countryside.

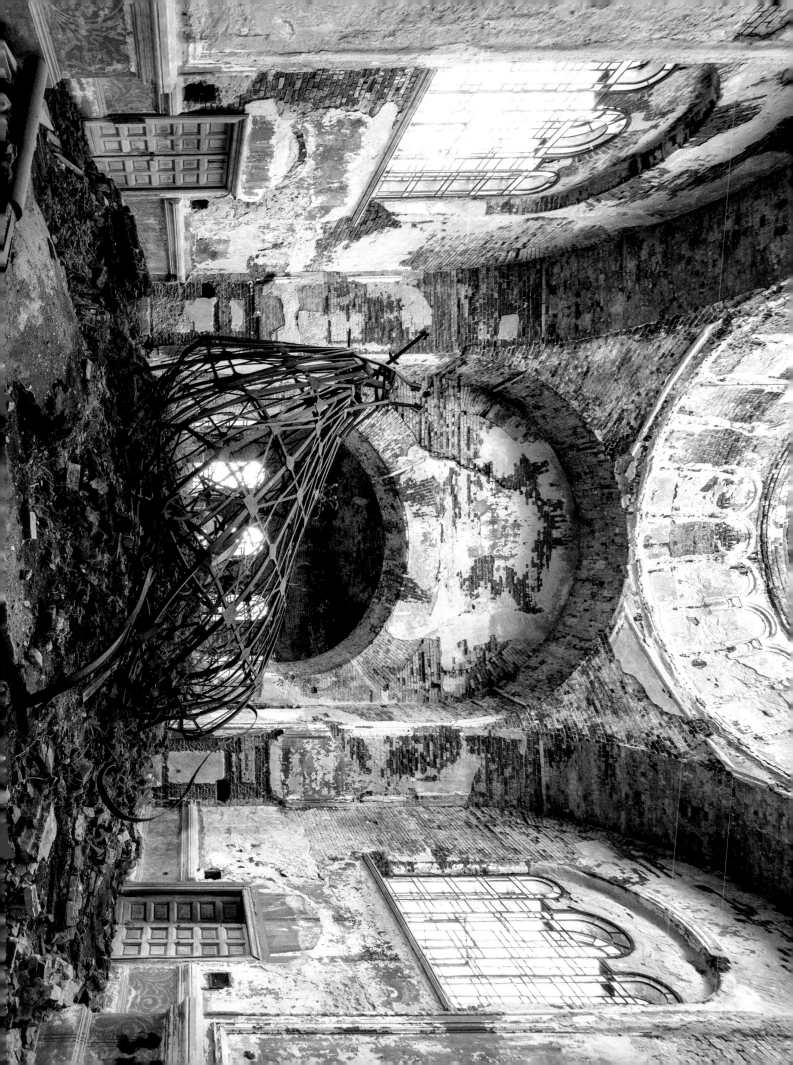

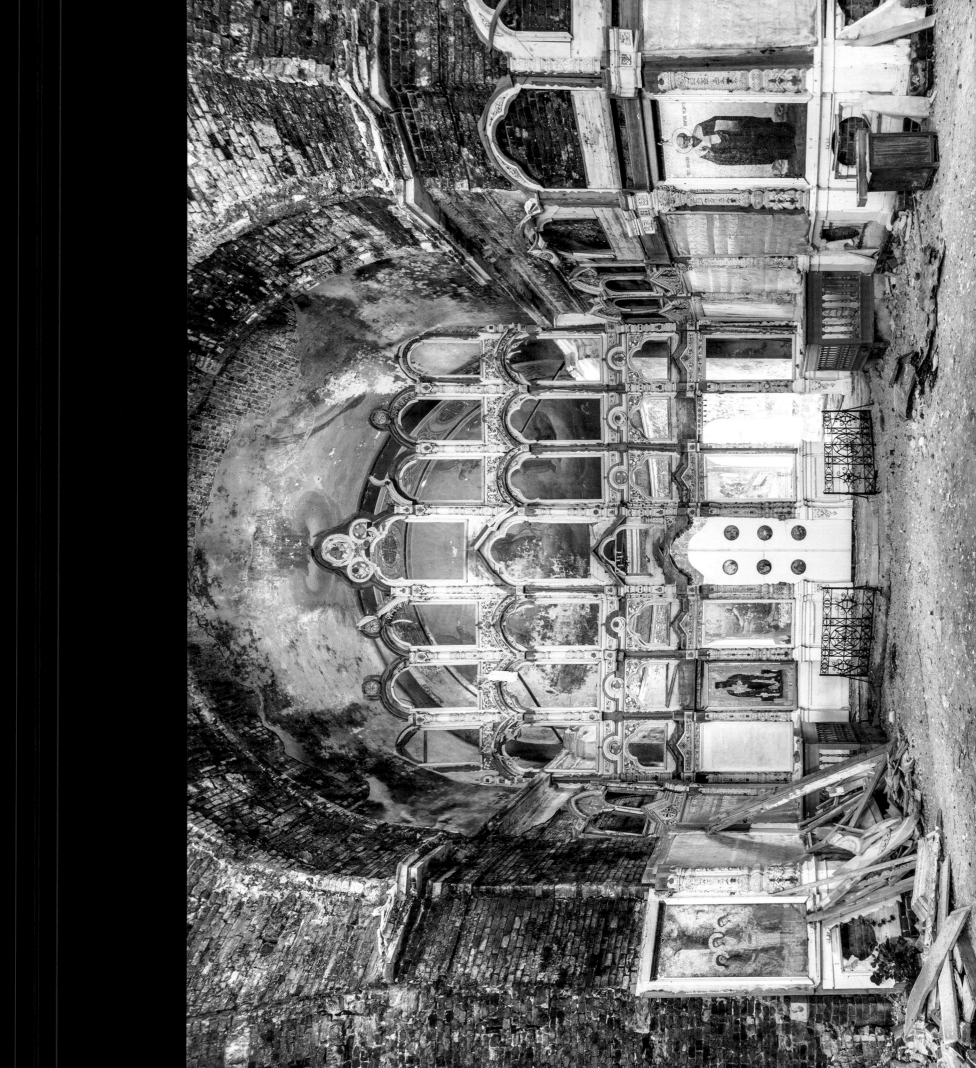

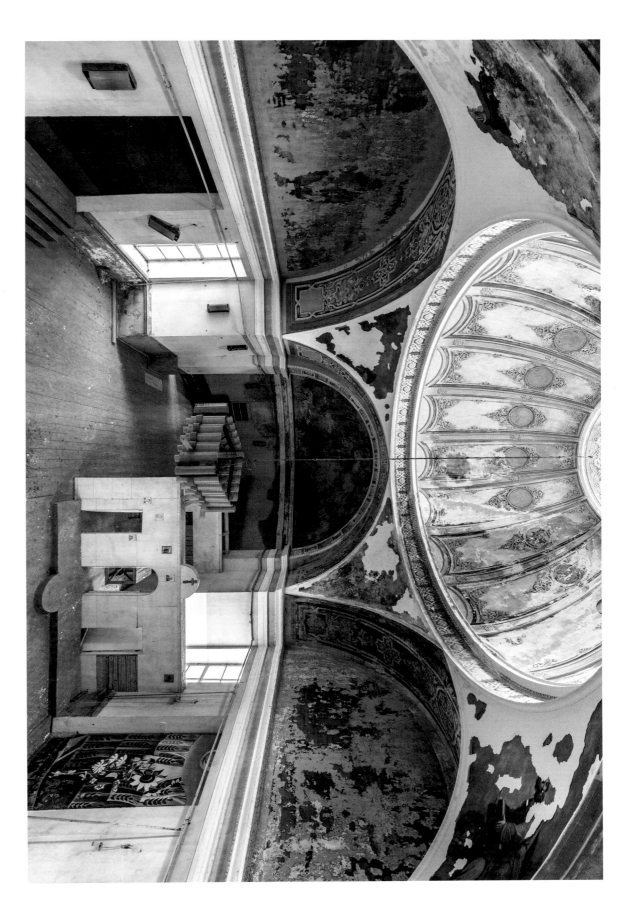

Church converted into a Palace of Culture. The symbols of religion were covered over and replaced with depictions of Lenin, as a symbol of the atheist ideology which supplanted the Orthodox religion.

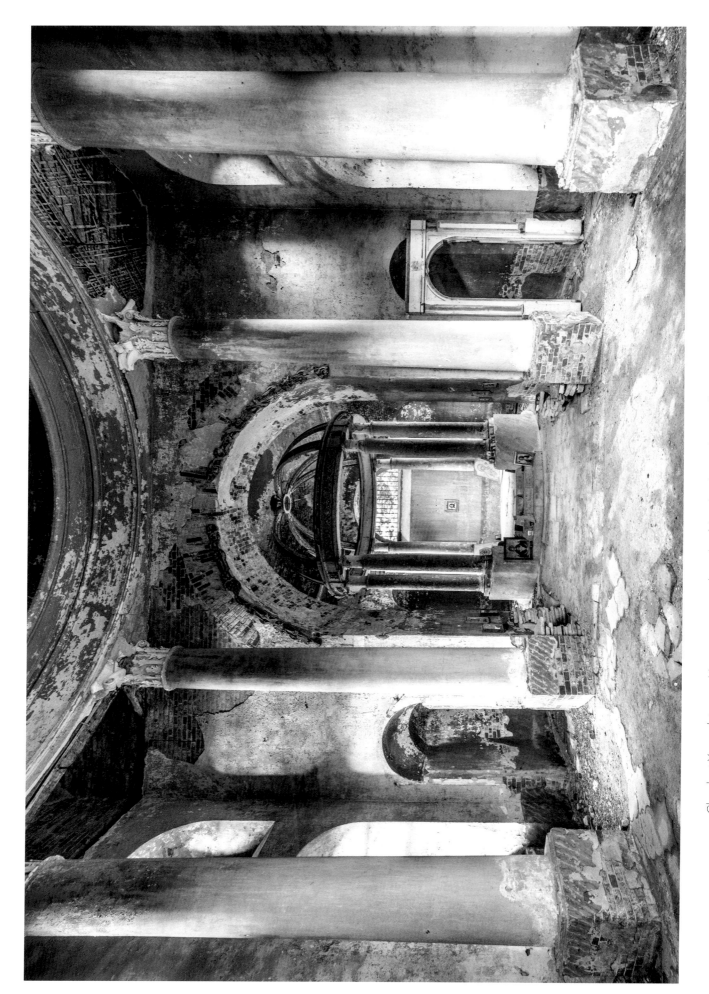

Church at Yaropolets near Moscow, copying the style of the churches in the city of Kazan. It was probably built in 1790.

# Latvia

Although it had declared independence in 1918, Latvia once again found itself annexed by its Soviet neighbour during the Second World War. However, despite vast numbers of deportations and the Russification of its culture, for many years the people of Latvia have clung onto the crumbs of their heritage, much in the same way as the silent church, imprisoned by the frost, stubbornly continues to resist the ravages of the weather.

Like her two Baltic sisters, Latvia gained independence in 1991, even before the dissolution of the USSR. United by their thirst for freedom, the three countries made a real impact when they formed the Baltic Chain, a human chain 600 kilometres long, that crossed Estonia, Latvia and Lithuania. The image of hundreds of thousands of people driven to unite in a common purpose contrasts sharply with the loneliness that pervades some places which are now abandoned. The deserted hall of a disused airport goes painfully hand in hand with the corridors of an abandoned school, where movement sensors barely manage to convey the impression of any past human activity.

Visits: 2018 – 2019

Orthodox church in a style similar to that of Russian churches. Snow from the broken windowpanes lends a muffled silence to the interior.

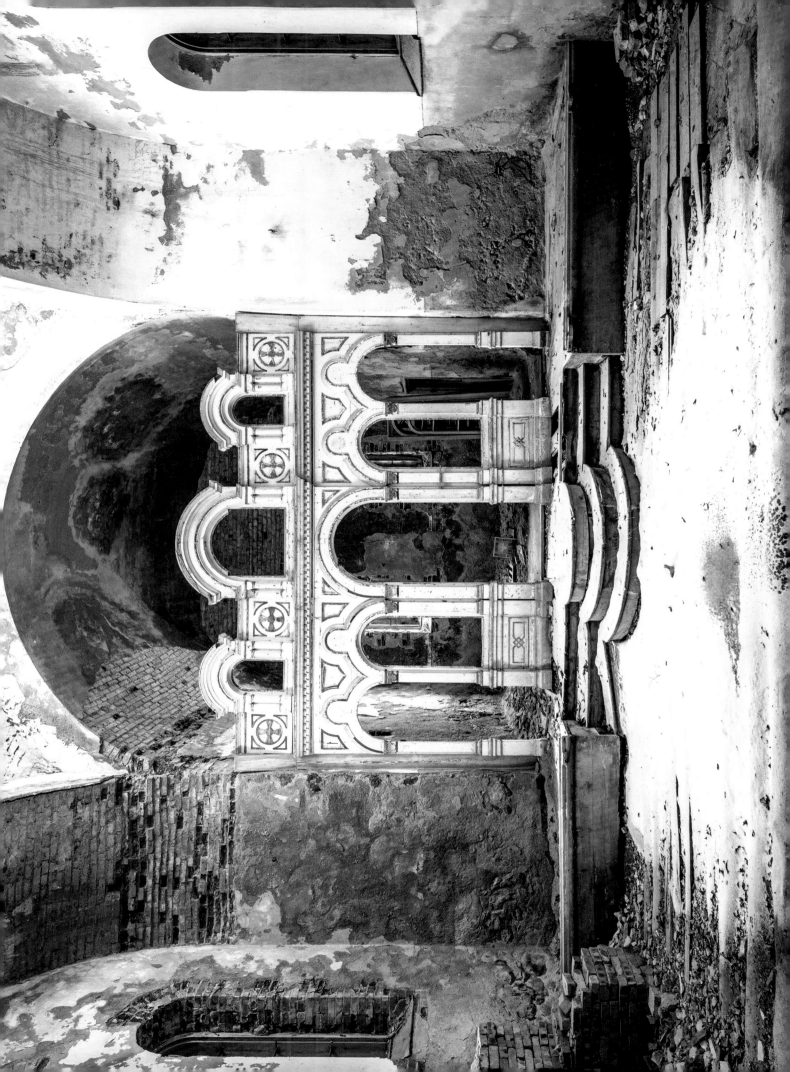

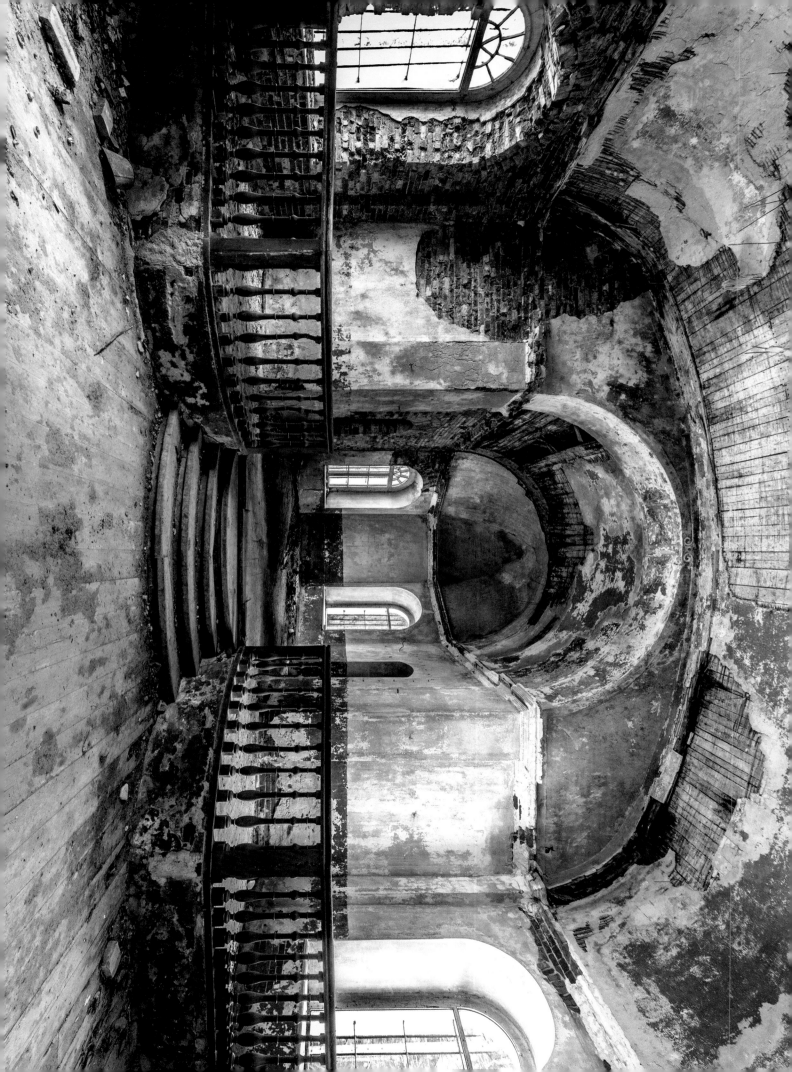

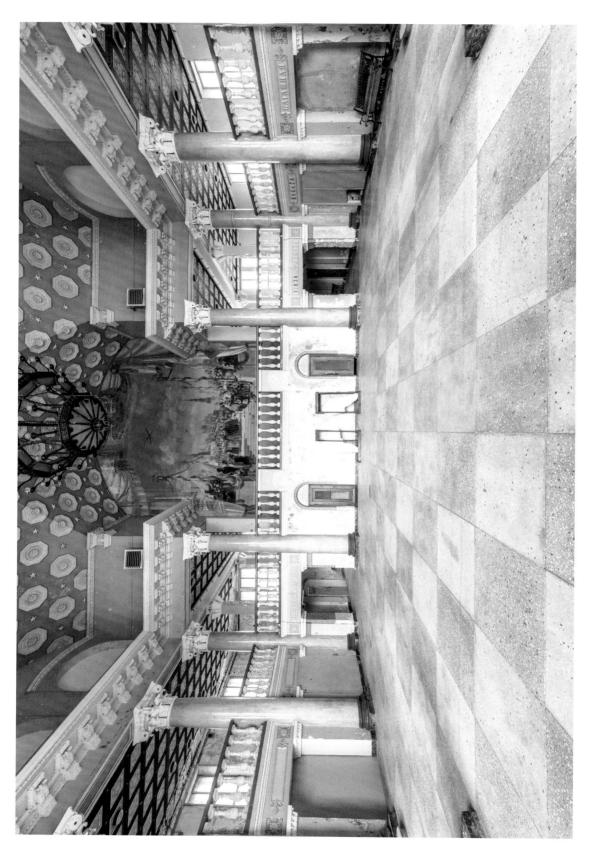

Riga's former airport was built in the Neo-classical style in 1954 by the USSR. It replaced a small complex, damaged by the war, that had hosted one single transcontinental airline. For a long time this was one of the most active airports in the western part of the USSR with 50 flights a day. It gradually declined until the new airport was opened, when it was then turned into a training area for civil aviation.

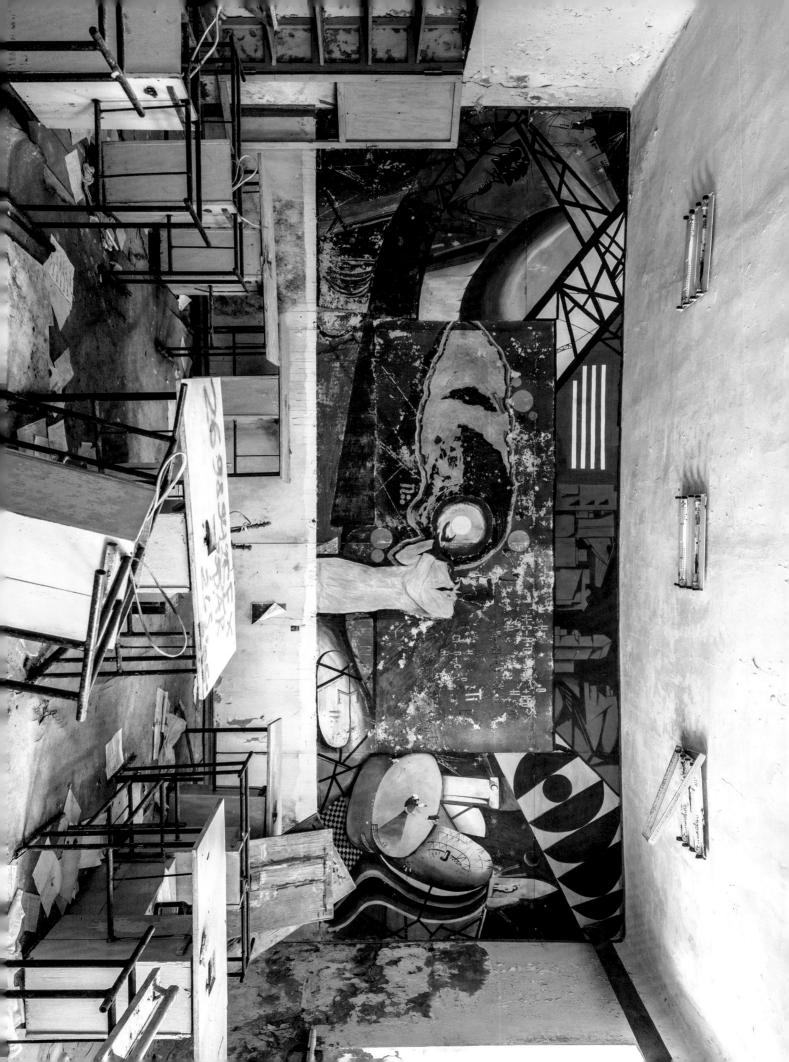

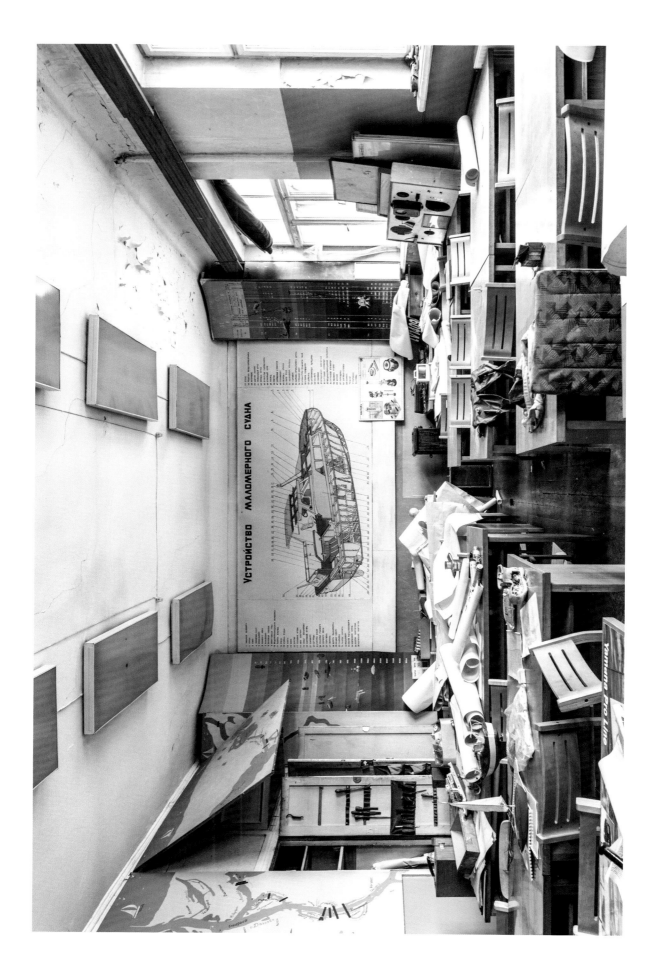

Disused marine school in Riga due to be demolished shortly after the time of the visit.

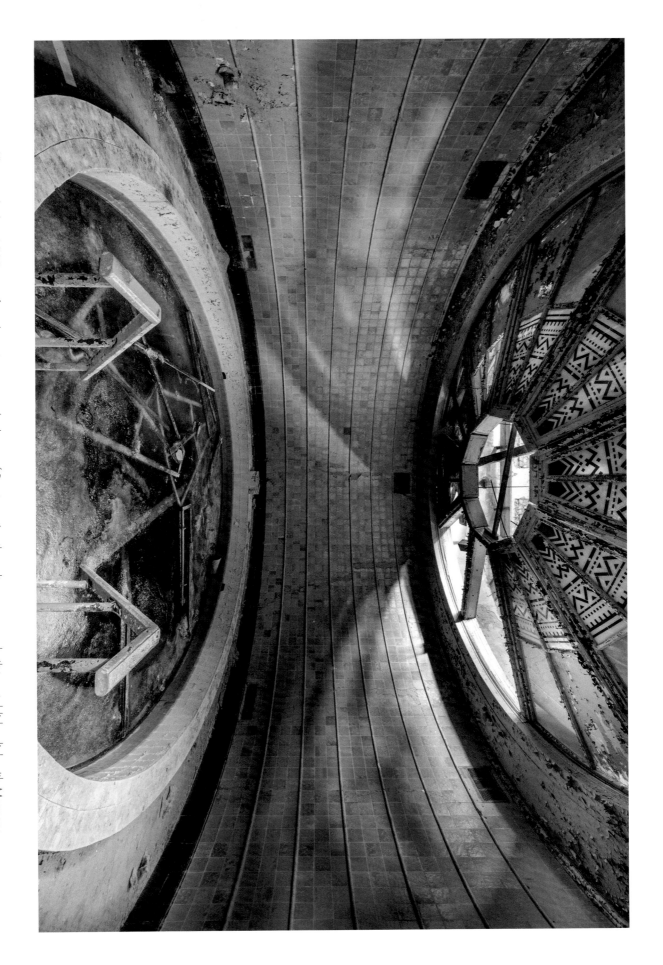

The spa, built in 1838, was for a long time a popular haunt of Russians. A railway line was even built to establish a link with Moscow.
The complex, shrouded in cold as the ice covering the pools testifies, is on the verge of collapse.

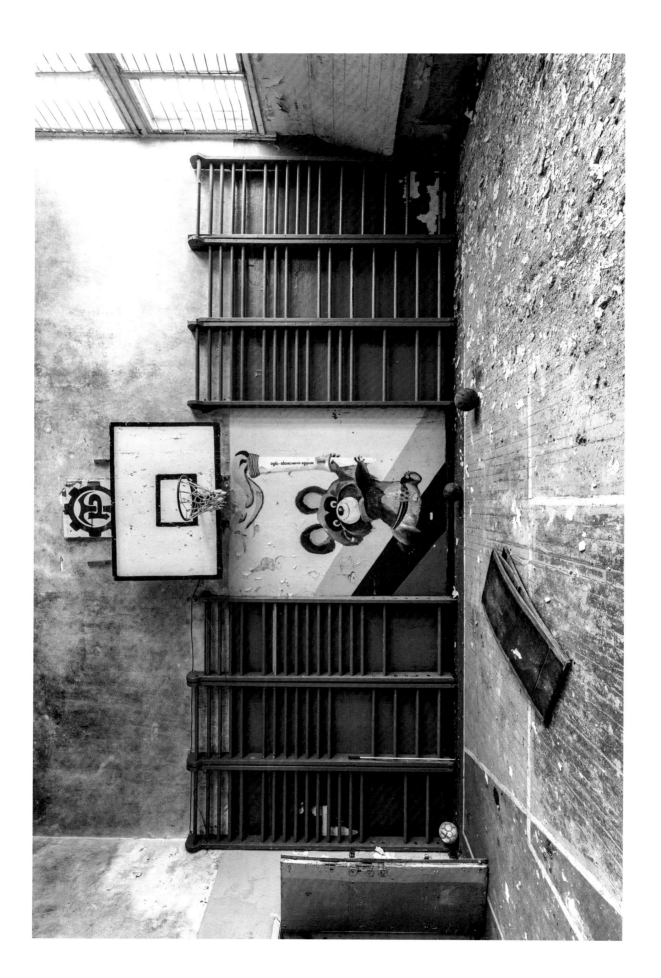

A school gym. Mishka, the famous mascot of the Soviet Union carrying the Olympic flag, takes centre stage.

Wall round a former Soviet barracks. It now conceals a different, more recent military site — this time belonging to NATO.

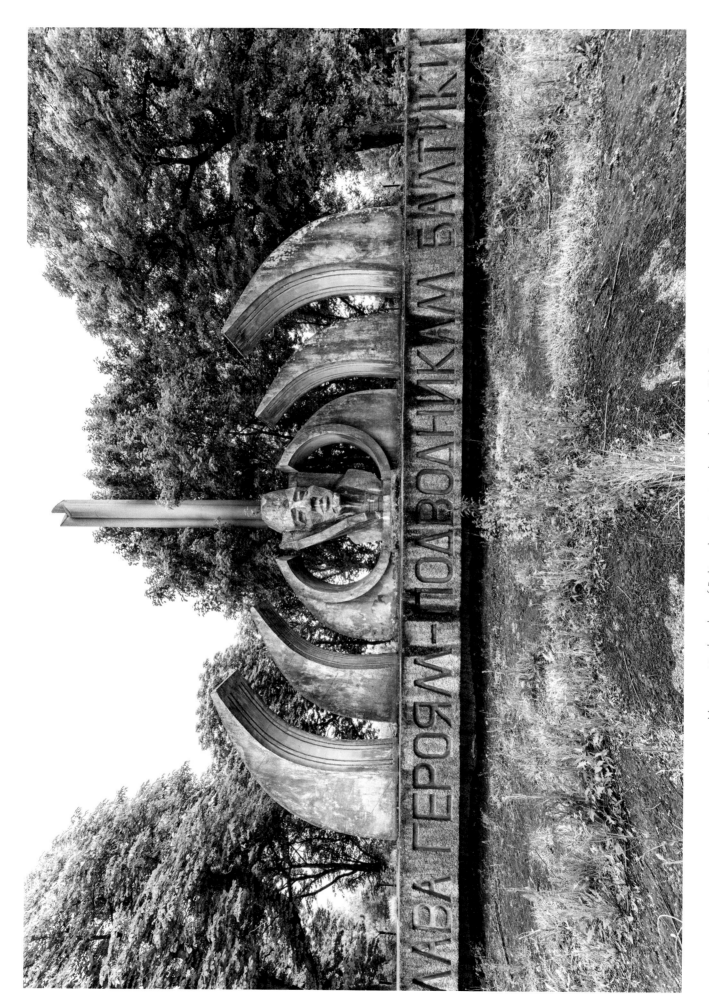

Monument to the glory of Baltic submariners in a barracks on the Baltic Sea coast.

# Ukraine

In 1918, Ukraine became a Socialist Republic, some months after the government in power had been overthrown by the Bolshevik party and the proclamation of independence. Despite falling victim to the greed of various powers, in 1922 Ukraine joined the newly formed USSR, which continued to exploit it every bit as much as the Russian Empire had done previously.

A Pioneer camp that seems to have been deliberately set in isolation in the darkest depths of a thick forest, and a former theatre where nothing remains other than portraits of Stalin and Lenin, bear witness to Ukraine's tortured identity. Here, the slightest hint of nationalism was considered a betrayal of the Bolshevik ideal. In some places the feeling of being watched has not completely disappeared: you feel the need to sneak surreptitiously from one room to the next to avoid the watchful eye of the guards, while taking great care not to alert the dogs as you tread on the debris of broken glass littered across the floor. In other places, such as the bombed factories of the Donbas with their post-apocalyptic atmosphere, or the ghost town of Pripyat a few kilometres from Chernobyl, permanent silence prevails.

Visits: 2013 – 2018 – 2020

Baroque palace that was clearly requisitioned for conversion to an orphanage or Pioneer camp. Some of the original ornate decoration can be seen through the cracked paintwork of the walls. These are a far cry from the austerity of communism that replaced them.

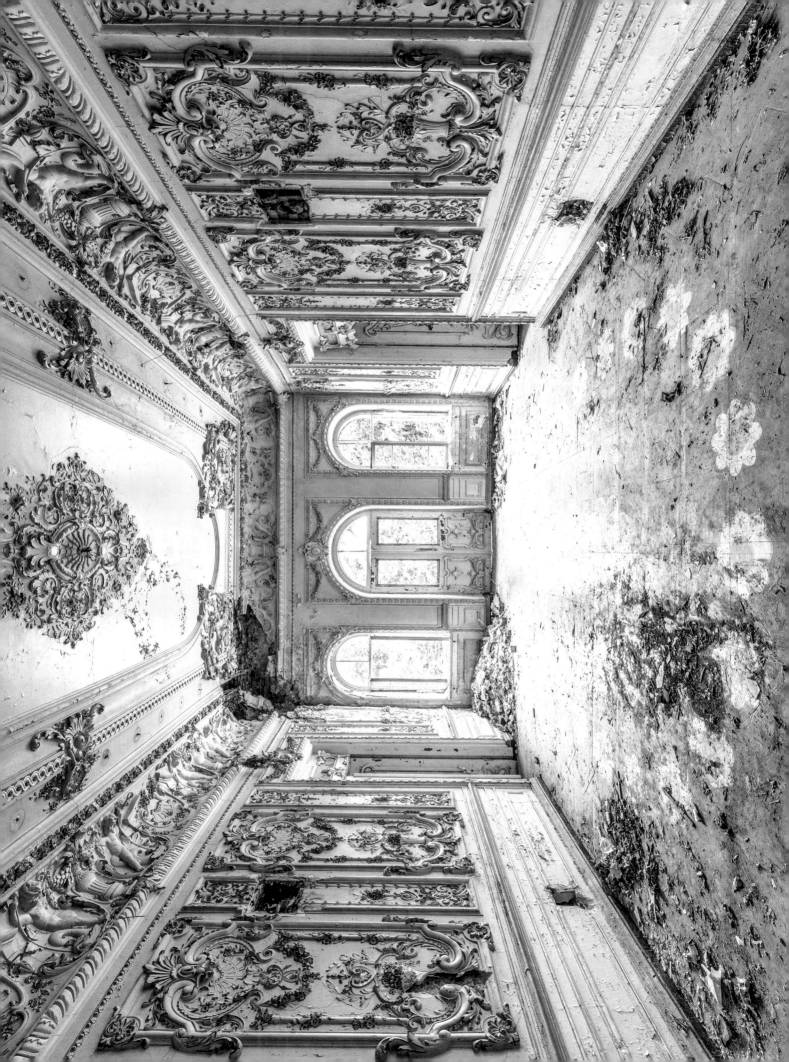

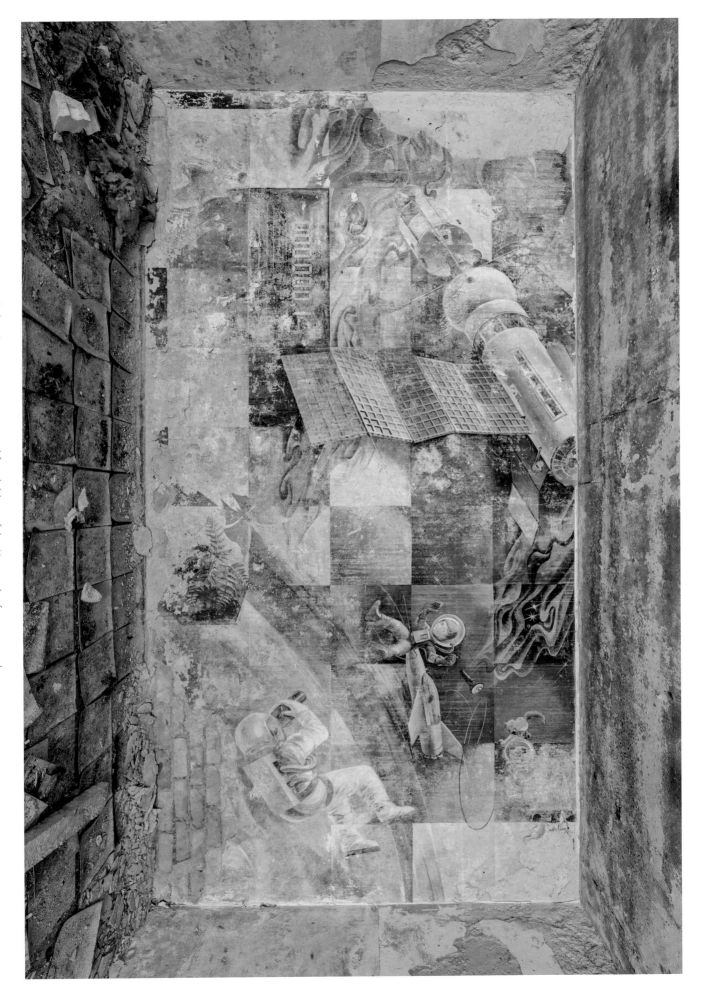

Salyut Pioneer camp reserved for children of the Kiev radio factory employees.

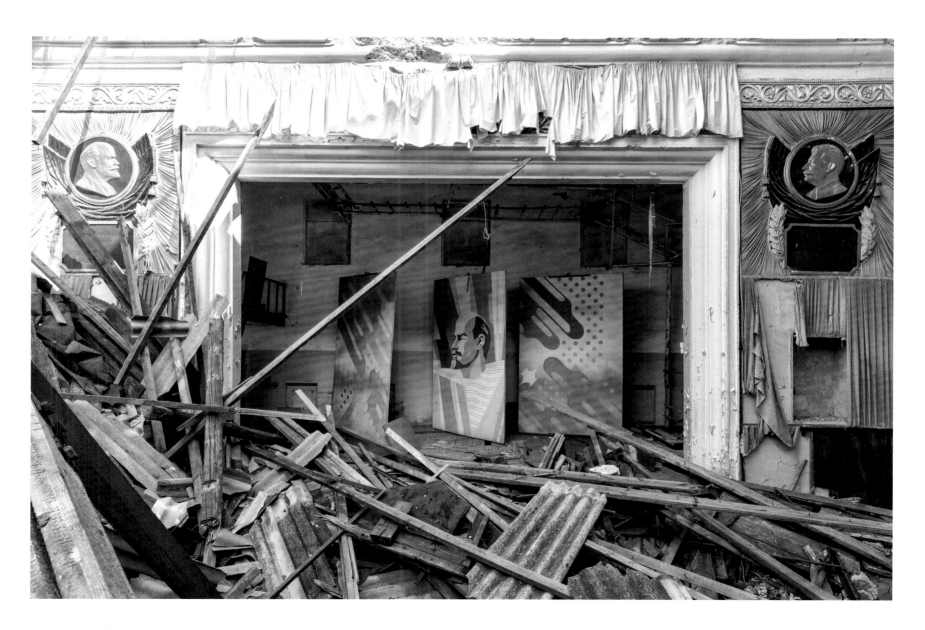

Theatre belonging to a sanatorium. The two medallions on either side of the stage show Lenin and Stalin in profile. In Ukraine depictions of Stalin became increasingly rare because he was responsible for the terrible famine that decimated the country between 1931 and 1933. Thus, most memorials bearing his image have been destroyed.

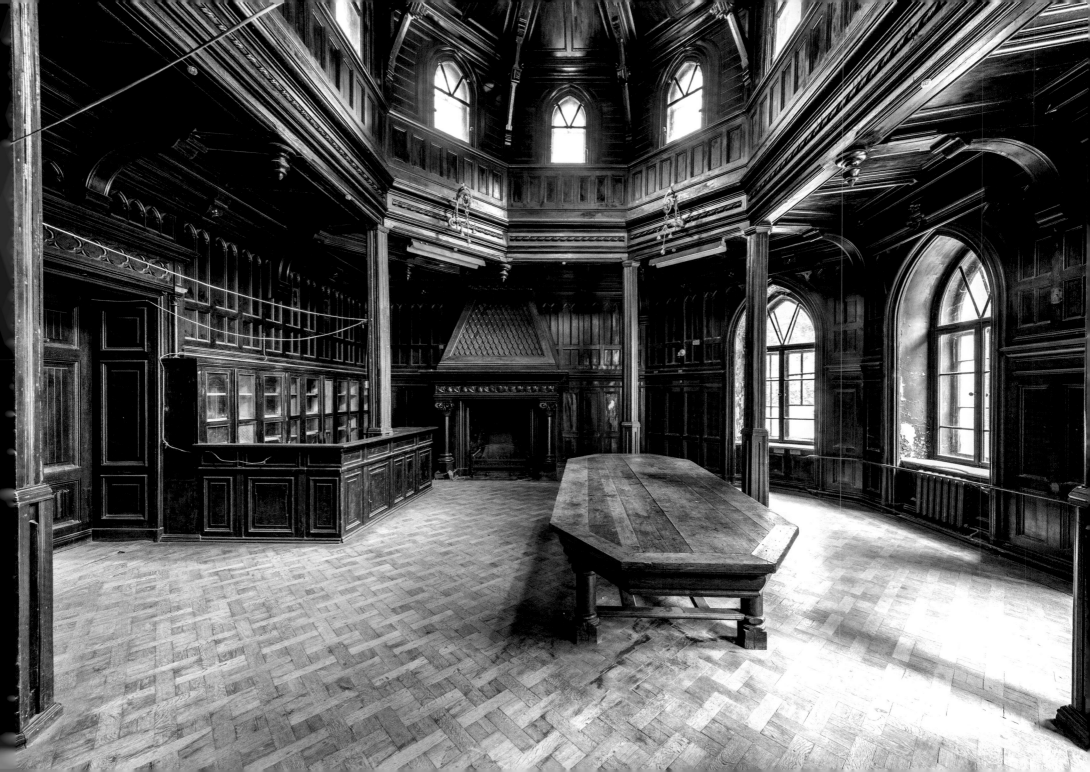

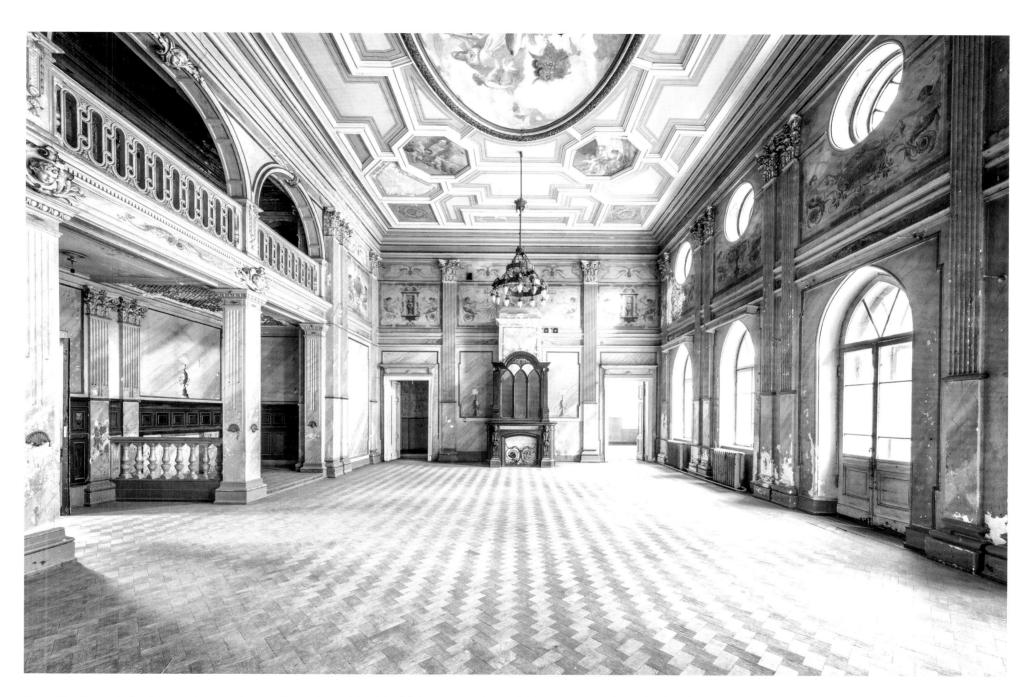

One of the Sharovski family's grand country houses. Built in the middle of the 19th century, it pleasingly blends the Neo-classical style with Russian Baroque. To the rear there is a large botanical garden.

The enormous Lenin Palace of Culture in the city of Dnipro. Currently undergoing renovation, it is one of the most striking relics of the Soviet era in the country.

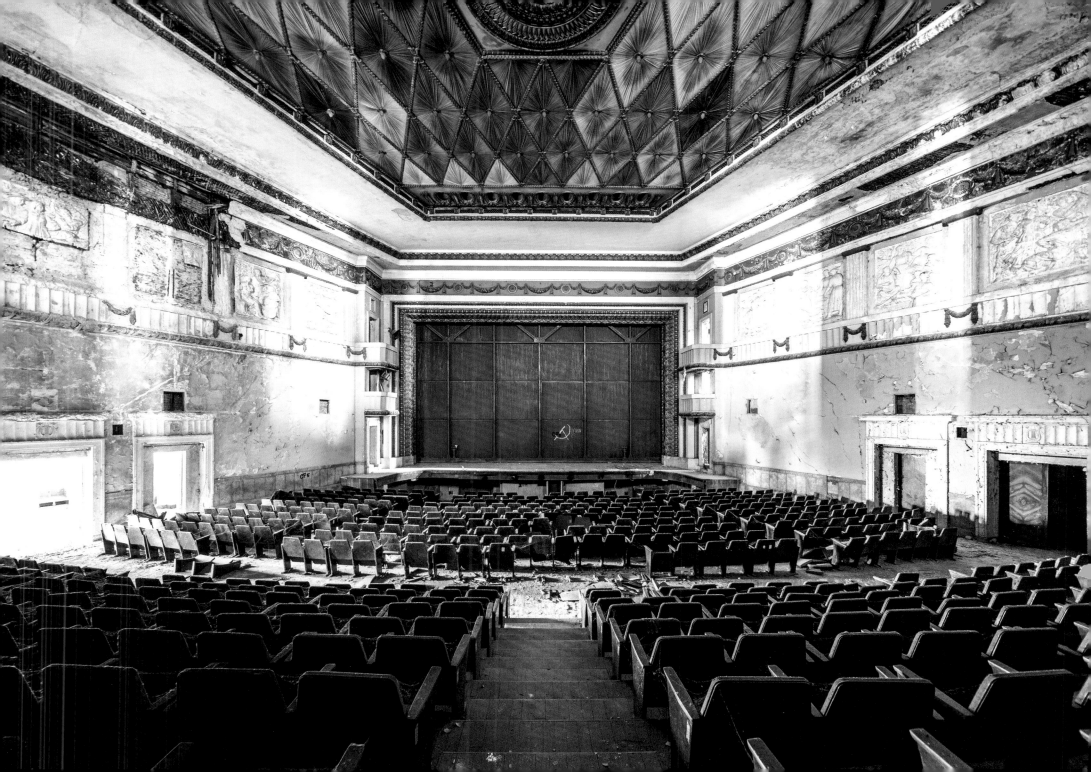

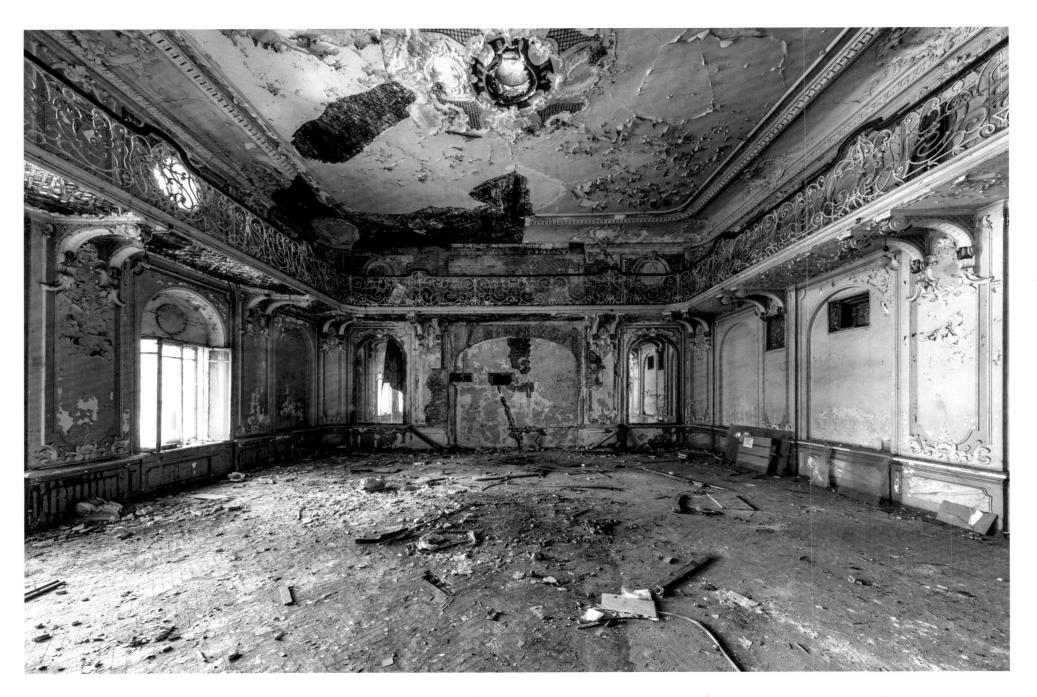

This room in a former English-style country house hosted German officers during the Second World War before later being reclaimed by the Red Army.

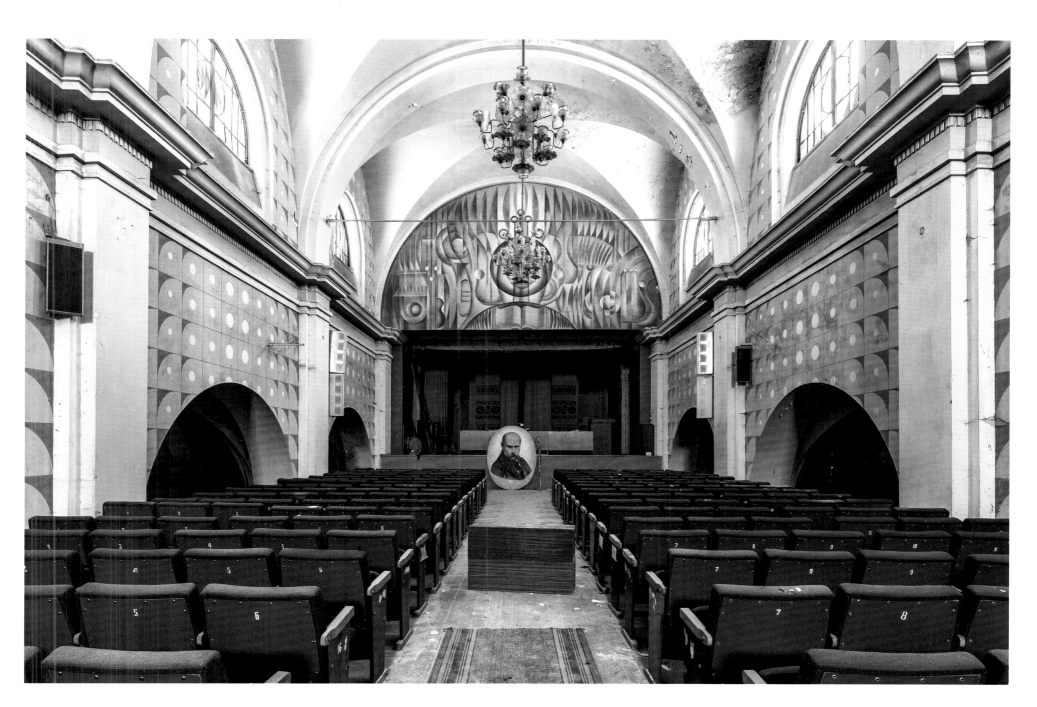

Palace of Culture created inside a former Art Deco church which was built in 1938. A portrait of the poet Taras Shevchenko can be seen.

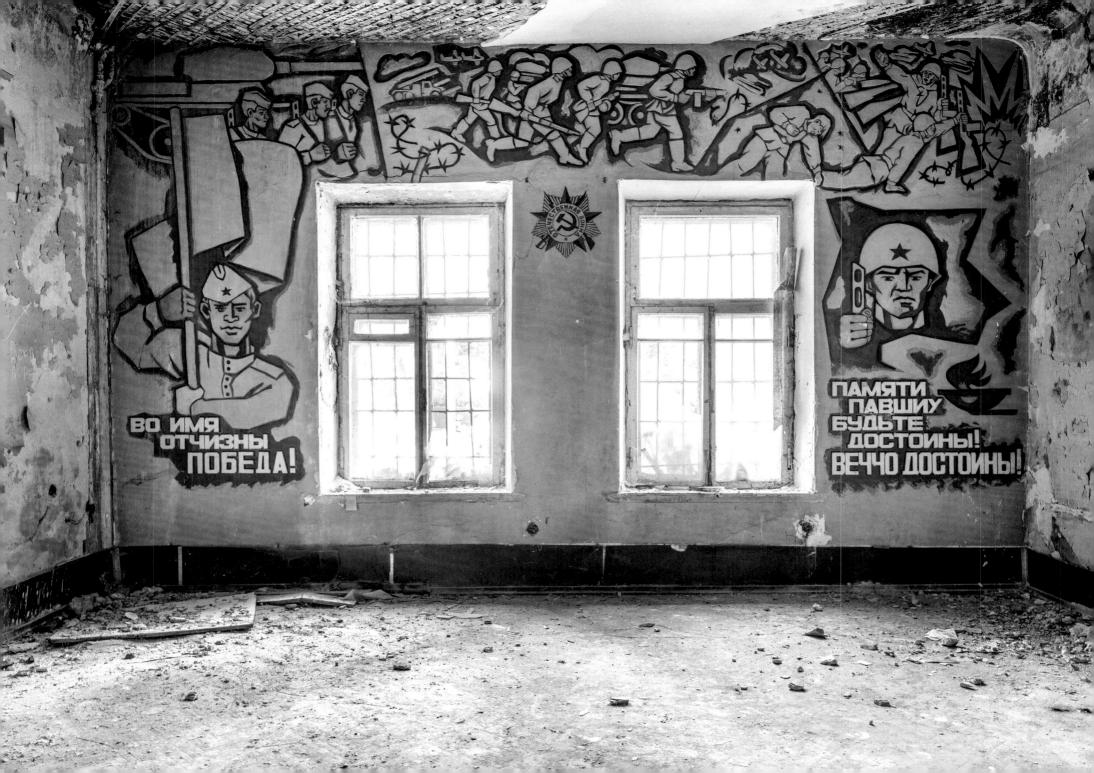

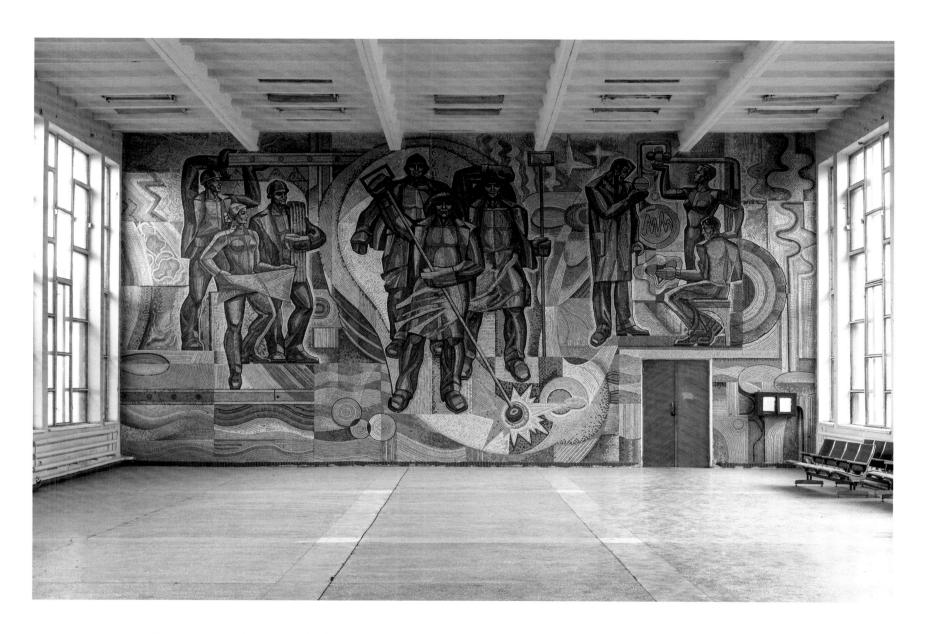

Mosaic mural in a disused railway station hall in Dnipro. It is not unusual these days to find murals like this covered over with advertising posters in an attempt to erase a communist past in countries that seek to distance themselves from the Russian-speaking world.

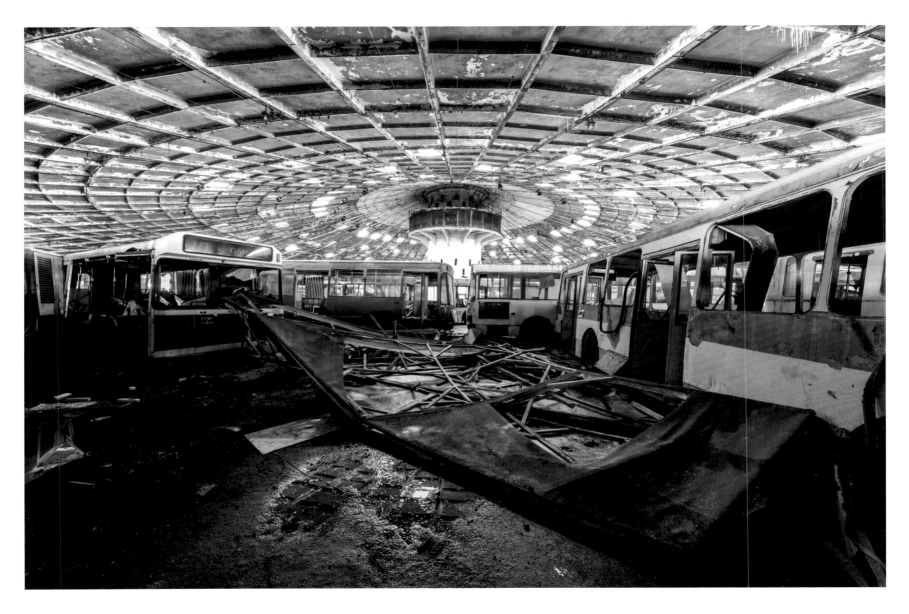

The former Bus Depot Number 7 in Kiev. Guards keep watch over its 20,000 square metres, assisted by their dogs. This Brutalist building was constructed in 1961 and remained in use until 2011, when the Metro expanded to become the preferred mode of public transport.

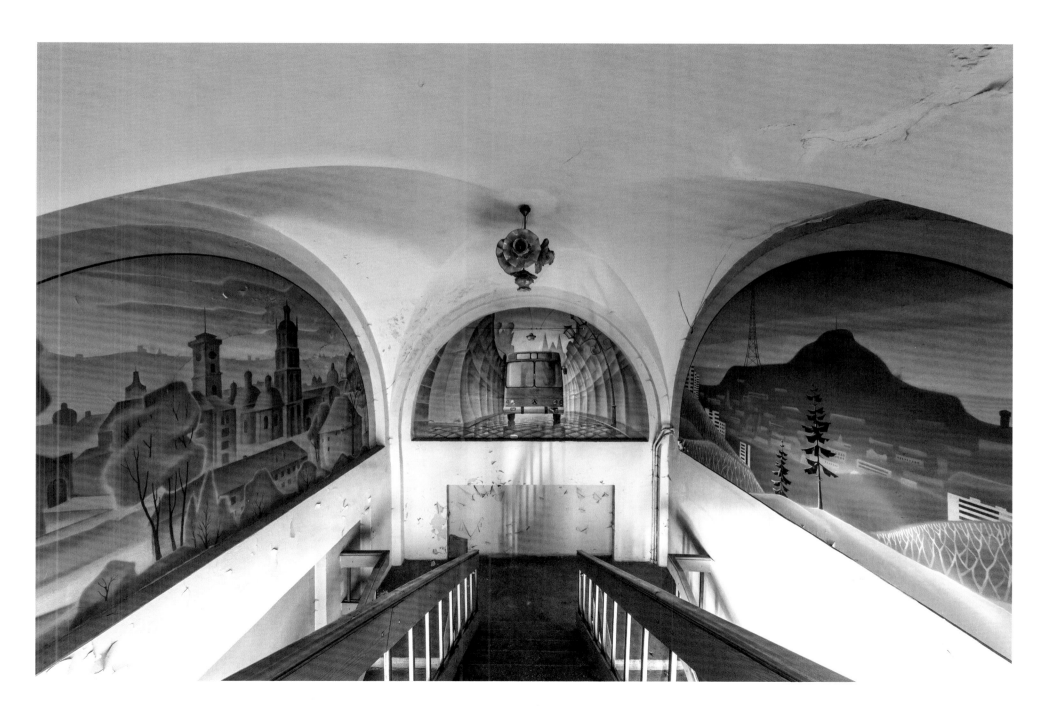

The entrance hall of a shoe factory.

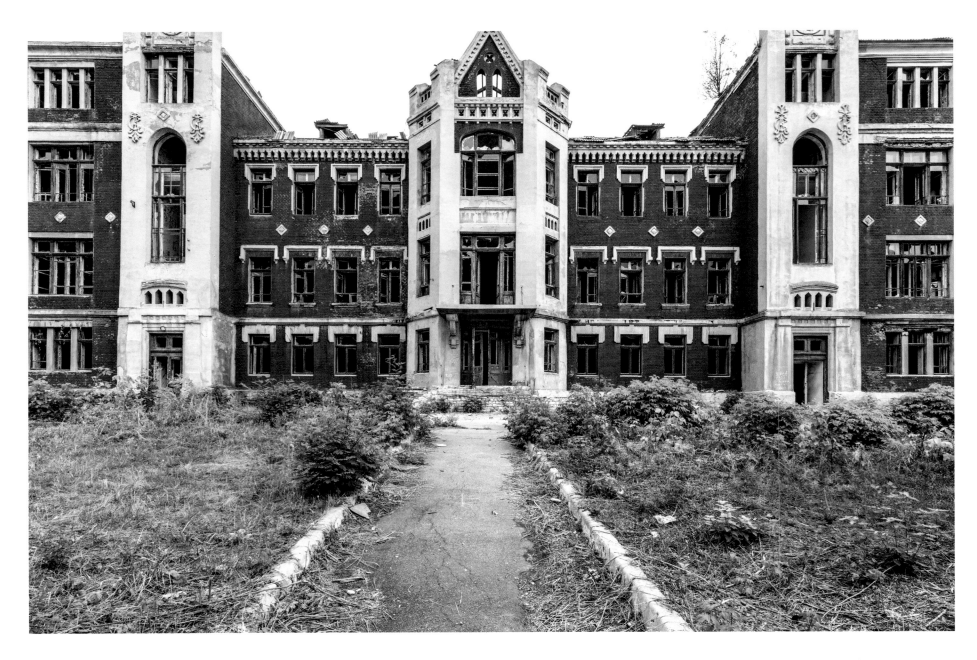

Hospital that was in use until 2014 when the Donbas war broke out between the Ukrainian army and pro-Russian separatist forces. The death toll was at least 13,000.

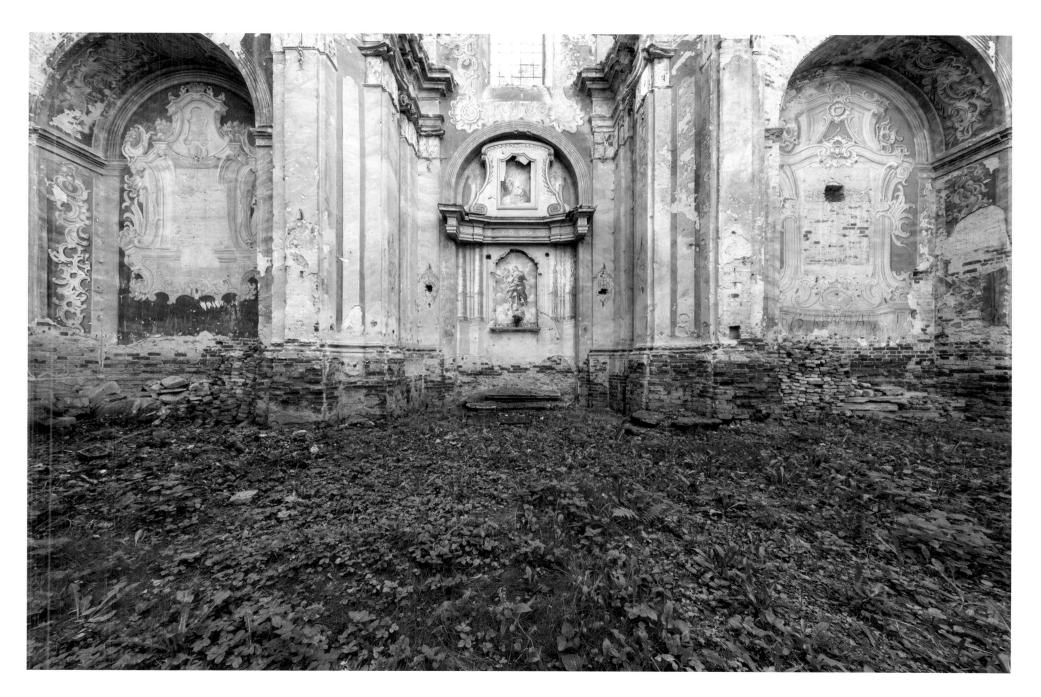

Ruined church on land taken from Poland in 1939 by Soviet occupying forces.

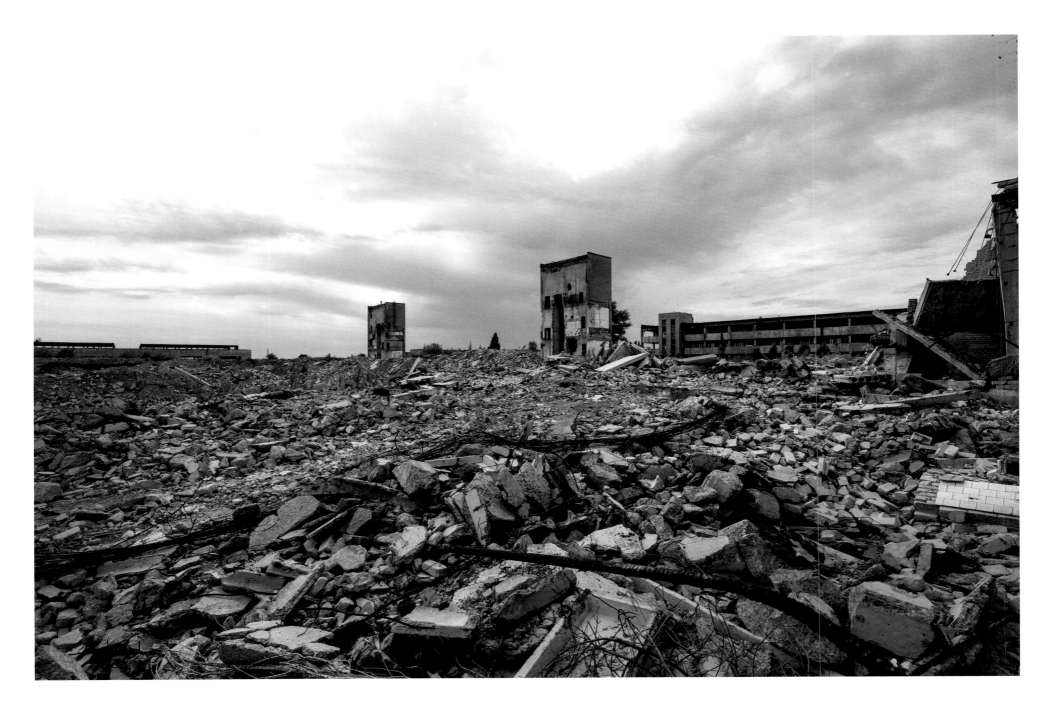

Ruins of a factory in the Donbas that was returned to the Ukrainian government in 2016.

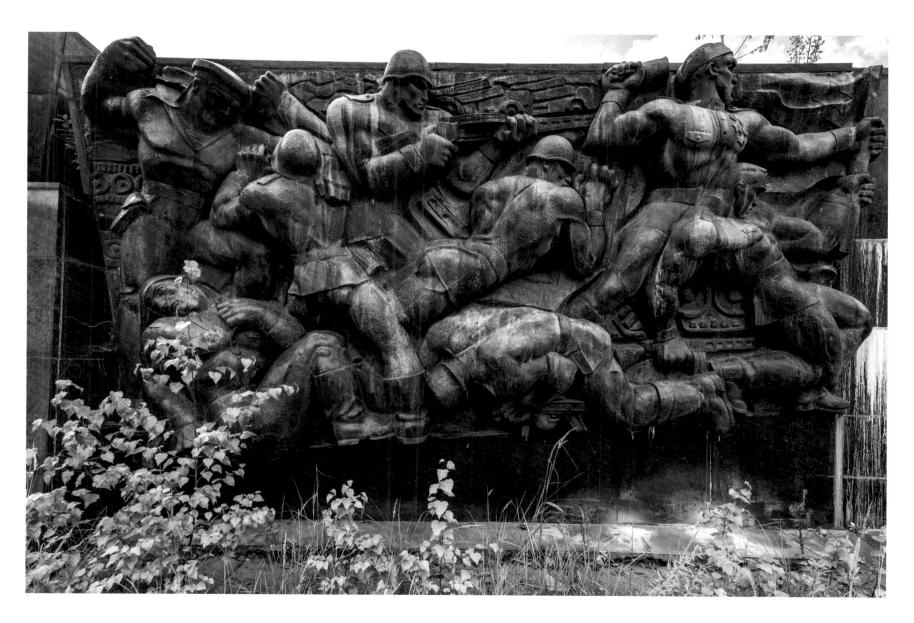

Monument depicting soldiers struggling against the German enemy in the Great Patriotic War of 1941-1945. Originally, the Germans were welcomed as liberators of Ukraine from Soviet domination, but their subsequent mistreatment of Ukrainians led to the population rising up against the new invader.

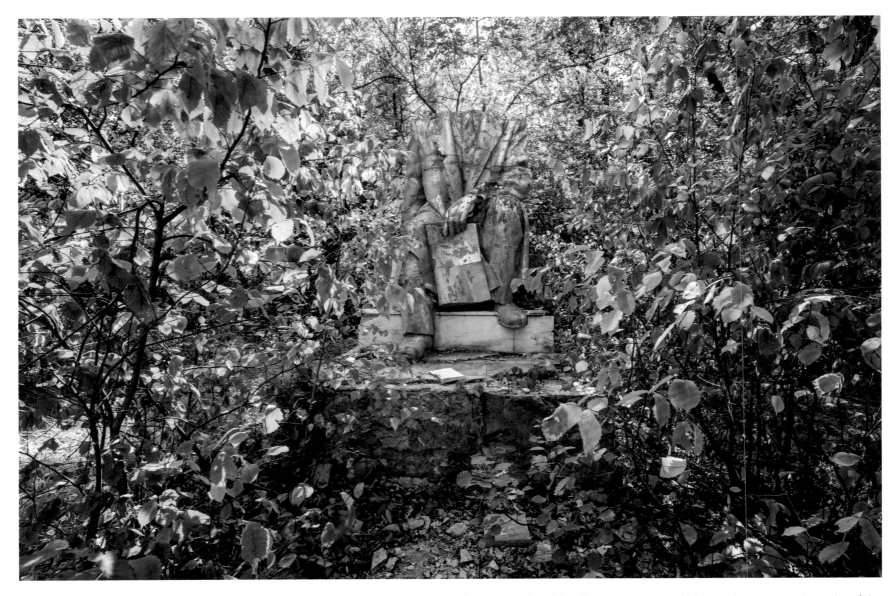

A decapitated statue of Lenin in an abandoned camp in the Luhansk region is a symbolic reminder of the decommunisation of Ukraine that grew in the wake of the war in the Donbas and the annexation of Crimea by Russia in 2014. Interestingly, a law came into force requiring the toppling of all statues portraying the father of the Russian revolution.

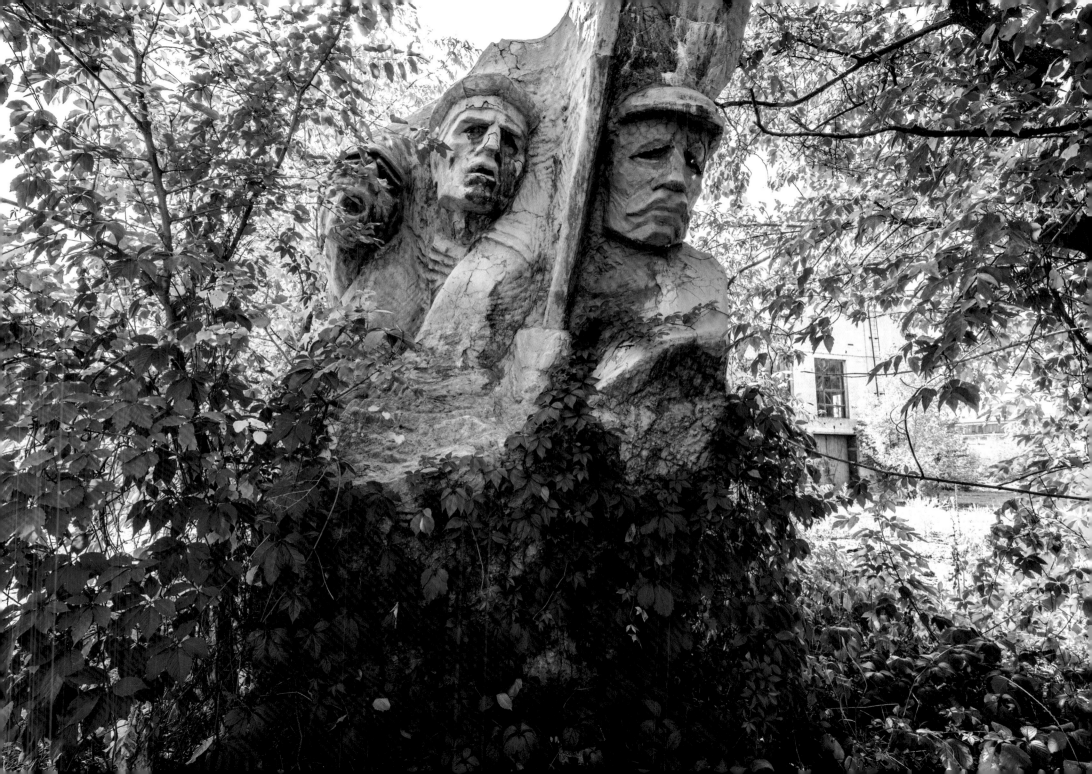

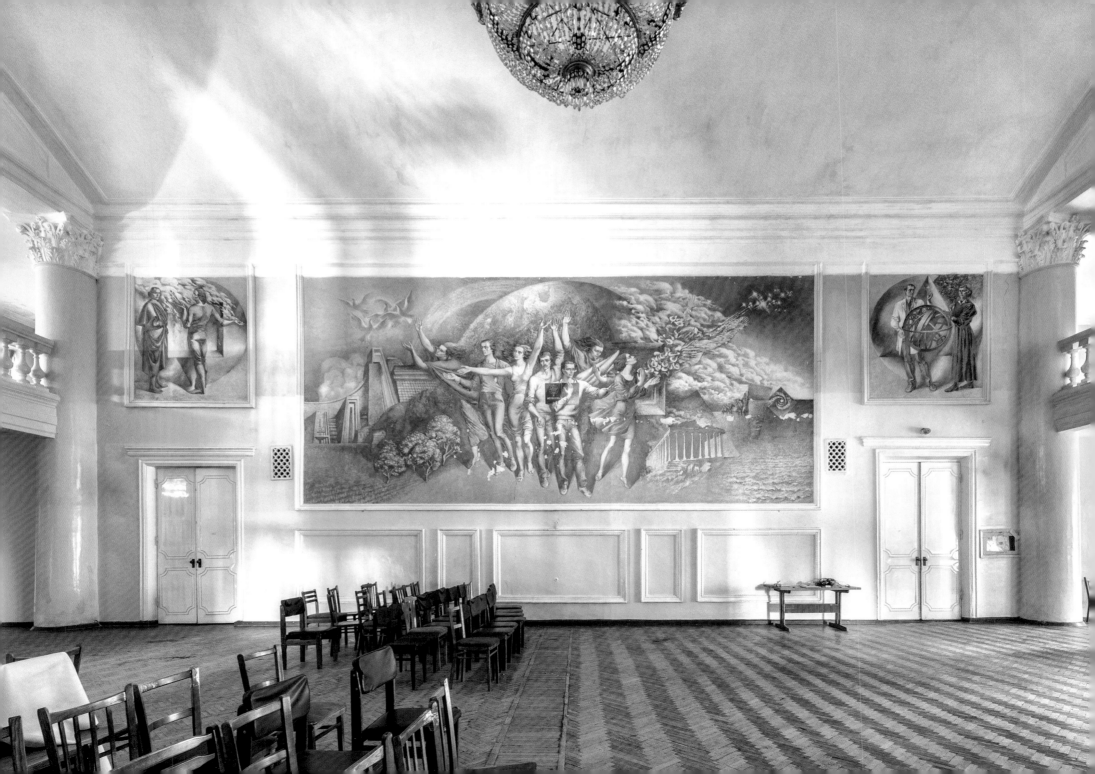

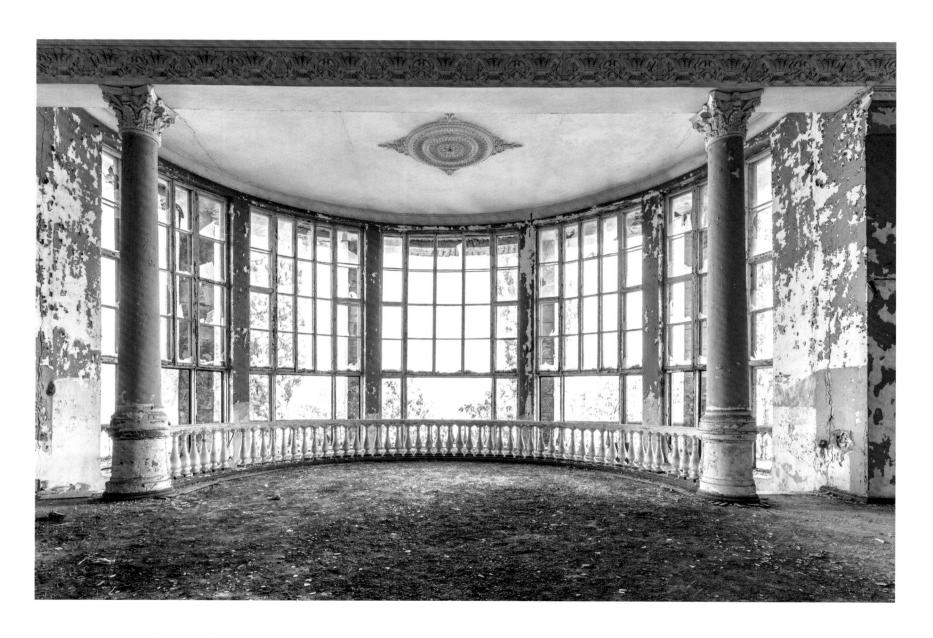

A Palace of Culture in a Donbas region town that was once thriving thanks to its mining activities. Most of the mines that had survived successive closures were finally destroyed by the war.

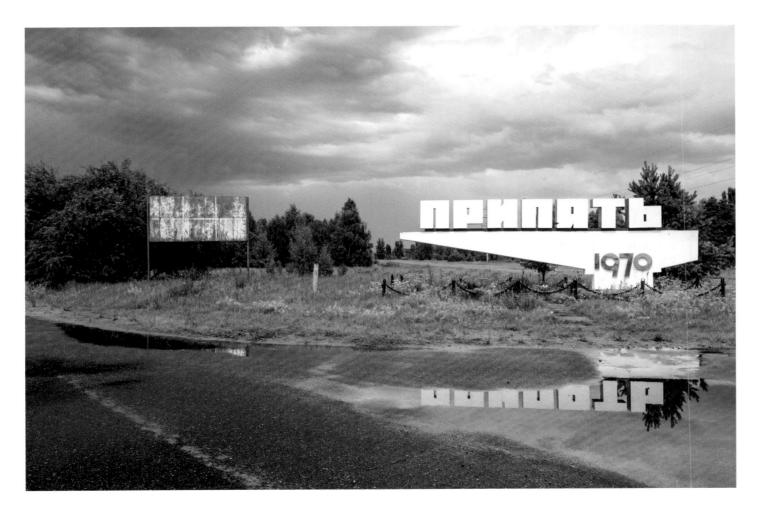

"Pripyat 1970" at the entry to this town that sadly gained fame at the time of the explosion in reactor number four of the Chernobyl nuclear power plant 3 km away on 26 April 1986. This catastrophe resulted in the deaths of several tens of thousands of people affected by radiation. The consequences for flora, fauna and people will continue to be felt for millennia. Today the area, which is still contaminated, can be visited with a guide.

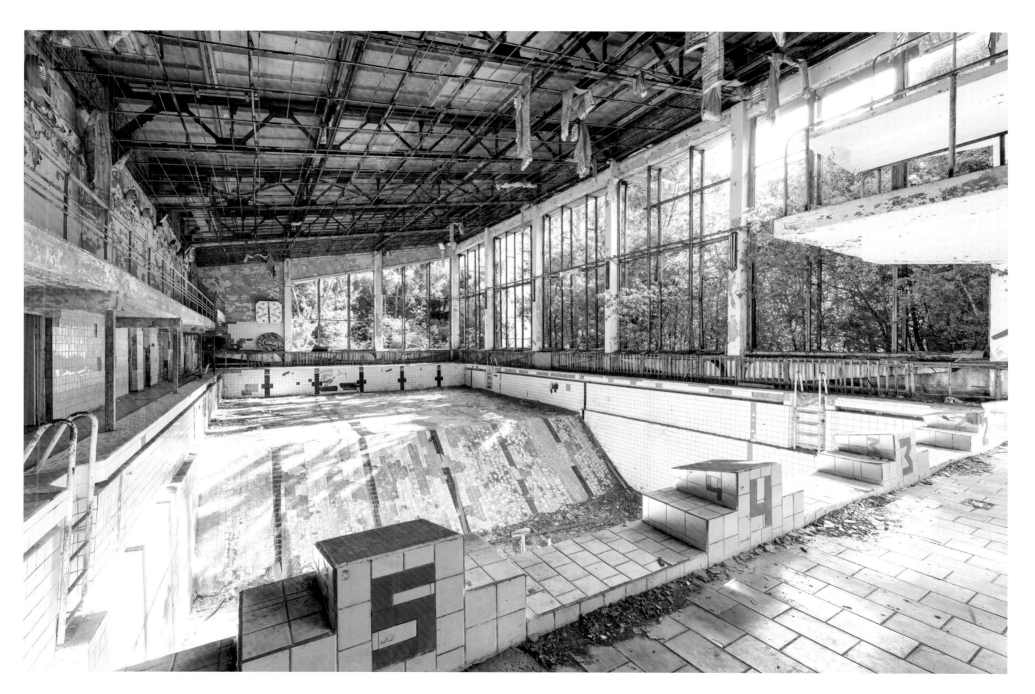

Pripyat swimming pool.

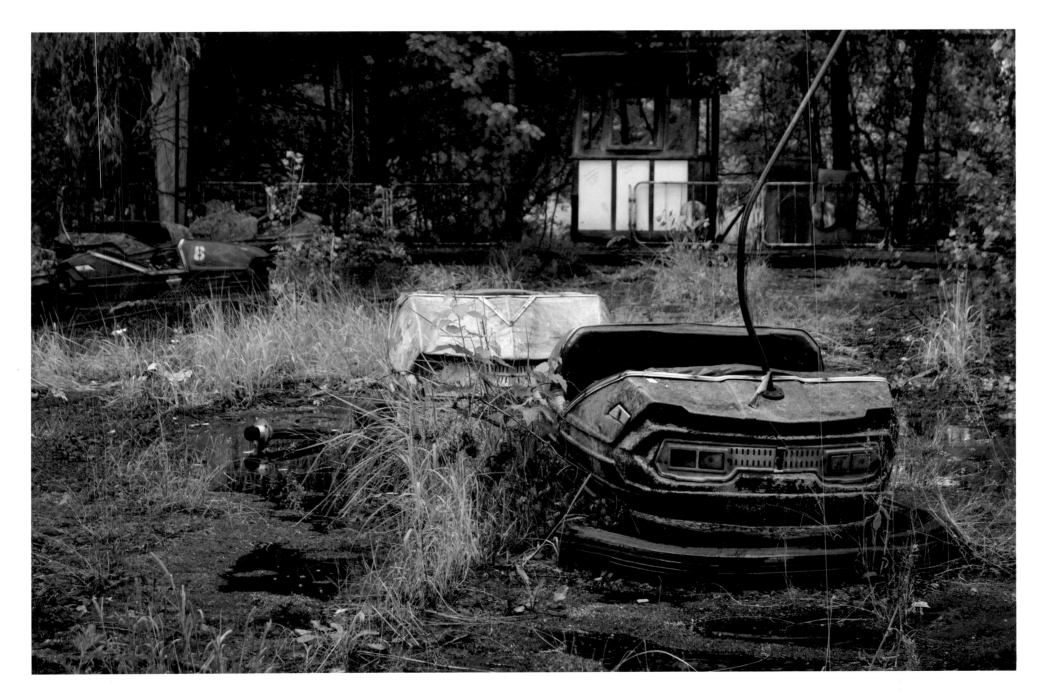

Dodgem cars in the recreation area in Pripyat town centre.

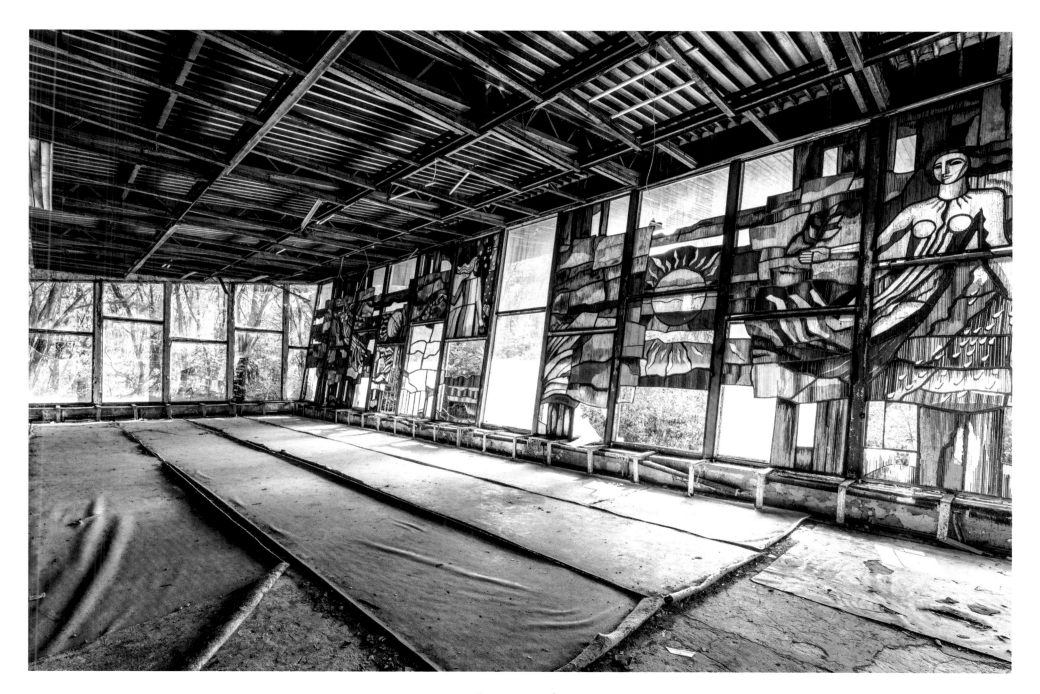

The Pripyat Café.

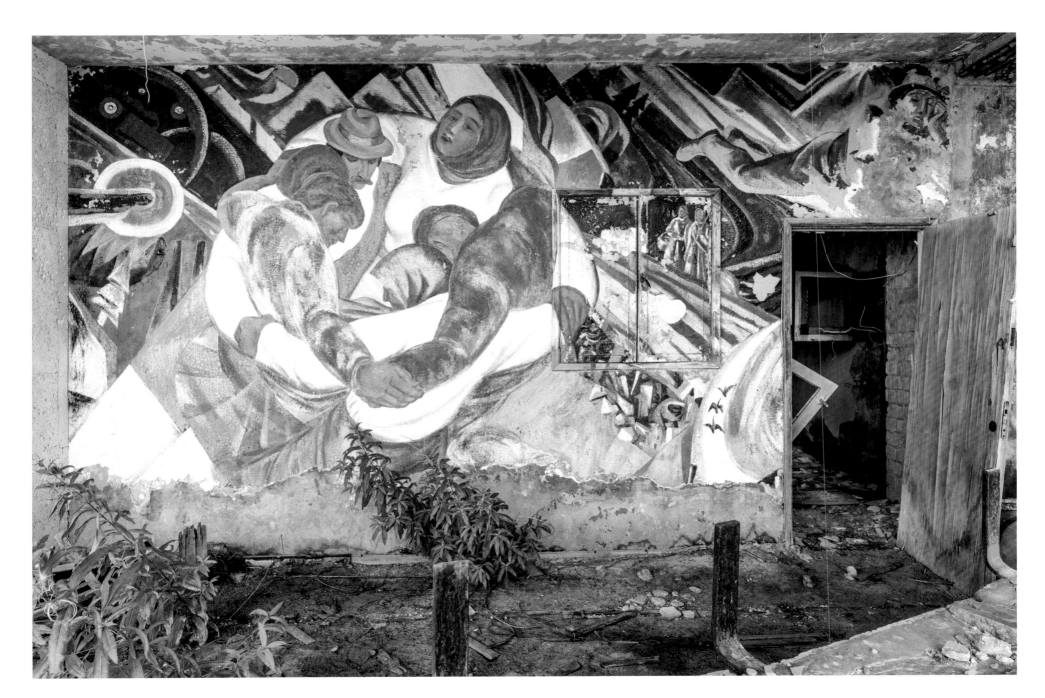

The Energetik Palace of Culture in Pripyat.

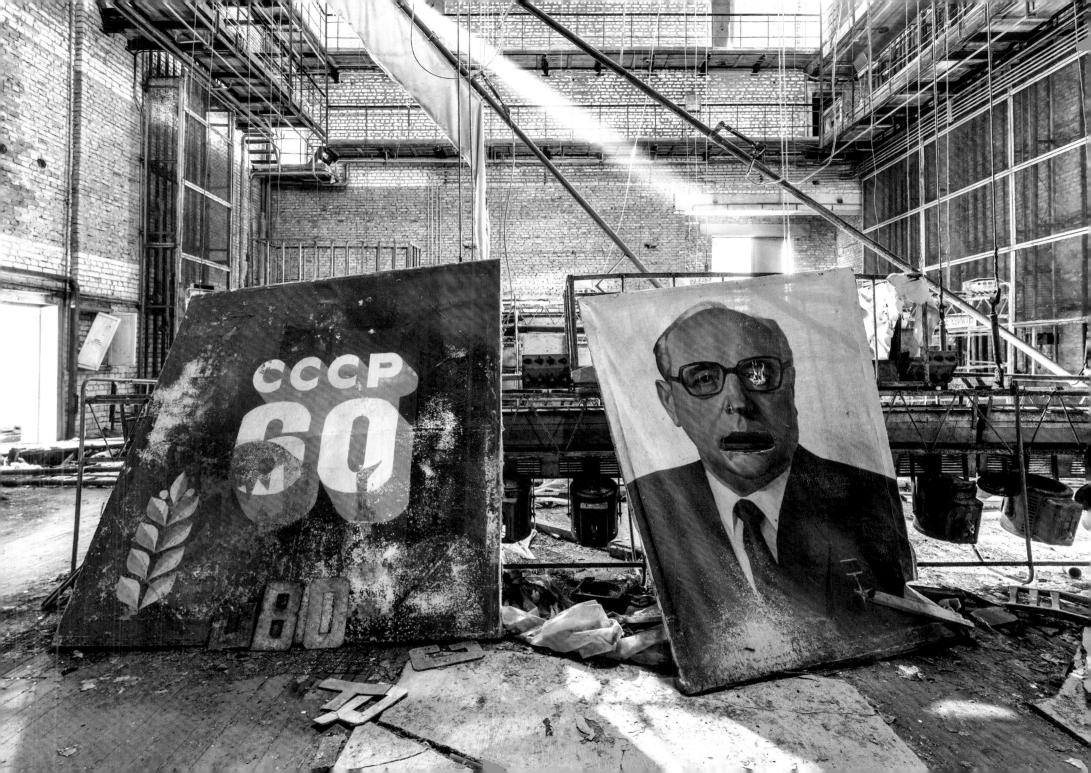

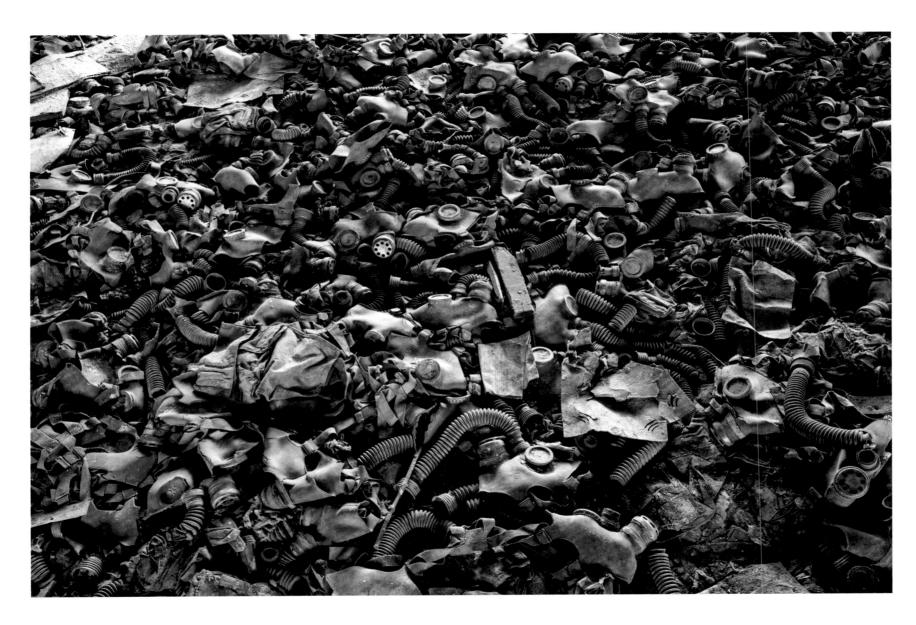

Gas masks carpet the floor in a school in Pripyat, no doubt left this way by visitors, despite them having been strongly advised not to touch anything because of the risk of radioactive contamination.

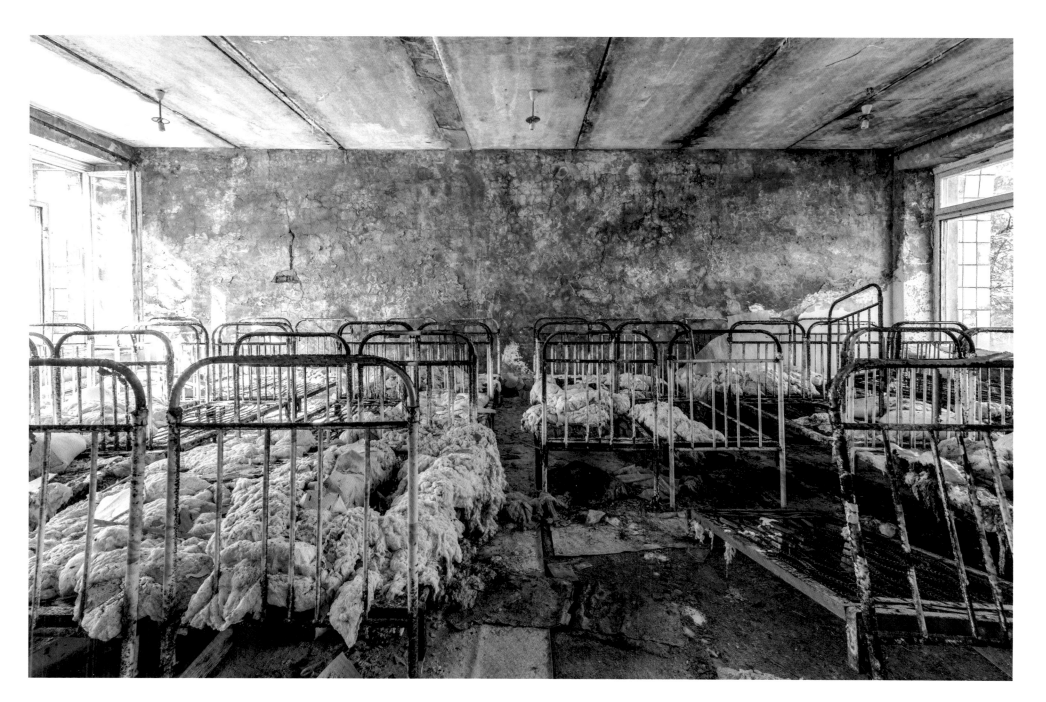

Maternity ward in Pripyat.

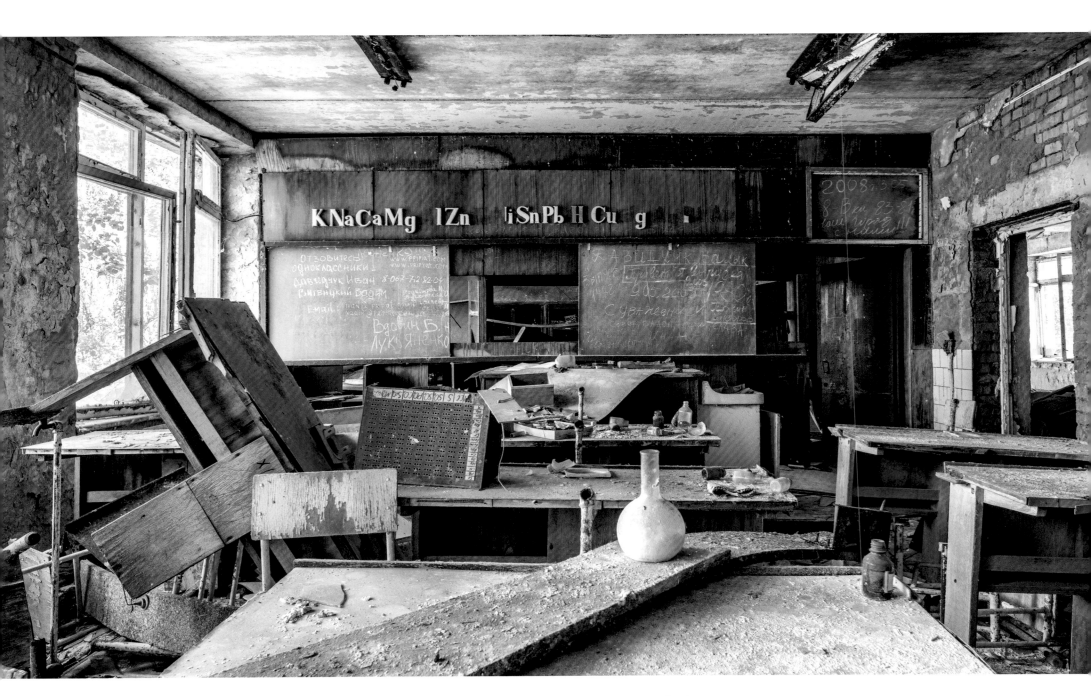

A chemistry classroom in one of Pripyat's many schools.

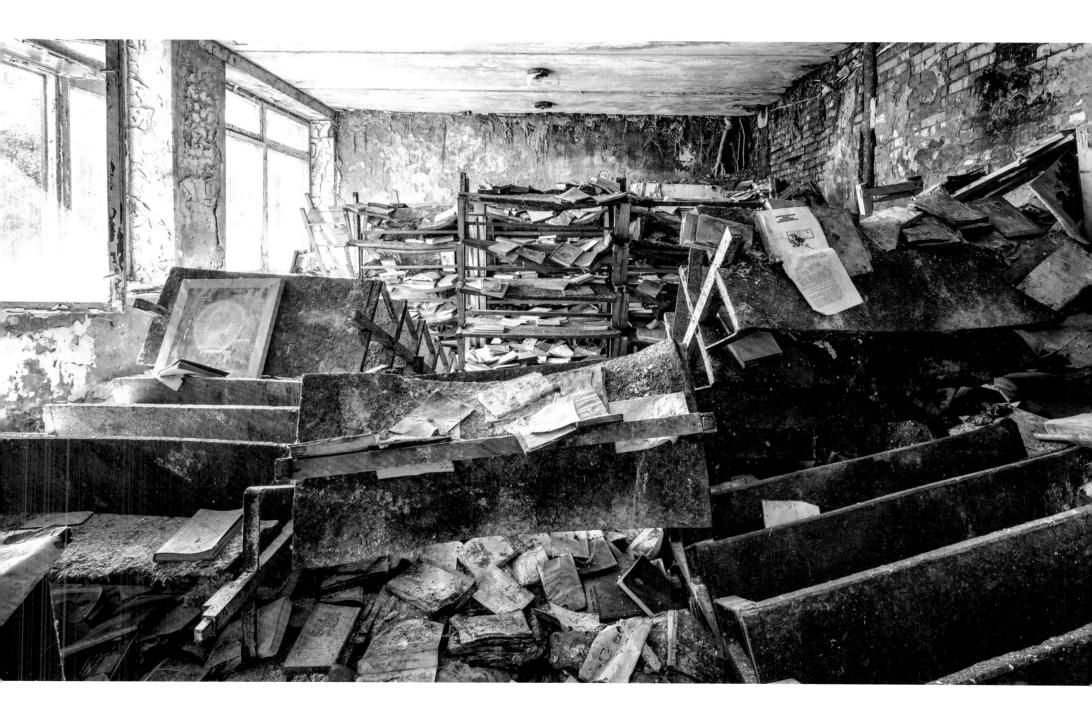

A school library in Pripyat.

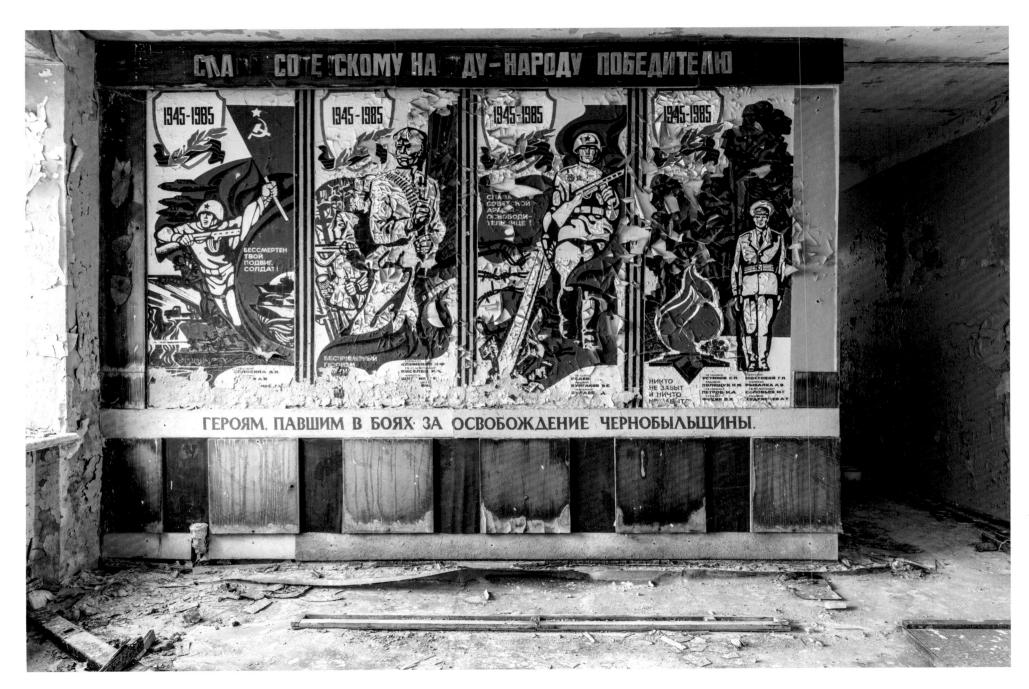

A wall panel in a Pripyat school depicting the various military bodies between 1945 and 1985.

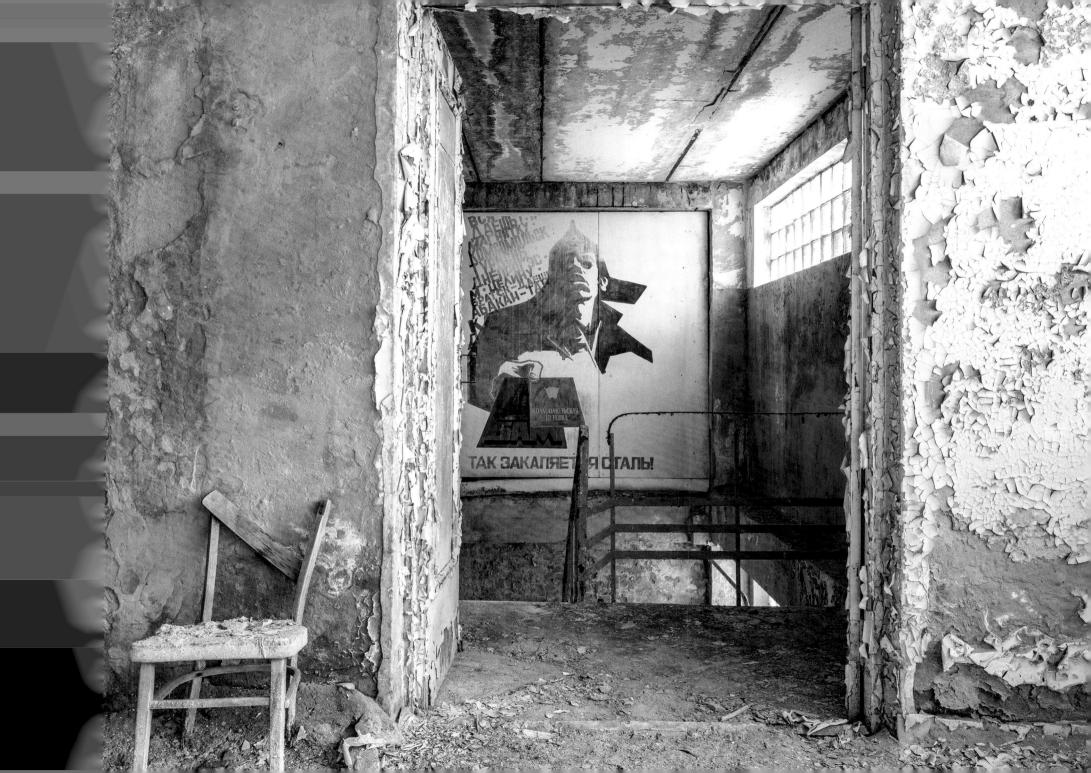

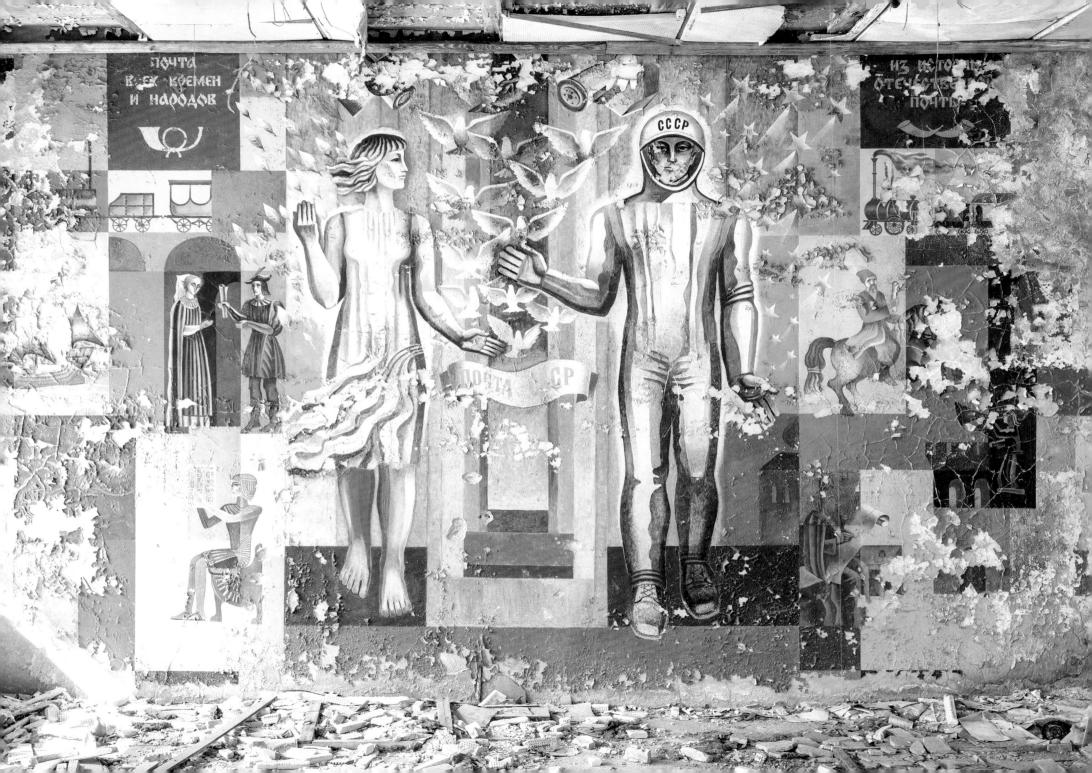

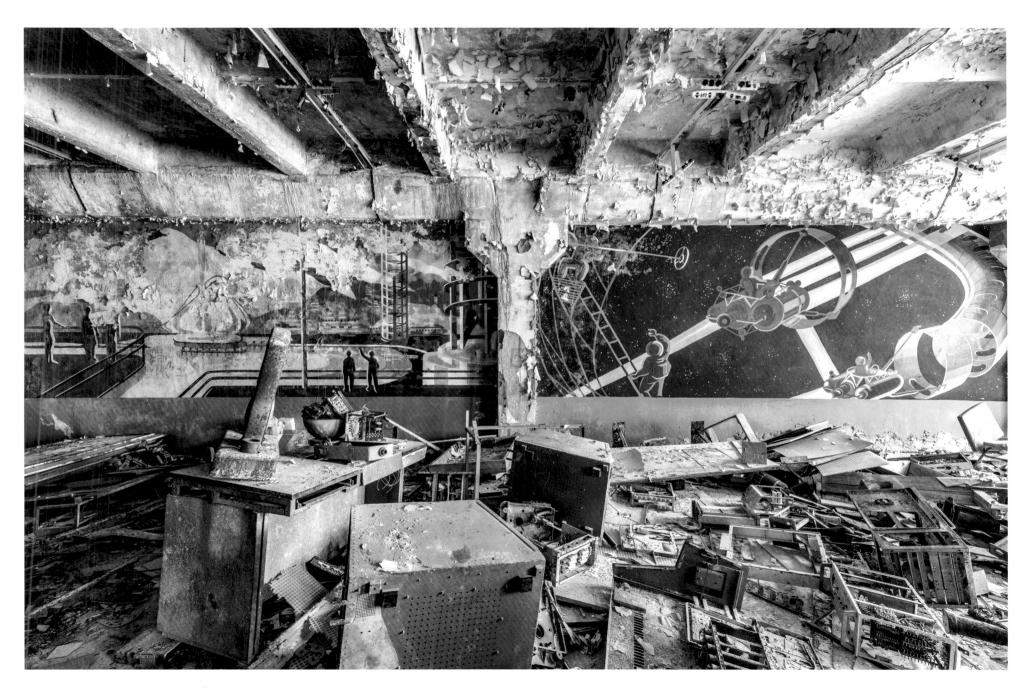

Wall paintings in the control centre of Duga-1, the early-warning radar nicknamed the Moscow Eye, located very close to Chernobyl.

# Moldova

In December 1917, Moldavians declared independence, but a few months later they united with Romania, with which they had very close cultural links. Their territory was greatly disputed during the Second World War and following the war, it was brought back into the Soviet sphere of influence. Large numbers of Romanian-speaking Moldavians, accused of fighting for Romania (which had aligned itself to the Axis powers during the Second World War) were deported. Although its population was greatly reduced by famine and unemployment, Moldova (as it has been called since 1991) managed to turn itself around and become an important wine-growing region. That is why today, in spite of having gained independence in 1991, it is still possible to find people with feelings of nostalgia for the Soviet era, such as the arts centre manager who raises a glass to a past long vanished at the end of a visit to his abandoned fiefdom.

Visits: 2013 – 2017 – 2018

Mosaic on the way into a village indicating that there were *kolkhozes* (collective farms) nearby. The farms were factories for agricultural production imposed by the Soviet government. During the Stalin years when the region was ravaged by famine, they had nightmarish consequences.

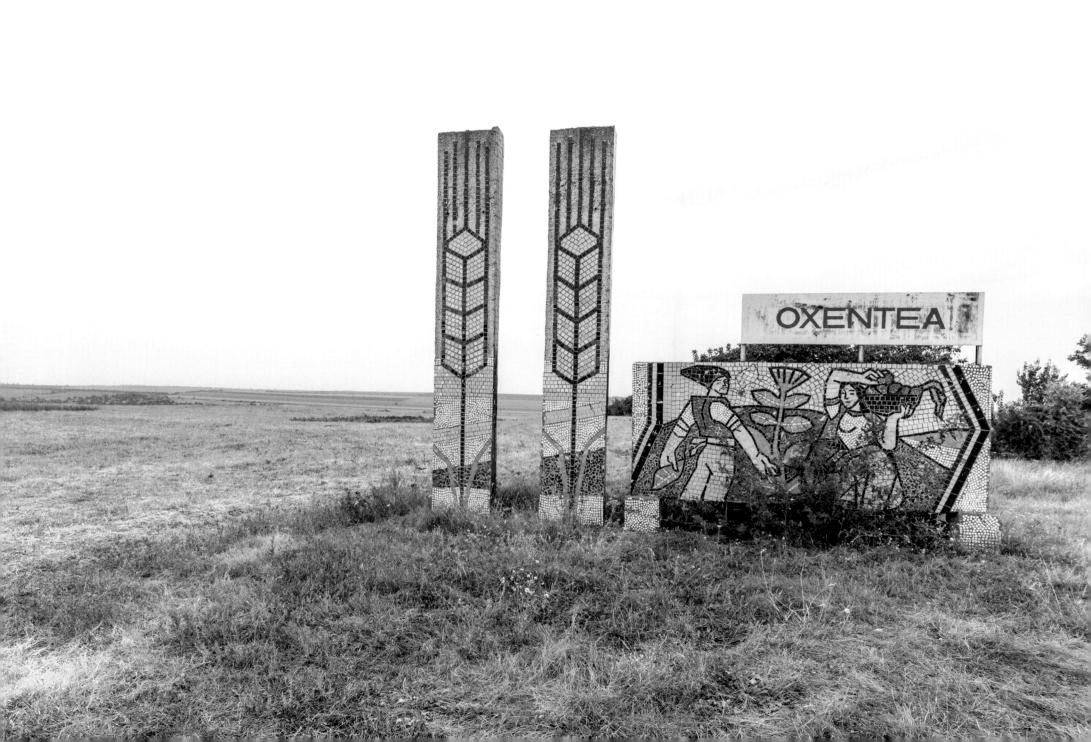

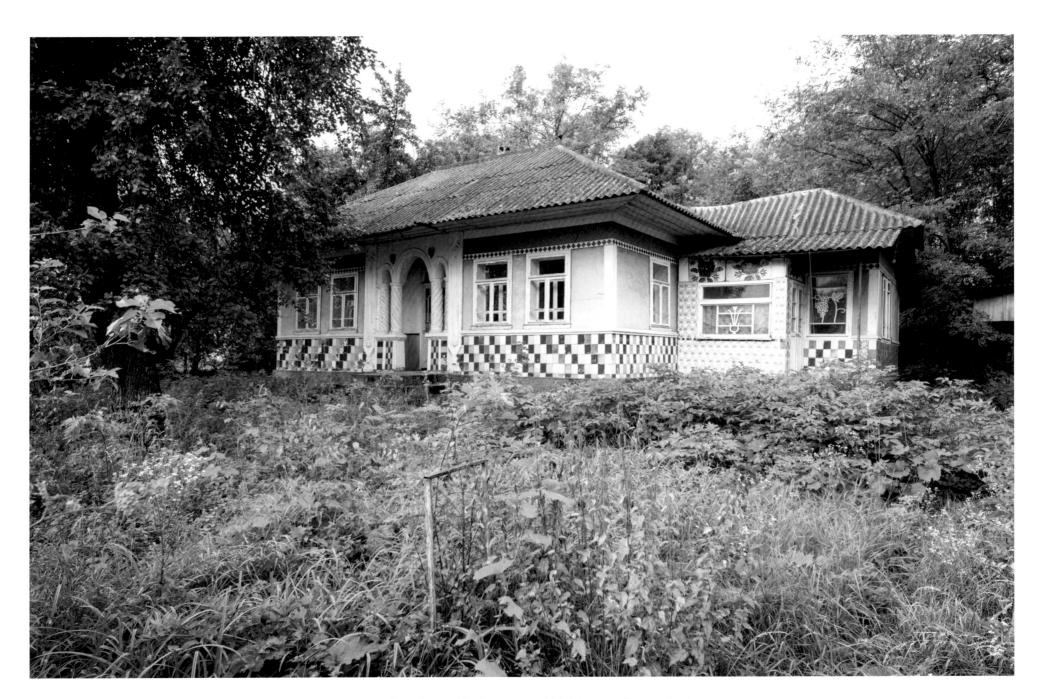

Former village hospital built in a typical Moldovan architectural style.

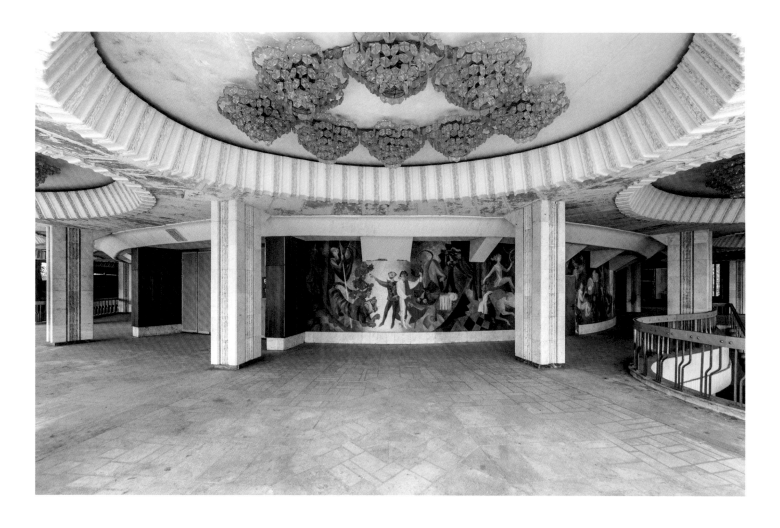

Chisinau's Circus was once considered the greatest and most impressive in the USSR. It could seat 2,000 people. Opened in 1982, it was built by architects S. Shoikhet and A. Kirichenko in the Brutalist style. It closed its doors, however, in 2004. A single adjacent room, preserved and updated for hosting performances, awaits a buyer.

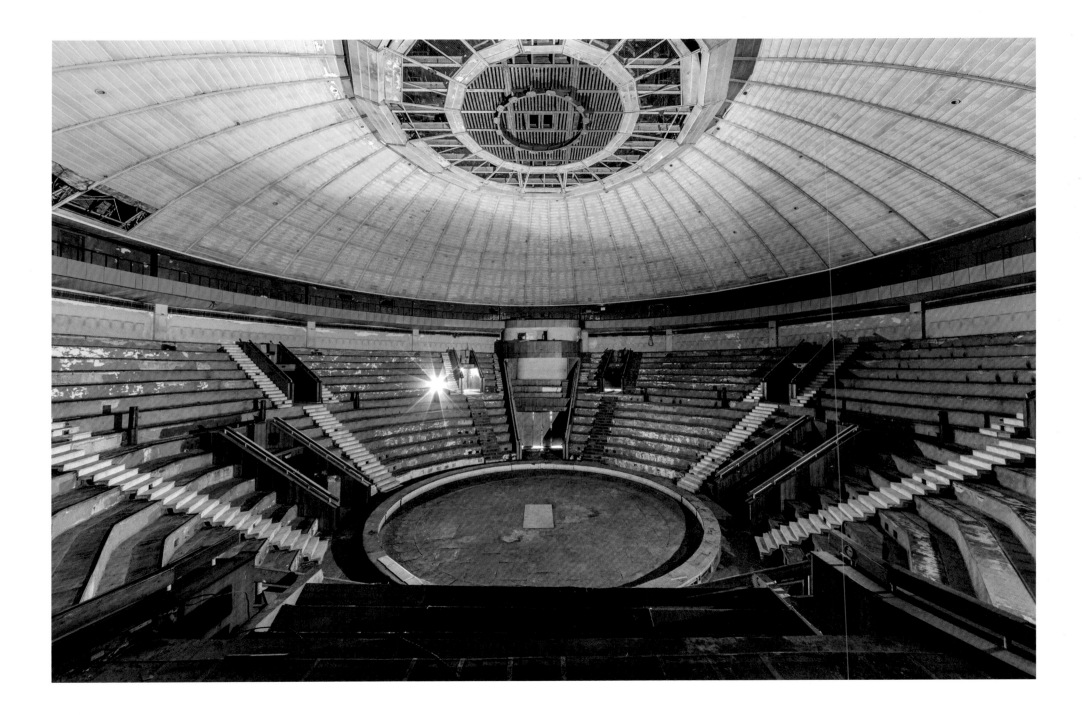

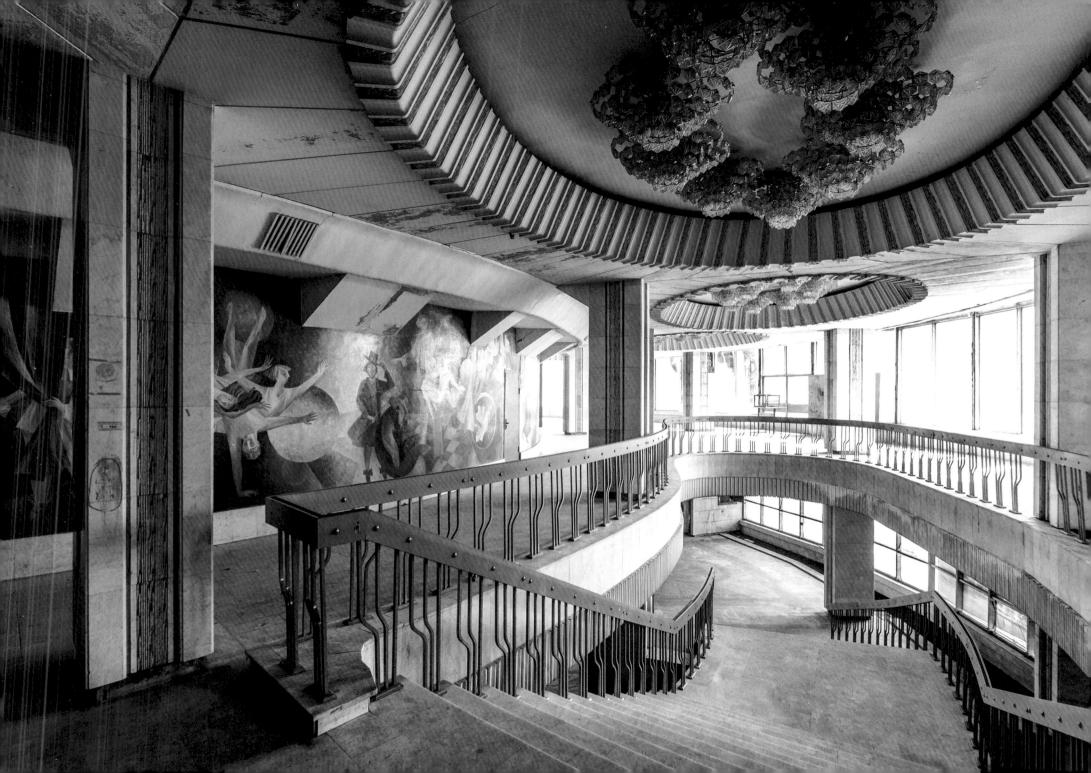

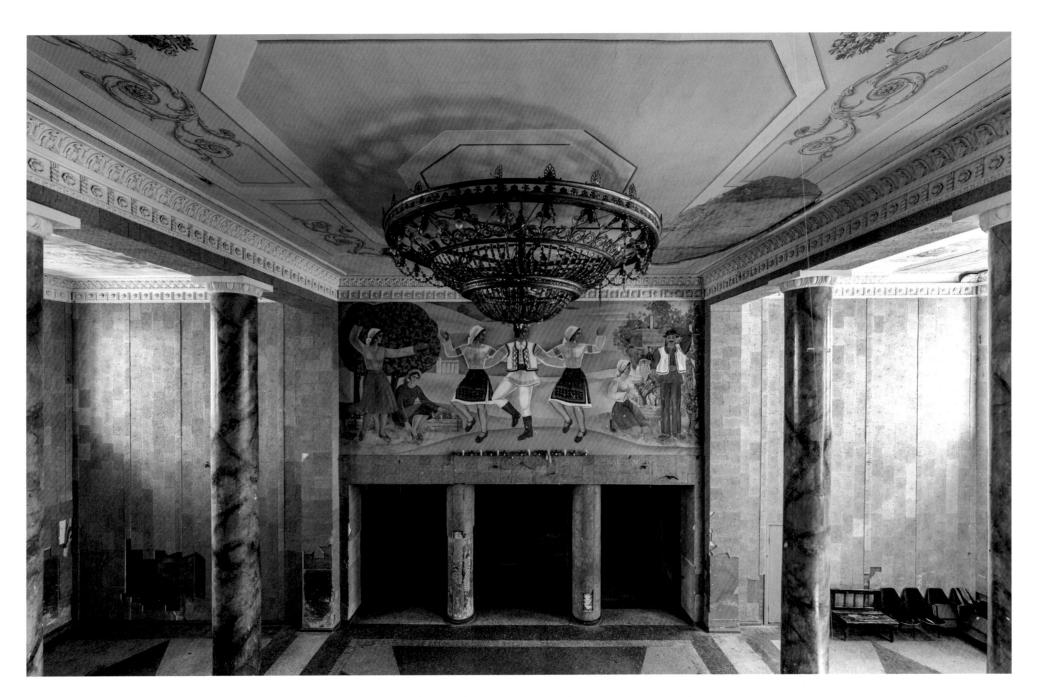

Richly decorated Palace of Culture apparently founded by a citizen originally from Odessa, one of Ukraine's most prosperous cities.

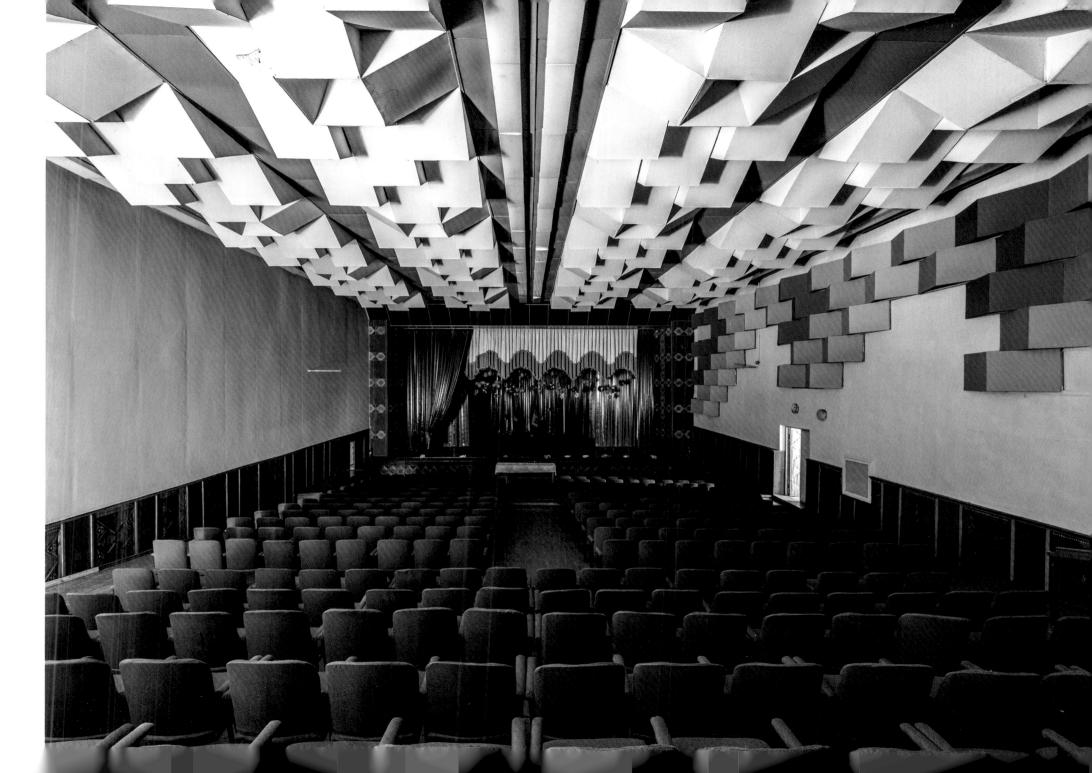

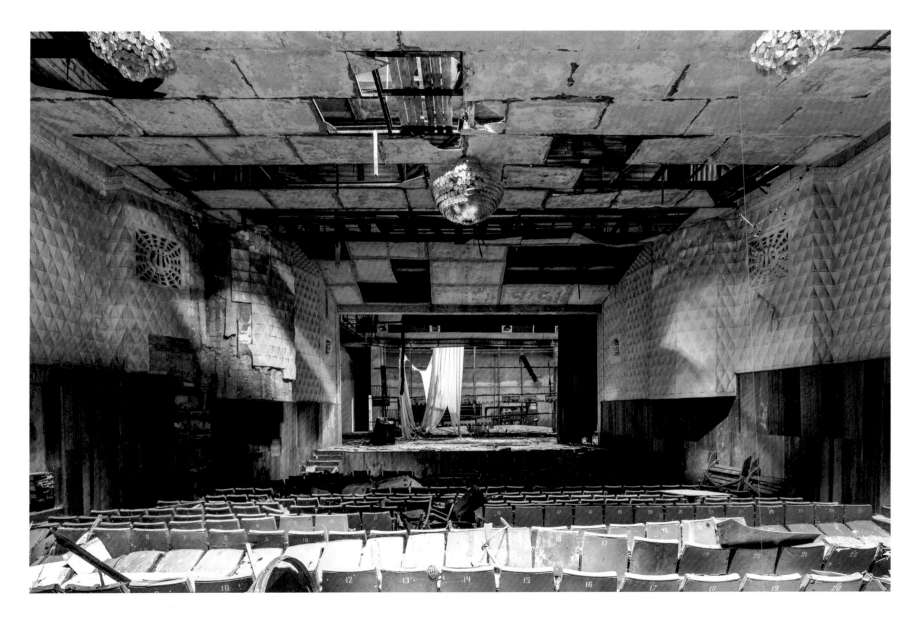

The extremely dilapidated state of this Palace of Culture strongly suggests that it was abandoned well before the era of decommunisation when many of its kind became derelict.

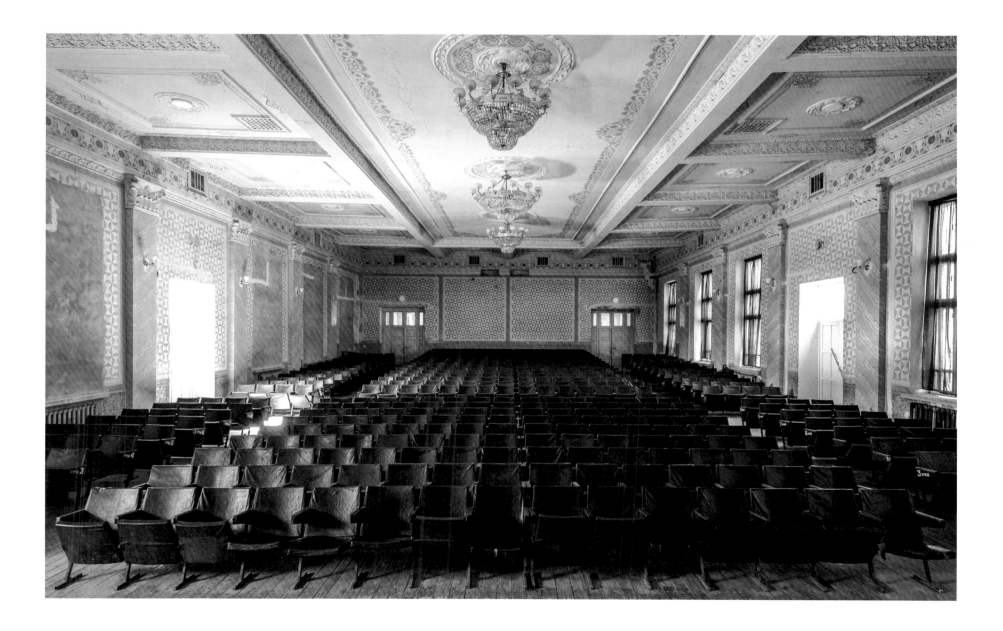

Palace of Culture dating back to the Stalin era, as suggested by period chandeliers and paintings.

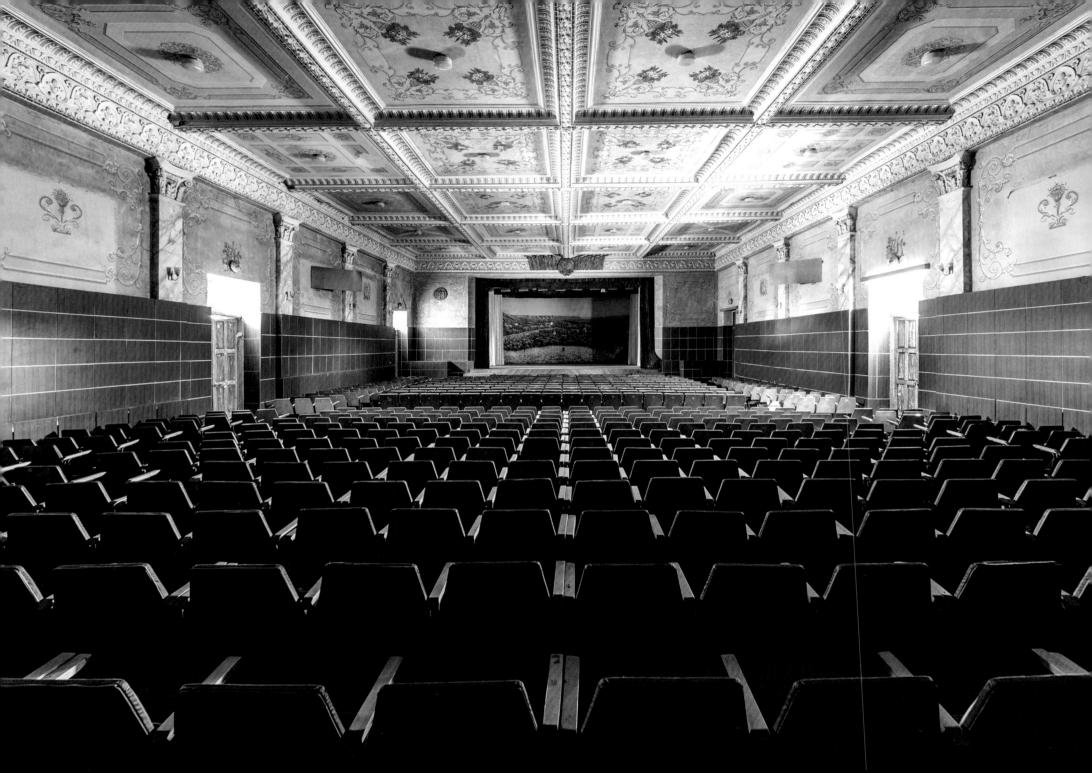

This Palace of Culture built in the 1940s is a perfect manifestation of the Stalinist style. Under Brezhnev, attempts were made to modernise buildings like this with an emphasis on minimalism and economy. As a result, many paintings were covered over with embossing which improved the insulation of the buildings. In the picture, the coat of arms of the Moldavian Soviet Socialist Republic can be seen above the stage.

Disused factory.

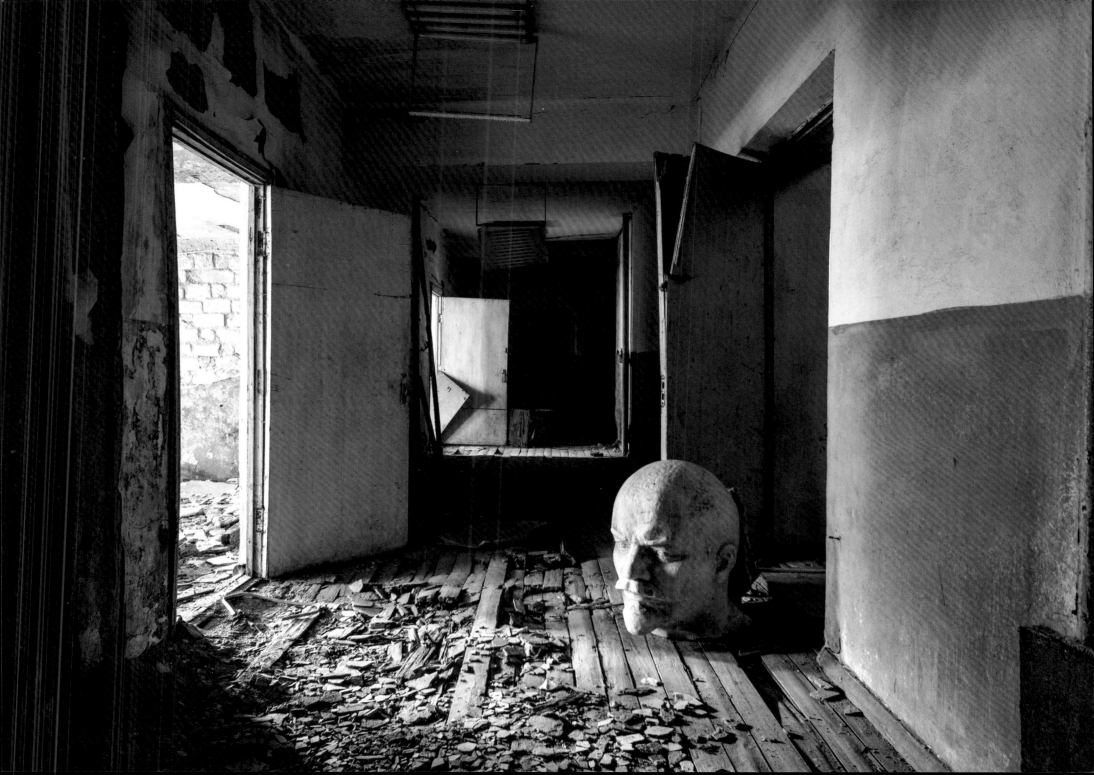

# Kazakhstan

The Kazakh Soviet Socialist Republic became a republic of the USSR in 1936, and quickly became very useful to the central government. Its population had been decimated by a third as a result of the great famines of the 1920s, and it was therefore a highly suitable destination for deportees during and just after the Second World War. These included Volga Germans, Koryo-saram, Crimean Tatars and Chechens. It also served as a theatre for Soviet military experiments, and it was here that a centre for nuclear launch tests was set up, which remains almost completely inaccessible even today. The only people who are granted the prized authorisations needed to visit the site are nuclear engineers. It would take a journey of 200 kilometres plus four hours' driving to bring this ploy to fruition and find a way through … The same goes for the *sanctum sanctorum*, the Baikonur Cosmodrome which hosted the Soviet space programme. It was from here that Yuri Gagarin was launched, making him the first man to go into space. The abandoned shuttles remain under close surveillance, so to have any hope of seeing what remains of the space adventure, it is essential to resort to devious means to avoid the watchfulness of the guards. Kazakhstan was the last country to gain its independence in 1991. It seems to keep a close watch over the relics of Soviet times, like this statue of Lenin which still stands in a half-abandoned village.

Visits: 2017 – 2019

Hammer and sickle lying at the entrance to a small enterprise in a place that now stands empty, a ghost village.

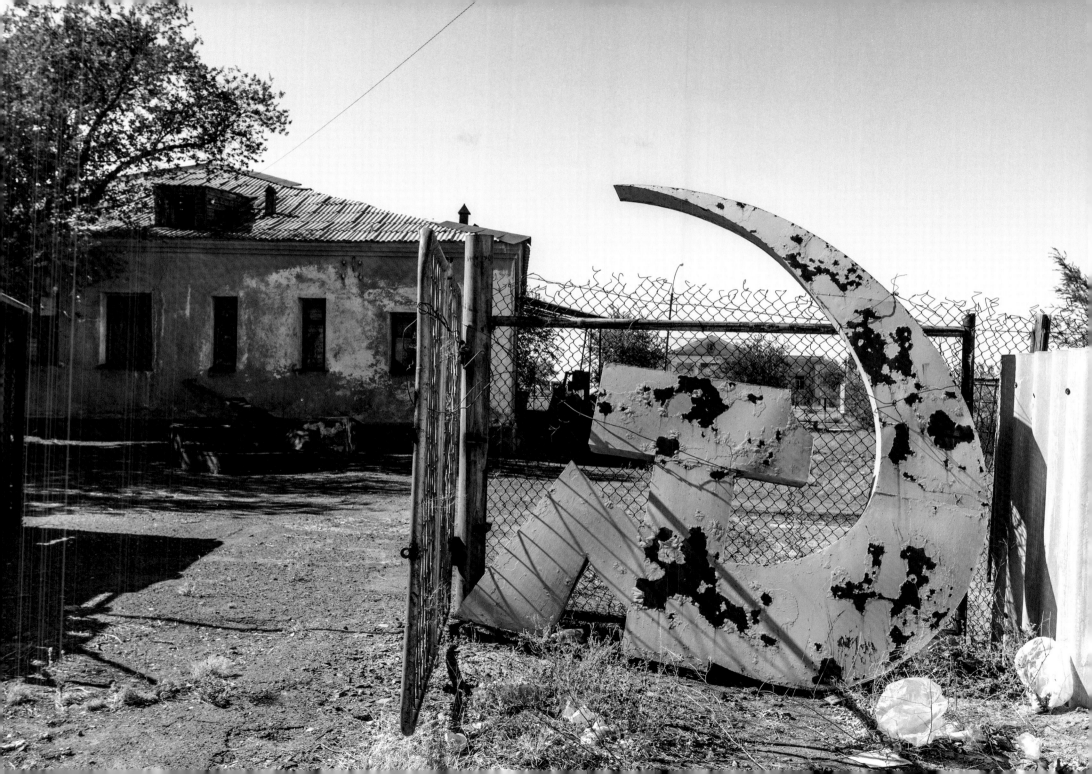

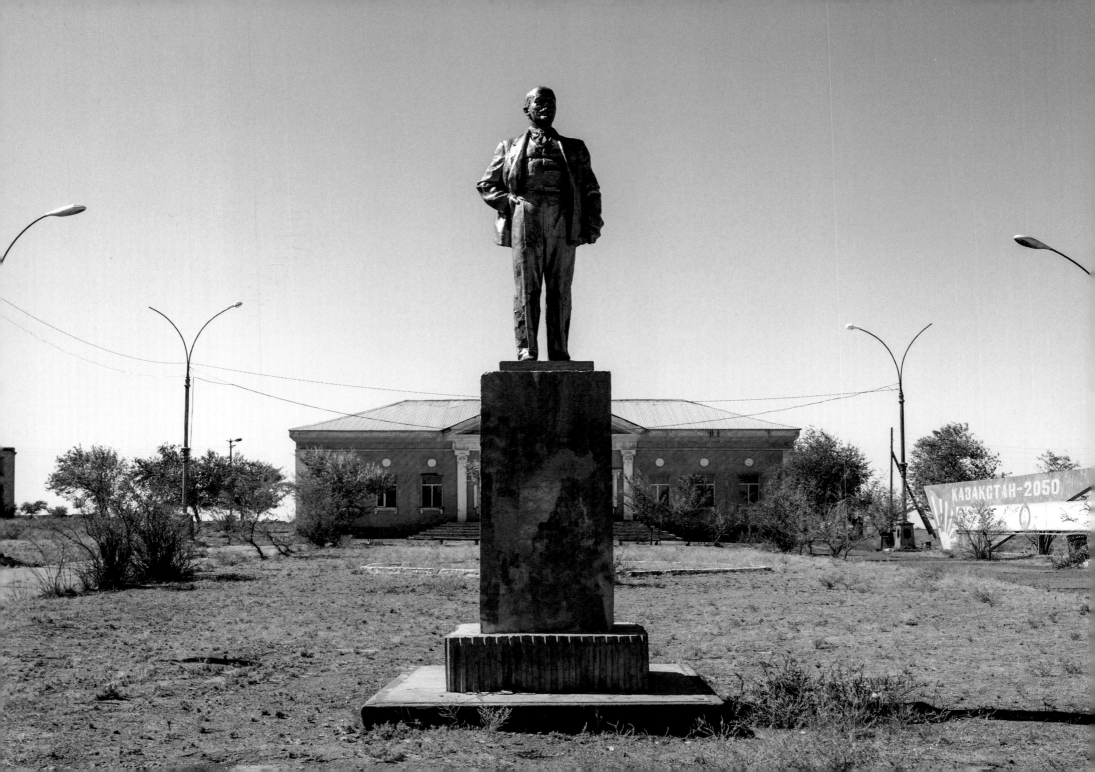

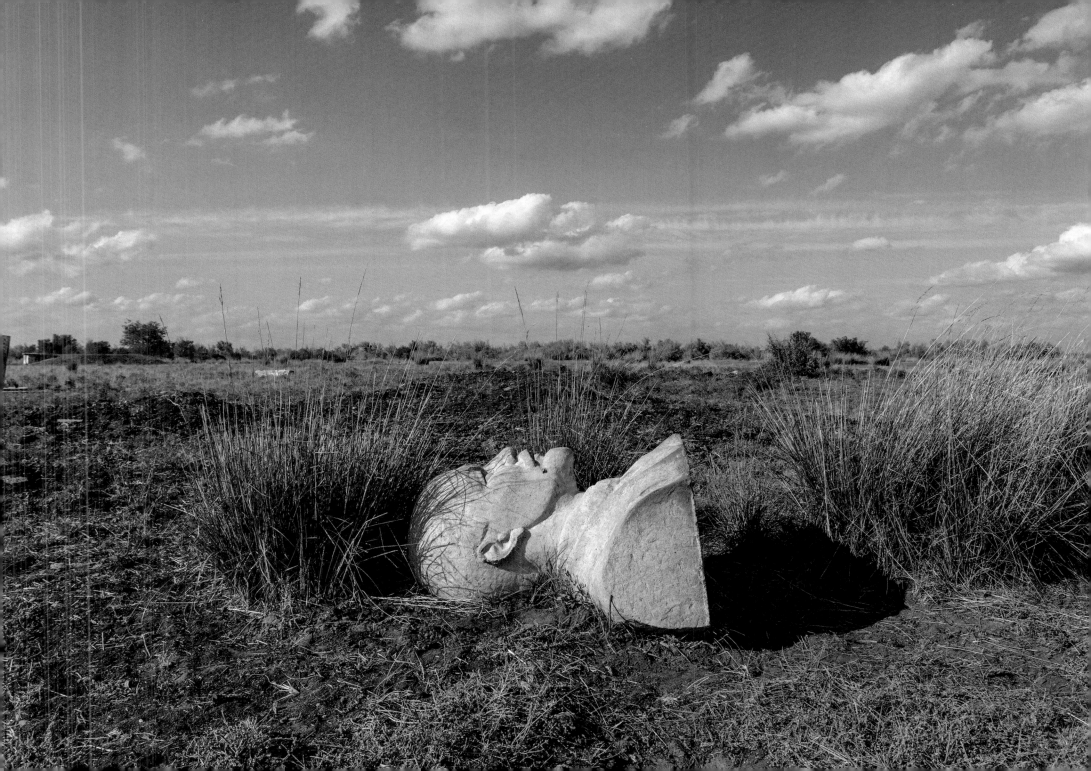

Commemorative creation that resembles a signpost in the middle of the Kazakh Steppe. It depicts a cosmonaut – Yuri Gagarin, perhaps?
A lot of debris is known to have fallen onto this area from space when component parts of rockets were jettisoned.

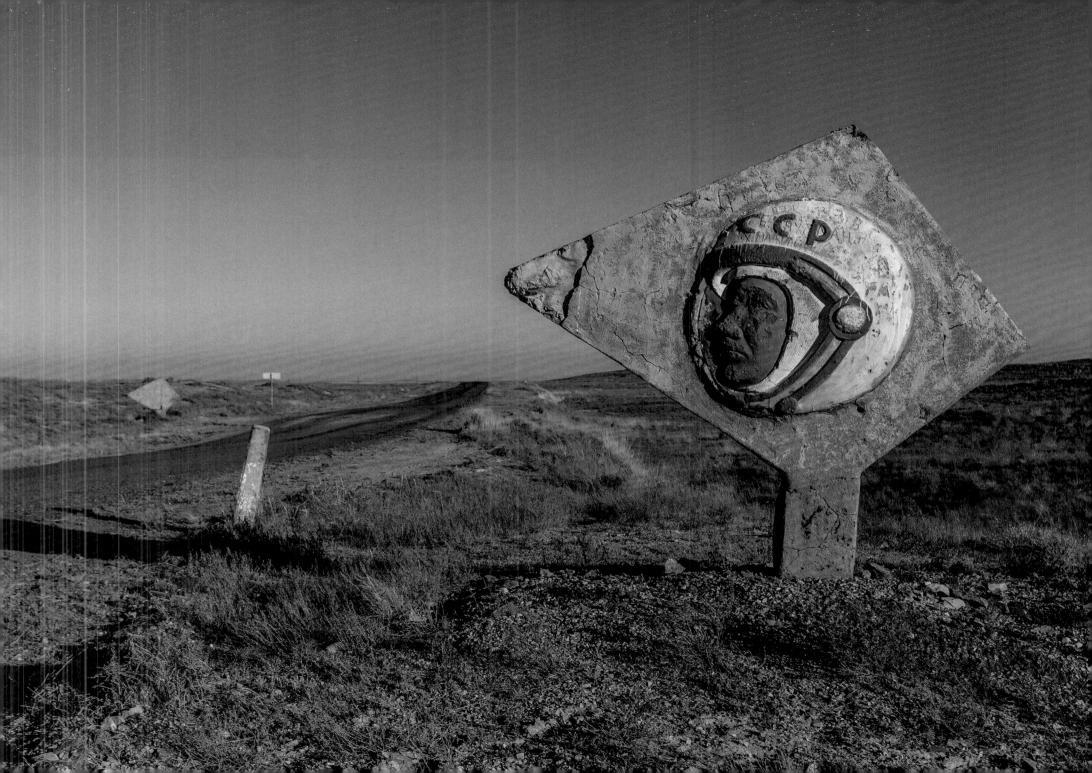

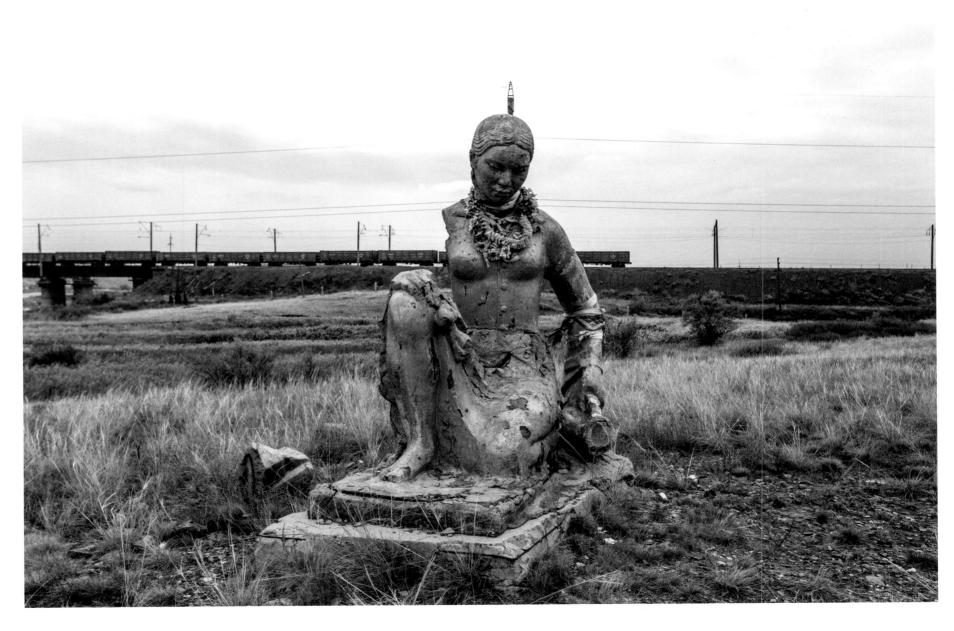

Statue of a woman found at the side of a road – her Eurasian eyes confirm she is a Kazakh. Her right arm is missing, but the garlands of flowers round her neck are still intact: tradition has it that when one of her garlands comes undone, the wish of the person who hung it round her neck will come true.

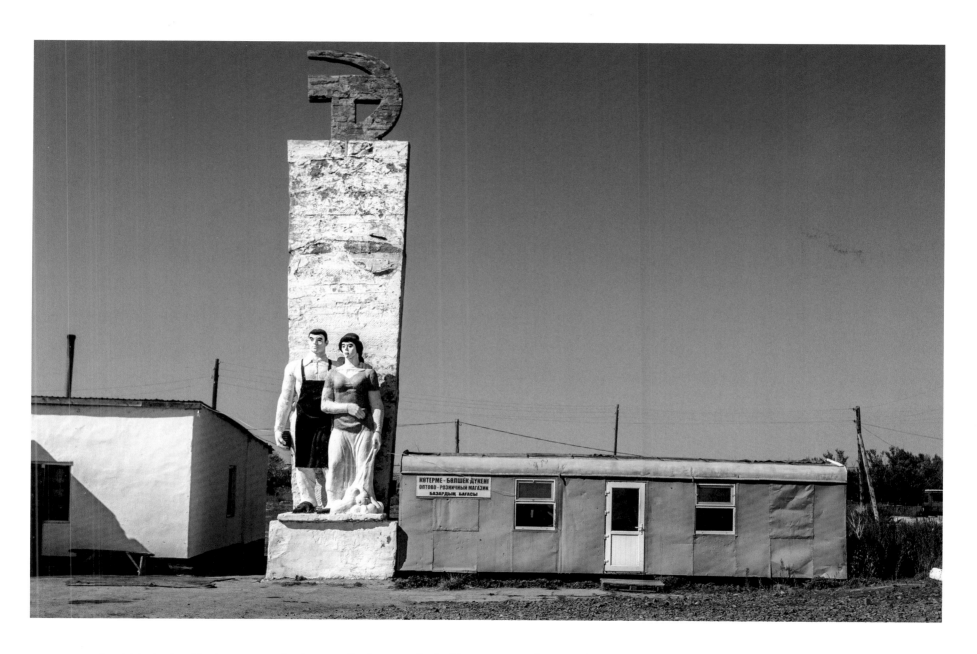

Roadside displays like this are typical in the area. The low wooden building is a general store and the monument next to it stands in honour of shopkeepers. The hammer and sickle above it link labour and the distribution of foodstuffs to the values of communism.

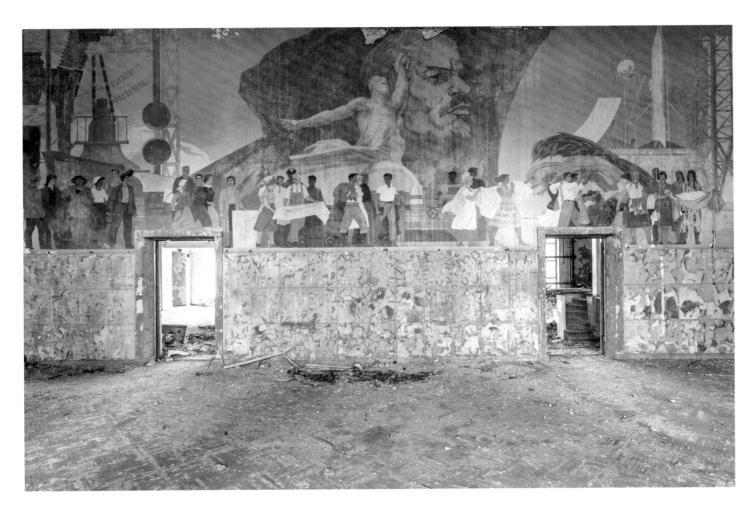

A propaganda painting covers a wall in the Palace of Culture's entrance foyer. It features a factory and workers and, set in front of a profile of Lenin, a famous communist monument (*The Worker and Kolkhoz Woman*, sculpted in 1937, standing 24.5 metres high, on display at the VDNKh, the Exhibition of Achievements of the National Economy of the USSR). It includes a rocket and other technology used in the conquest of space, as well as agricultural workers. All the peoples of the world, from Africa to Central Europe via Asia, are represented.

Film set used in the shooting of *Nomad* in 2005 with a budget of 40 million dollars. It tells the story of Abylai Khan (a khan of Kazakhstan in the 18th century).

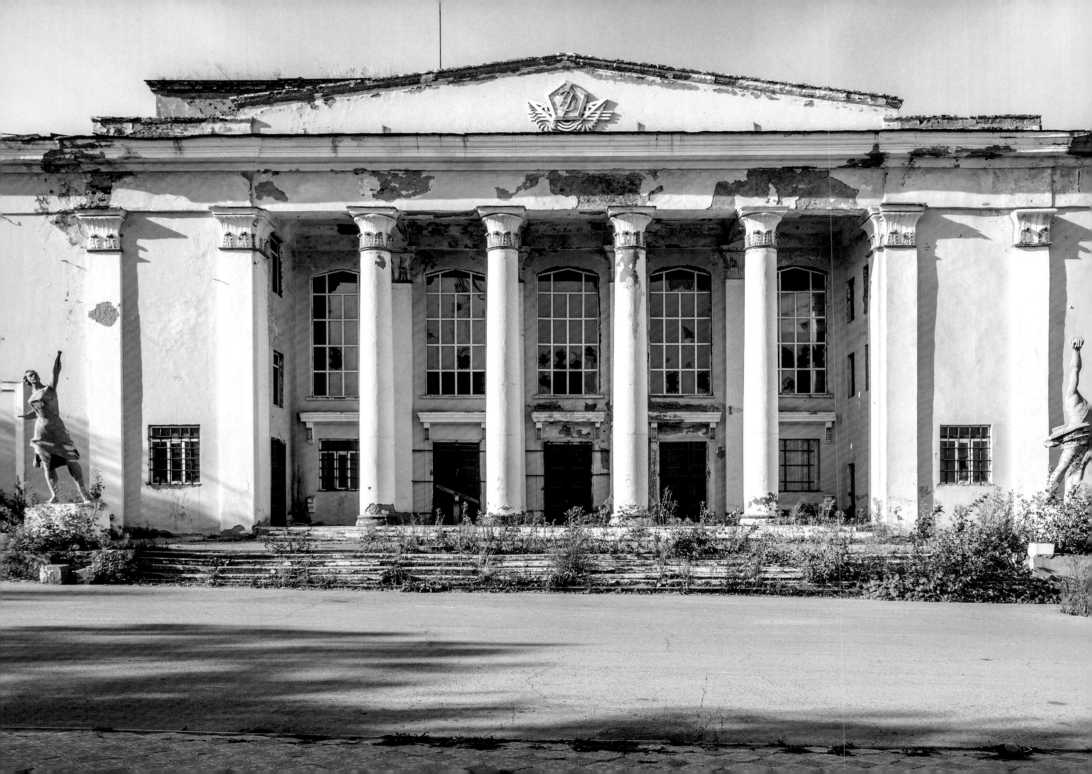

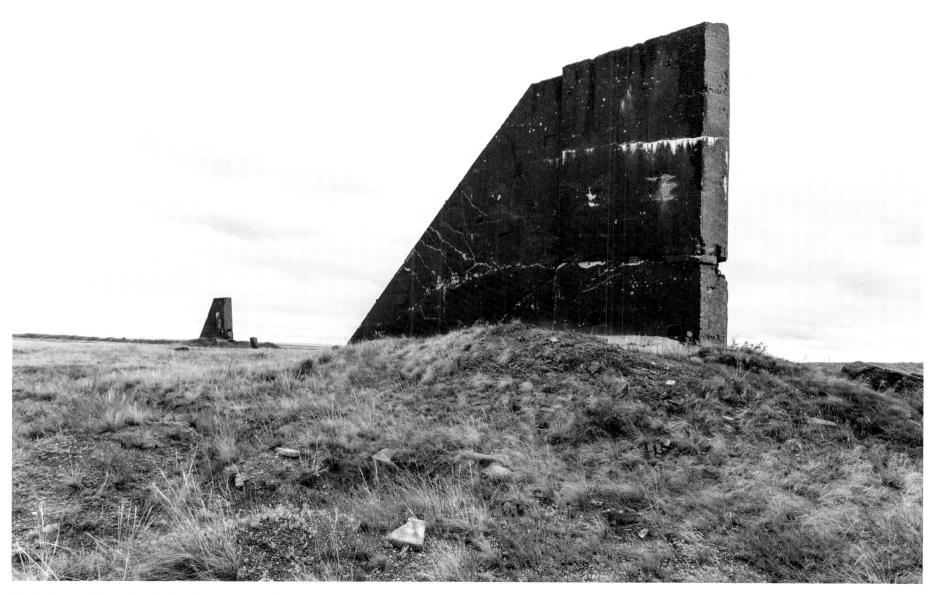

The Polygon at Semipalatinsk was the primary nuclear test site. From 1949-89, more than 450 tests were carried out, the equivalent of 2,500 Hiroshima bombs. The amount of radiation generated here was several hundred times greater than that of the Chernobyl catastrophe. These concrete structures acted as bunkers to protect the cameras that recorded the effect of radiation on the artificial town of Semipalatinsk. When this photo was taken, the counter read up to 20 microsieverts, or 40-70 times a normal level of radiation.

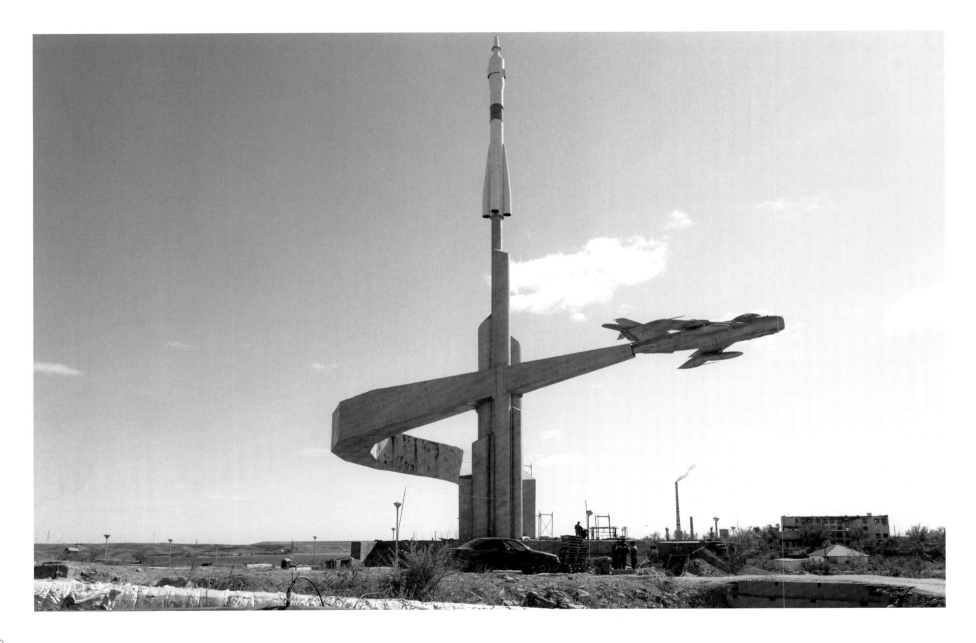

Huge monument in an industrial town. This futuristic metal structure celebrates aviation and the conquest of space.

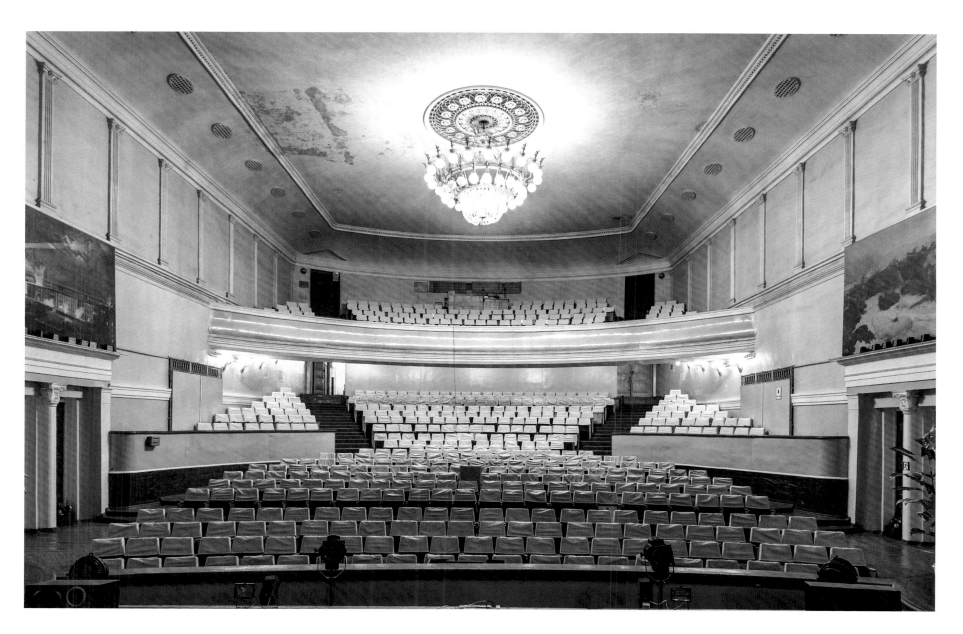

Palace of Culture reserved for officers in a town forbidden to foreigners. With a bit of luck and some misunderstanding, we managed to get in. The pictures displayed on the walls    111

celebrate the Patriotic Wars, indiciating that, while dedicated to art, this place remains faithful to the ideal of military austerity.

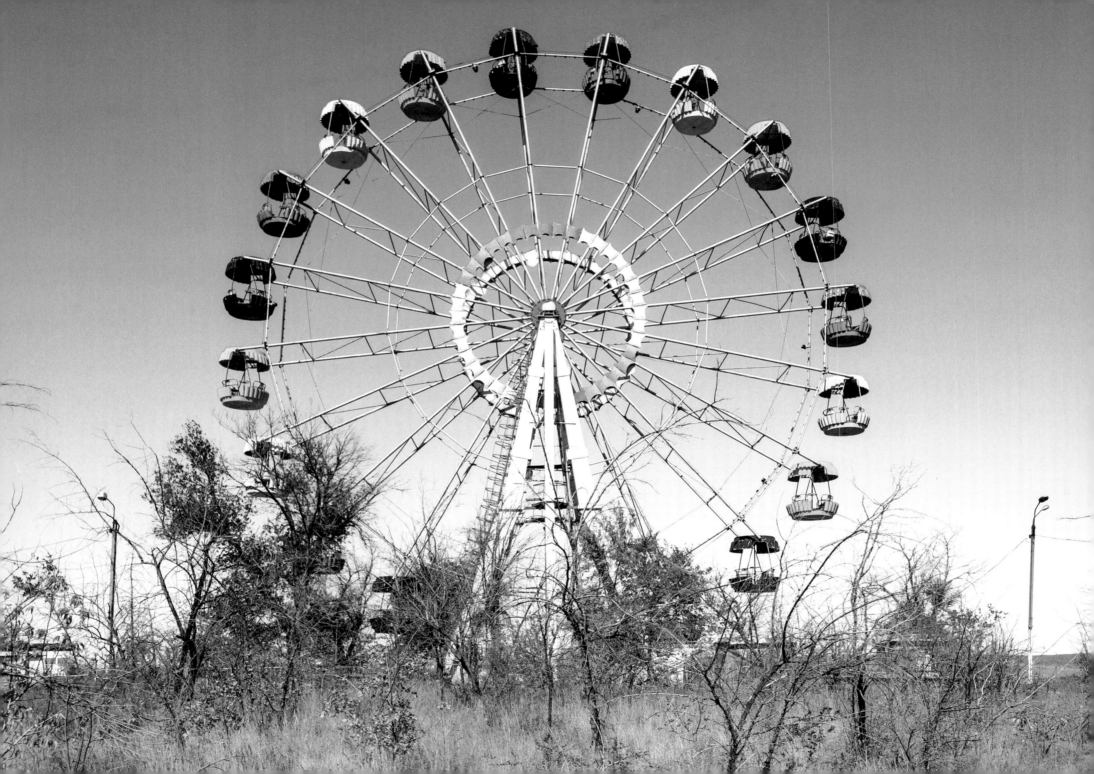

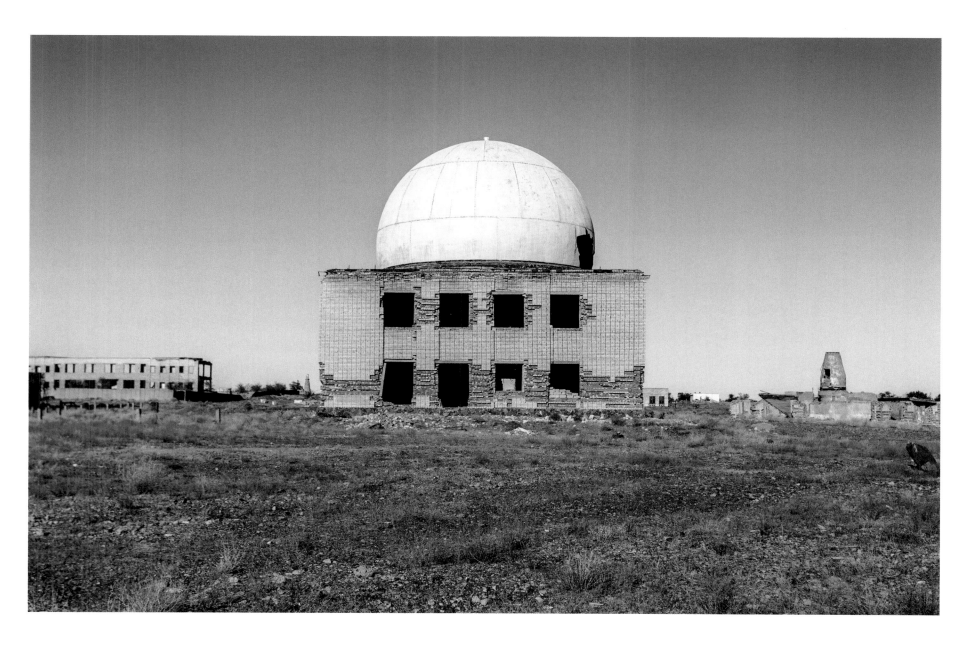

Observatory that was used for monitoring information relayed by the well-known Sputnik satellite. Until recently this zone was still classed as off-limits and could only be visited with special permission from the government.

The Baikonur Cosmodrome. The Soviet space programme launched the Buran (Бура́н) project in 1976 in response to developments in America. Although considered indispensable against the geopolitical backdrop of the time, the conquest of space turned out to be the costliest project in Soviet history. For that reason, despite its considerable successes, such as launching numerous artificial satellites and sending the first man, Yuri Gagarin, into space, it was abandoned at the end of 1993.

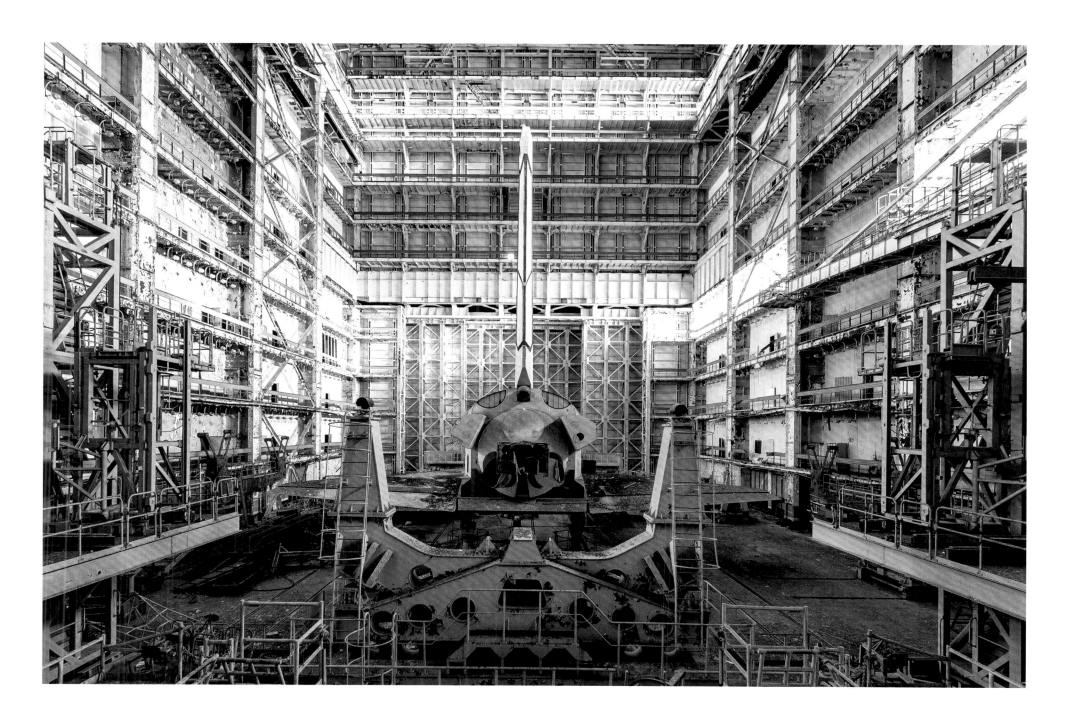

These disused hangars, that contain the Soyuz and Proton launchers, are located in the Baikonur site which is still in use. Today rockets are still regularly launched a few kilometres away from these buildings. When we undertook this venture over the New Year period, 2019, the temperature was -20°C. We spent two nights in the hangars hiding from guards patrolling the site – and it had taken several hours' walking in the cold and snow to reach it in the first place! Truly an unforgettable experience!

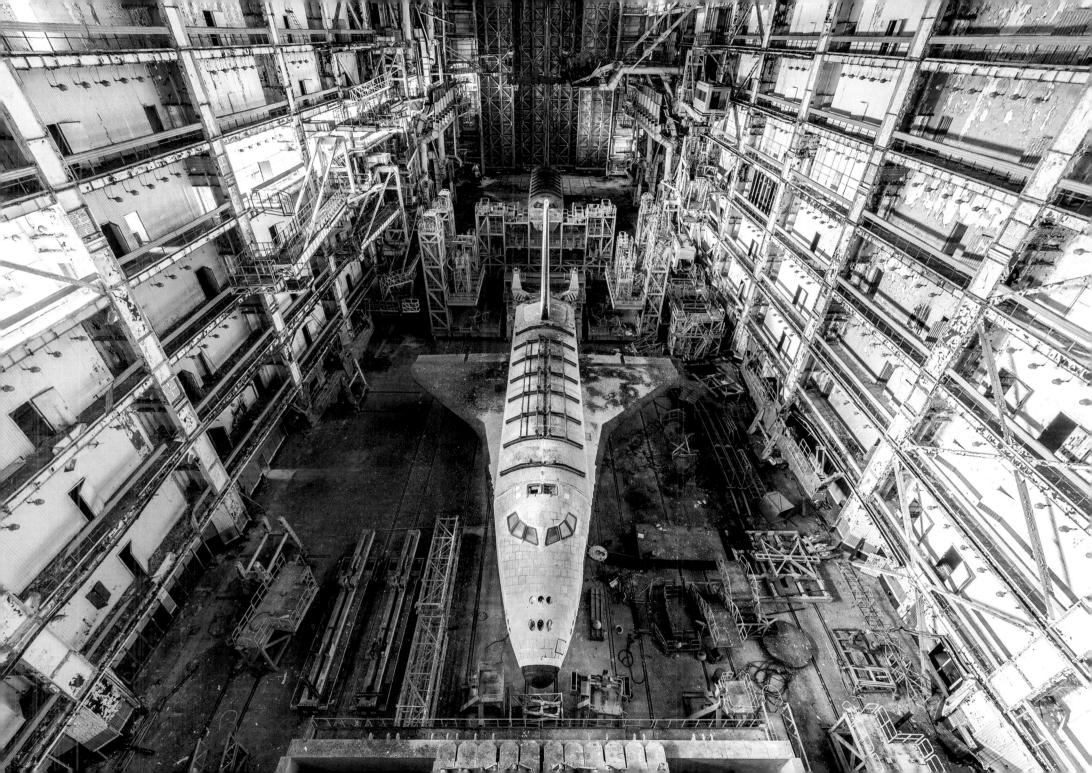

# Georgia

Georgia came under Soviet influence in 1921, and later joined with neighbouring countries to form the Soviet Republic of Transcaucasia. As the birthplace of Joseph Stalin, this land enjoyed a privileged status following his rise to power. Members of the Russian intelligentsia in search of entertainment and relaxation were welcome guests there, and Georgia became synonymous with the pursuit of pleasures such as dancing and fine cuisine. Some of its once majestic establishments still retain a vague aura of their former grandeur, in spite of having fallen into a state of disrepair, such as the sanatoria of Tskatulbo, which are nowadays largely occupied by refugees fleeing the fighting in Abkhazia. Khrushchev paid particular attention to Georgia after the death of "The Father of Nations", enthusiastically dismantling Stalin's personality cult. The country was emancipated in April 1991, but conflicts quickly arose between the central authorities and certain regions seeking independence, namely Abkhazia and South Ossetia.

Visits: 2015 – 2016 – 2017 – 2021

The oldest funicular railway in Tbilisi carried up to 500,000 people a year from the city centre to Mtatsminda Park at the top. It was built in 1903, but it was closed down following a horrendous accident in 1990 in which 20 people died and 15 were injured. A renovation project has recently been completed.

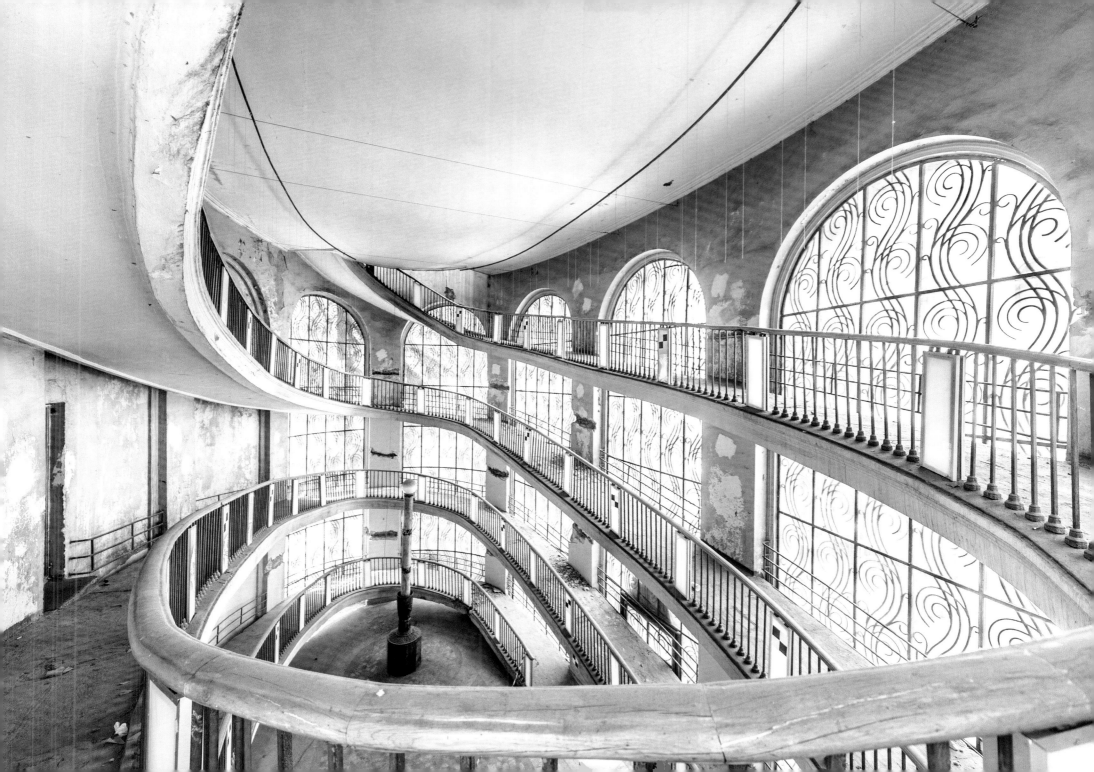

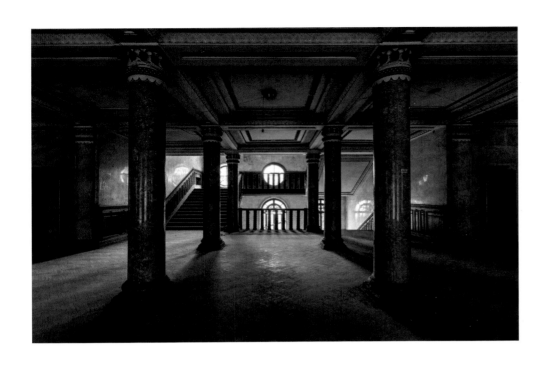
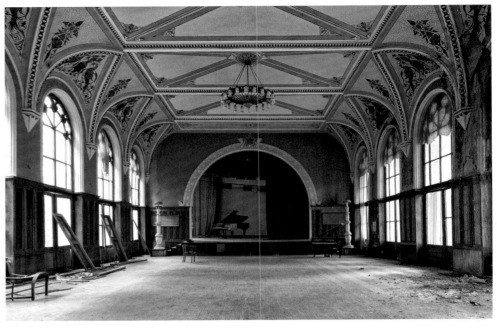
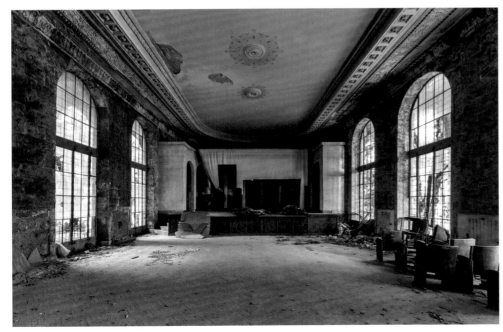
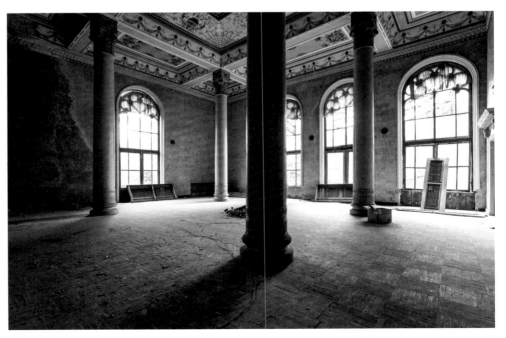

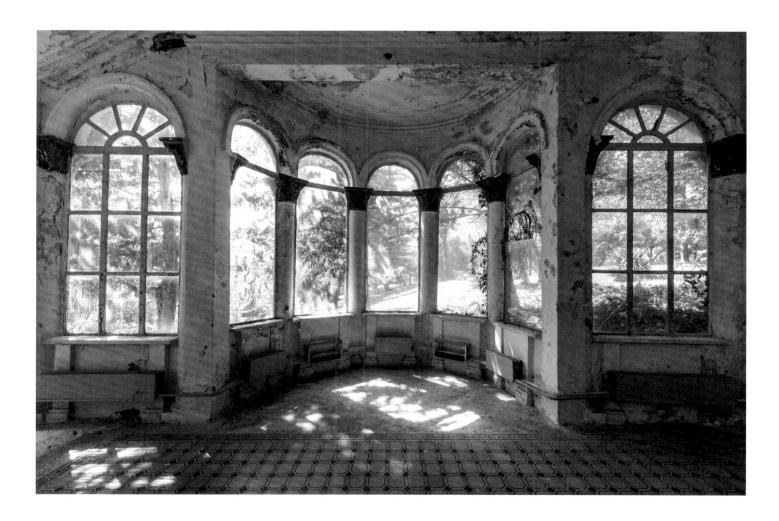

Sanatorium of Tskaltubo, completed in 1953. Tskaltubo, which is home to about 10 or so sanatoria, was one of the best-known spa towns in the USSR. It had the capacity to receive up to 125,000 people a year, including Stalin himself. He regularly stayed there and had his own private spa in the heart of the city, which can still be visited today. All the bathing complexes closed their doors in the wake of the 1993 war between Georgia and the autonomous republic of Abkhazia. Since then, they have housed about 9,000 Georgian refugees from Abkhazia.

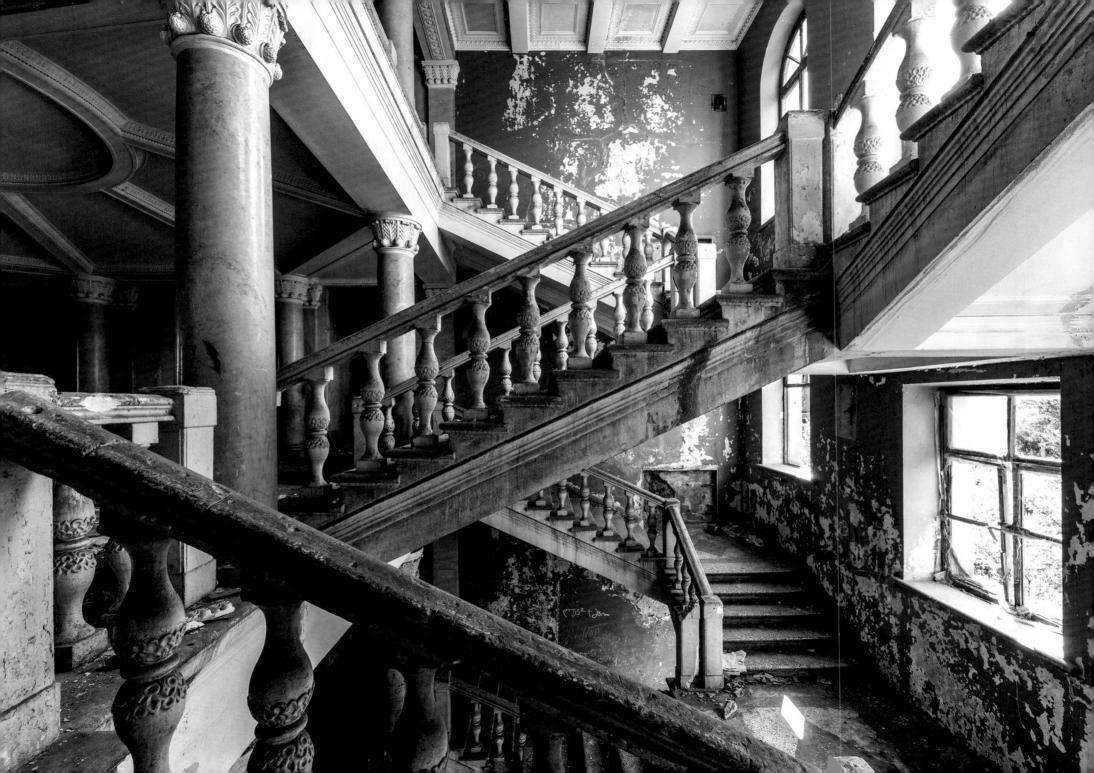

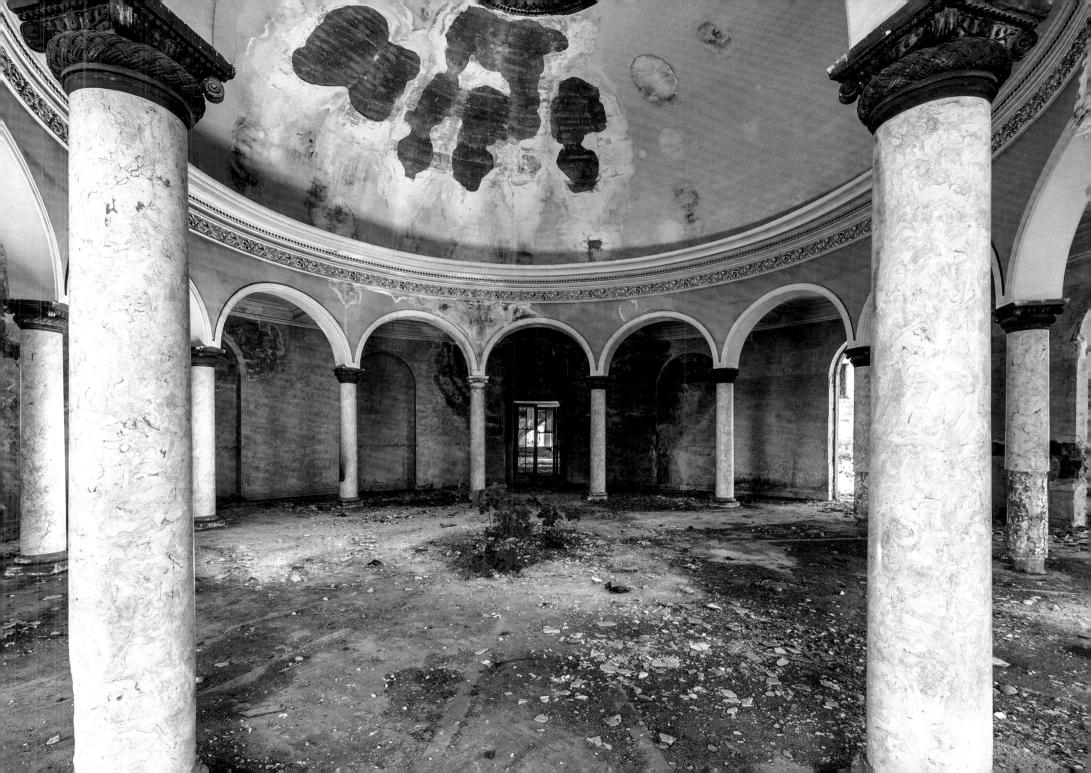

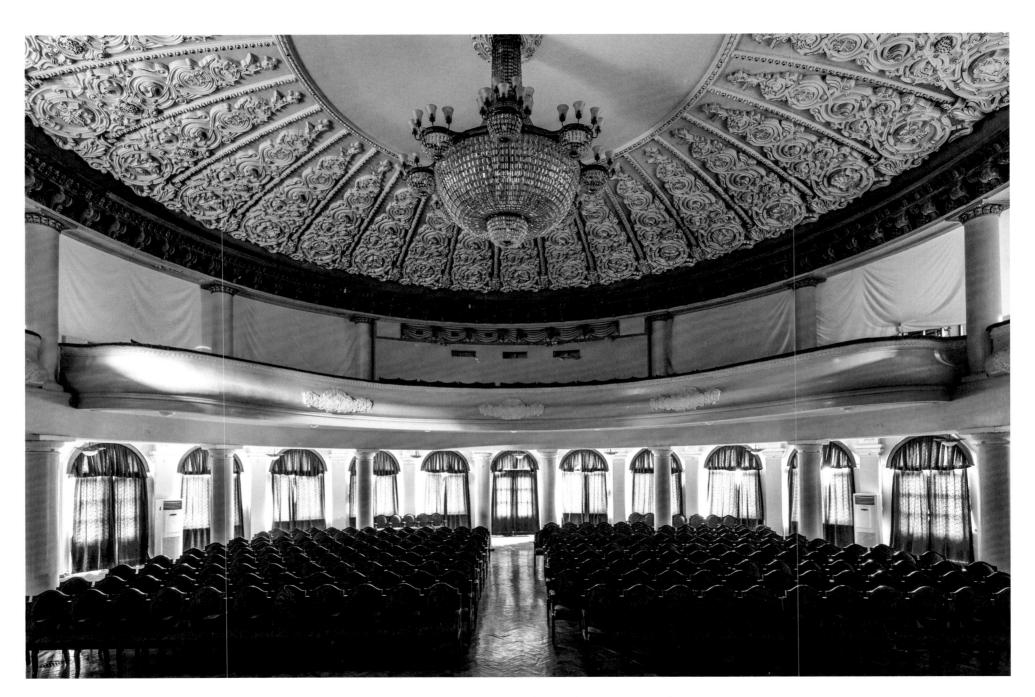

Small private theatre within the sanatorium used by Stalin, now preserved as a museum.

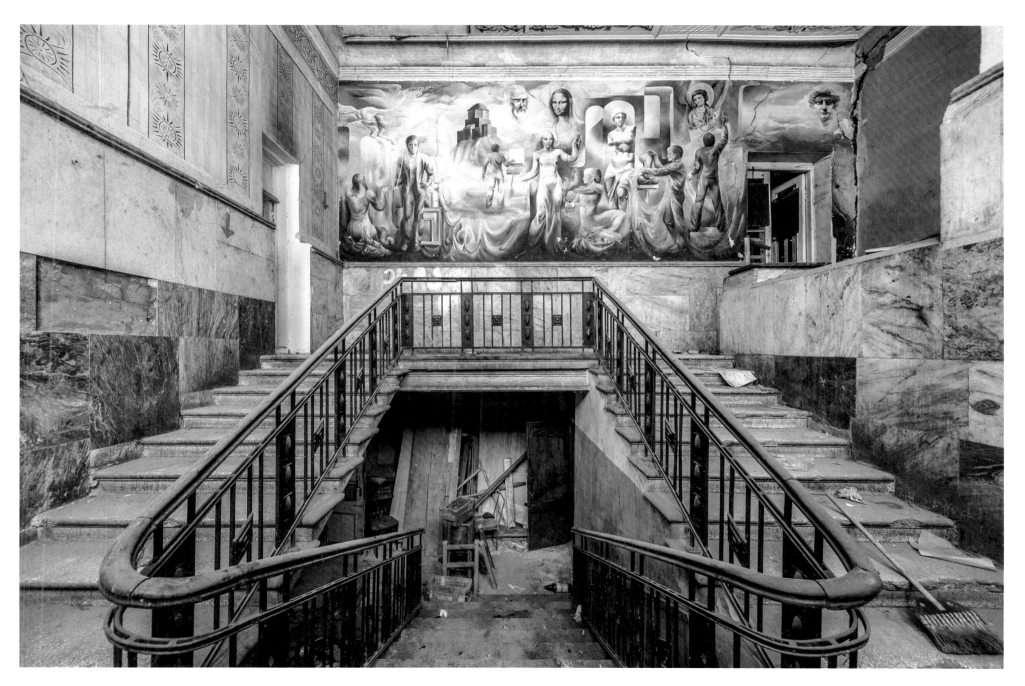

Abandoned School of Art in the centre of Tbilisi. The cracks in the wall on the right were caused by the 7.2-magnitude earthquake that severely damaged the capital in 1991.

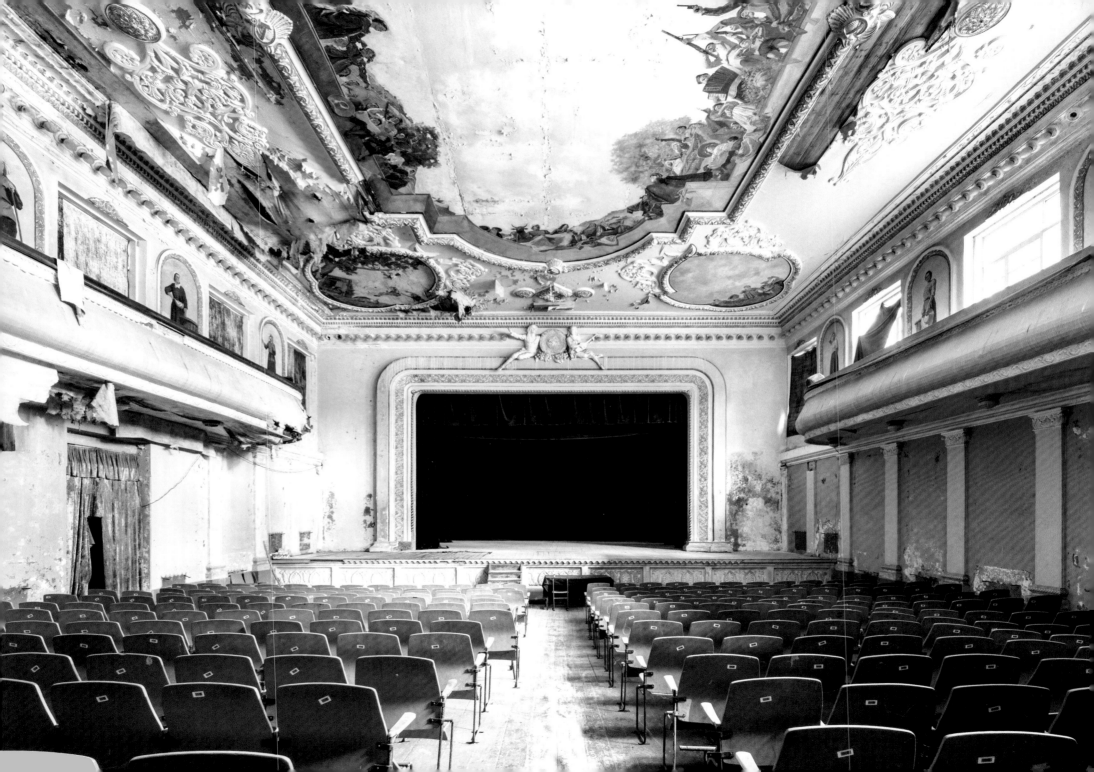

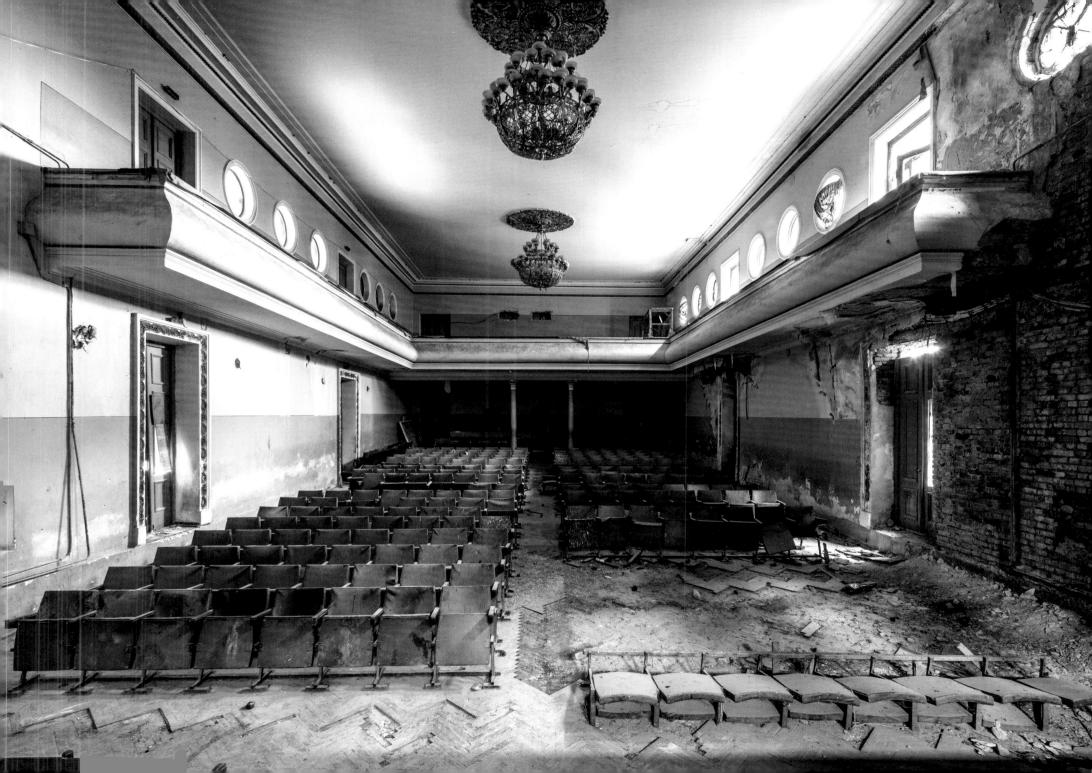

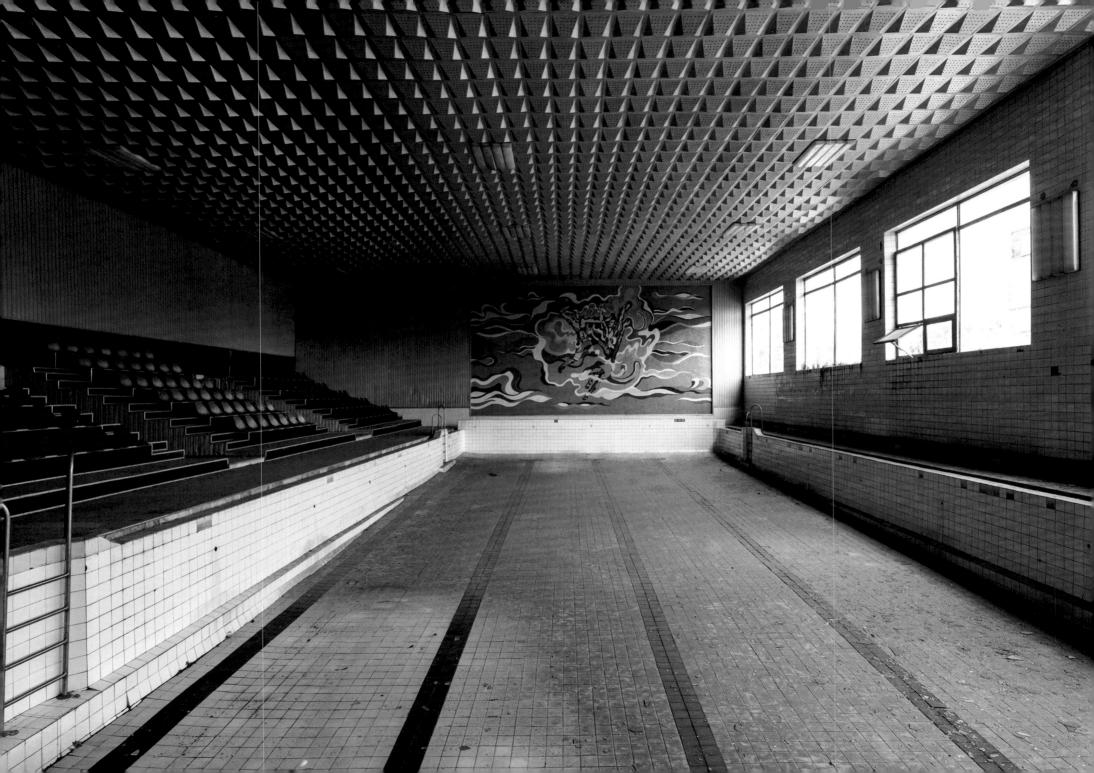

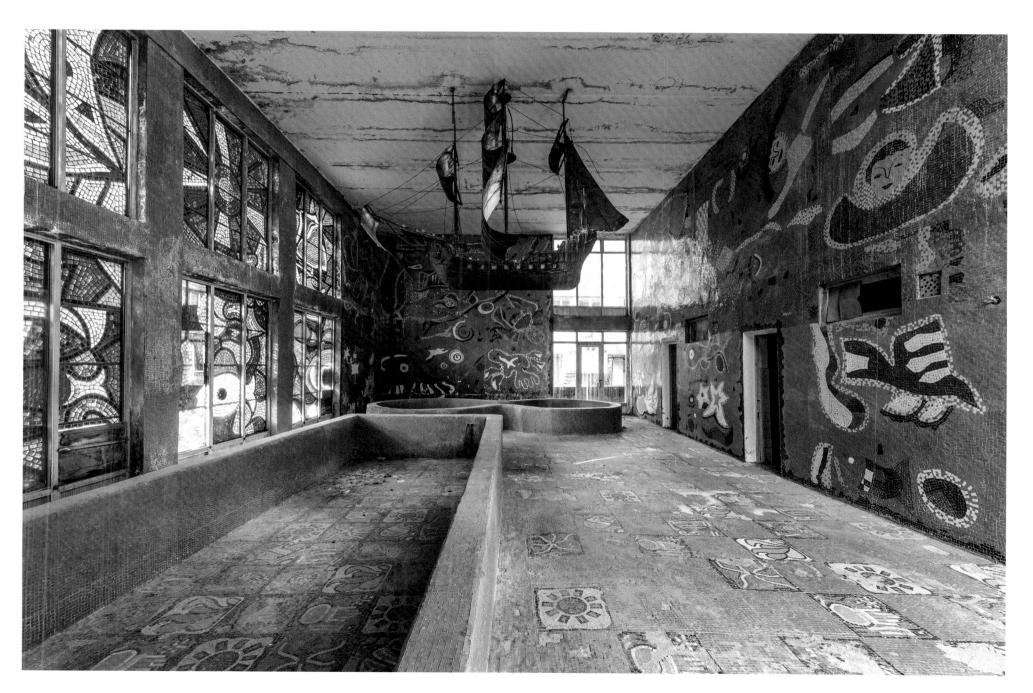

Swimming pool in a primary school.

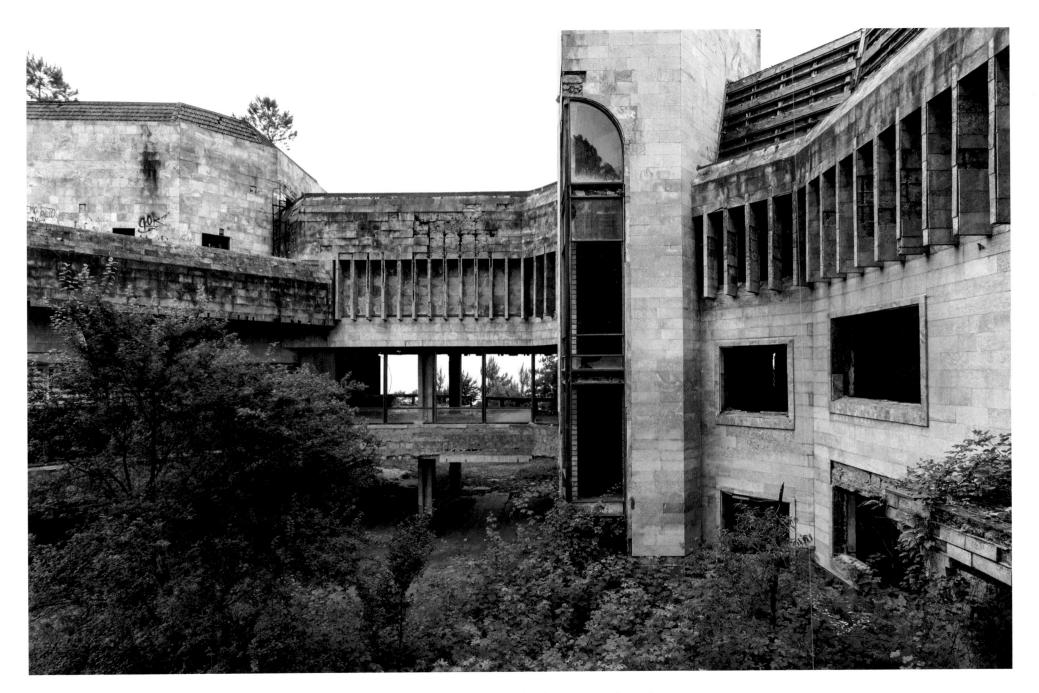

Former casino hotel, a fine example of 1970s Brutalist architecture.

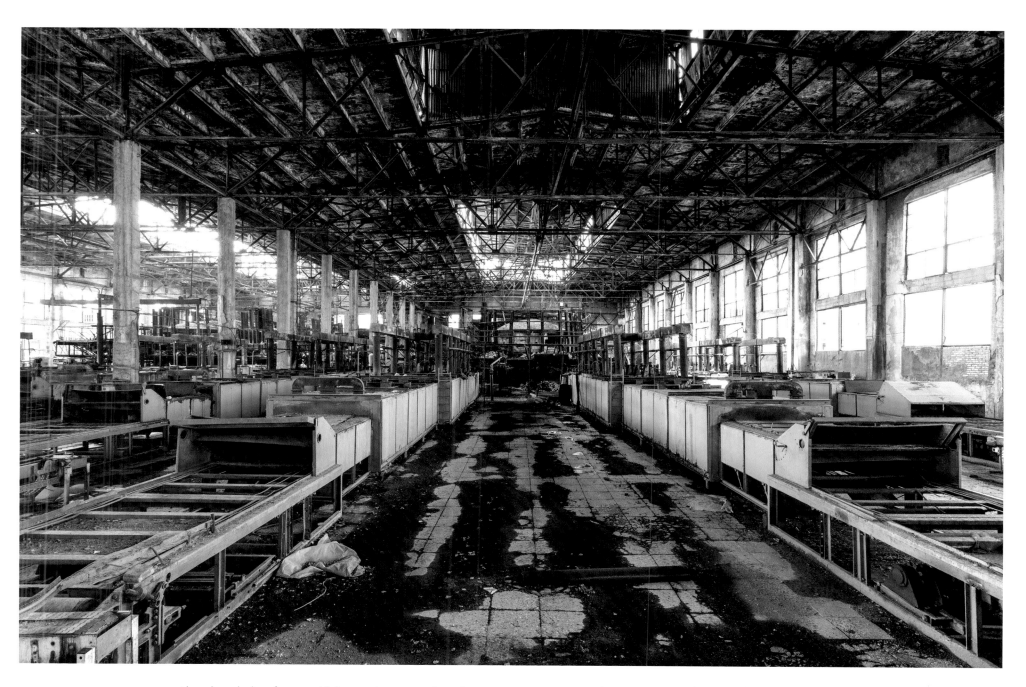

Abandoned glass factory. All the machinery is still in place, tempting visitors to take a journey into the past of this establishment.

# Armenia

In 1918 following the Russian revolution, Armenia, like its neighbours, ceased to be part of the former Empire and in 1920 became the Armenian Soviet Socialist Republic. Later, in 1922, it became part of the Republic of Transcaucasia, one of the founding members of the USSR. After Transcaucasia broke up in 1936, questions remained regarding the annexation of certain territories, in particular Nagorno-Karabakh which was annexed to Azerbaijan. However, things remained unchanged for the duration of Soviet domination, until the demonstrations of 1988. When independence was proclaimed in 1991, Armenia remained on good terms with Russia, and this is borne out by the many statues and frescos which remain dotted around the country. Nevertheless, conflict with its neighbour flared up even more fiercely, and despite a ceasefire being concluded in 1994, the issue remains unresolved. The country that has never forgotten the United Armenia of the old days must be content to dream as it looks at the abandoned railway lines which cross the borders erected by history.

Visits: 2015 – 2017

Monastery dating from the 13th century tucked away in a mountainside. The sculpted crosses on the wall are *khachkars*, UNESCO-listed steles, part of Armenia's heritage.

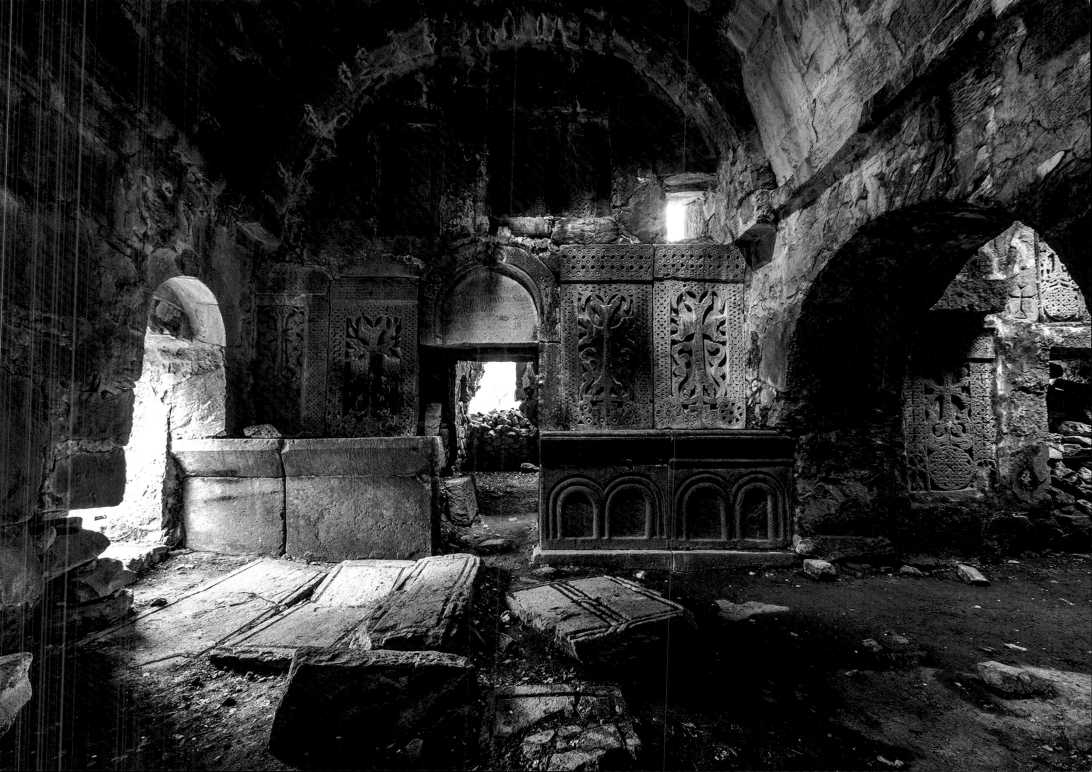

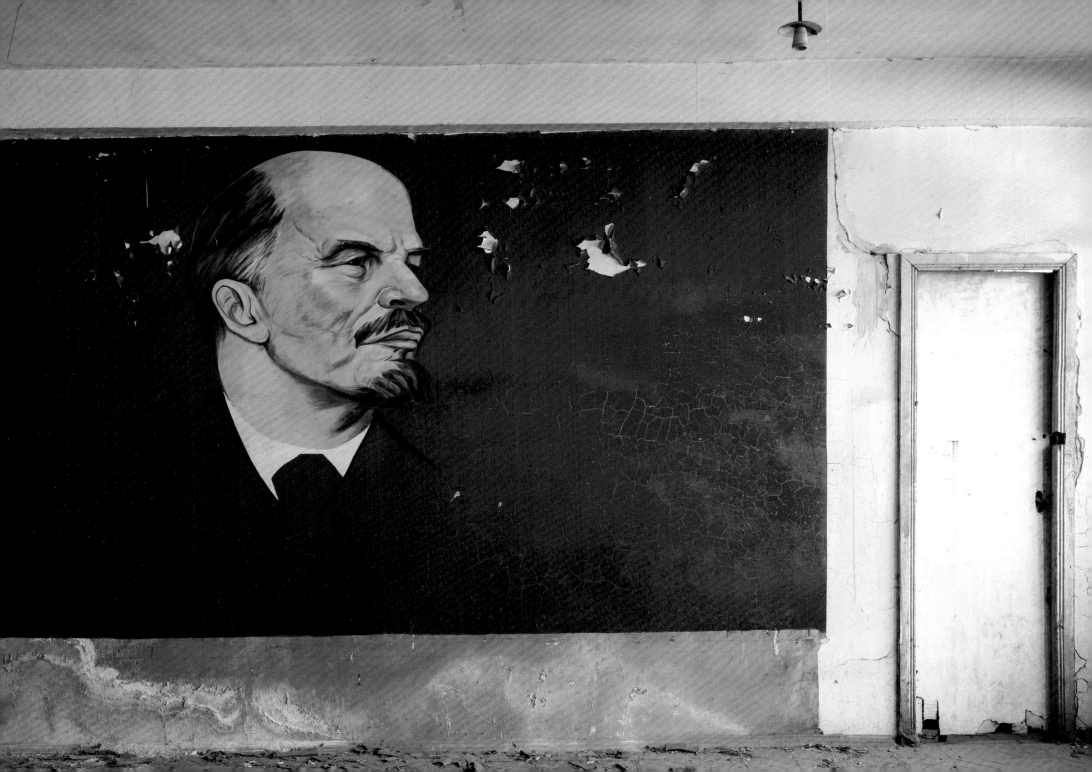

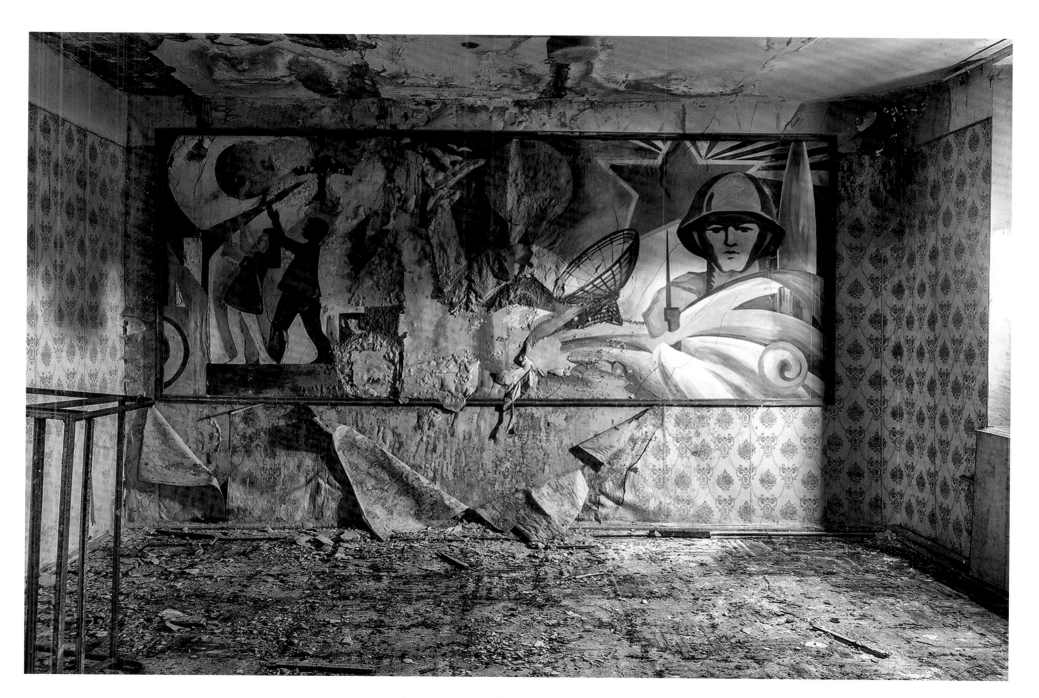

Military painting on the wall of officers' quarters.

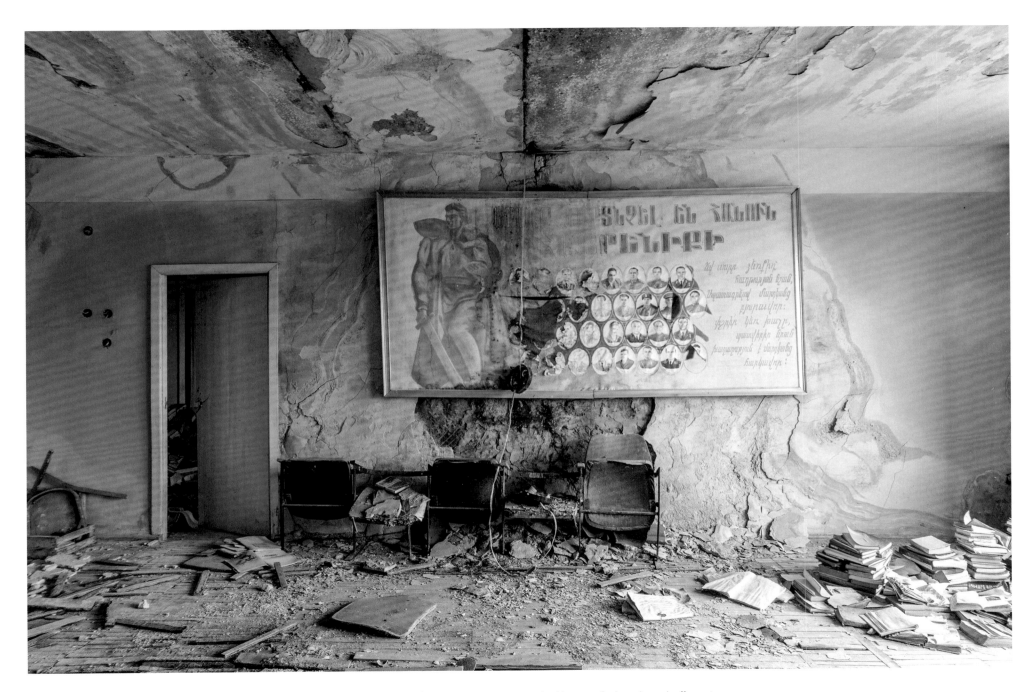

Commemorative picture with Armenian writing in the library of abandoned officers' quarters.

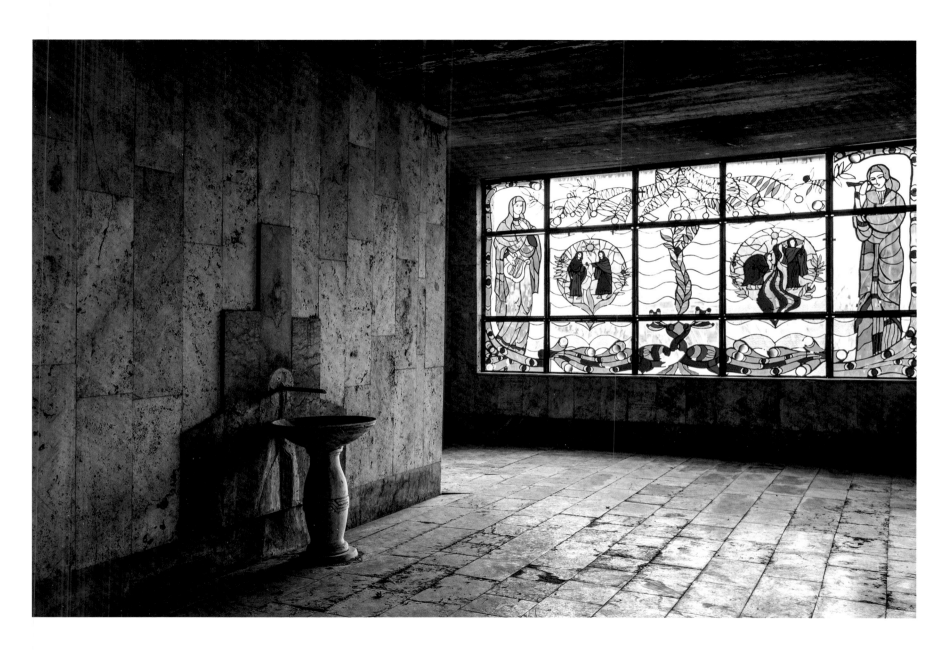

Spa hotel in the same town with hot springs. 10 or so storeys high, it was dotted with fountains where guests could drink sulphur water for its health benefits.

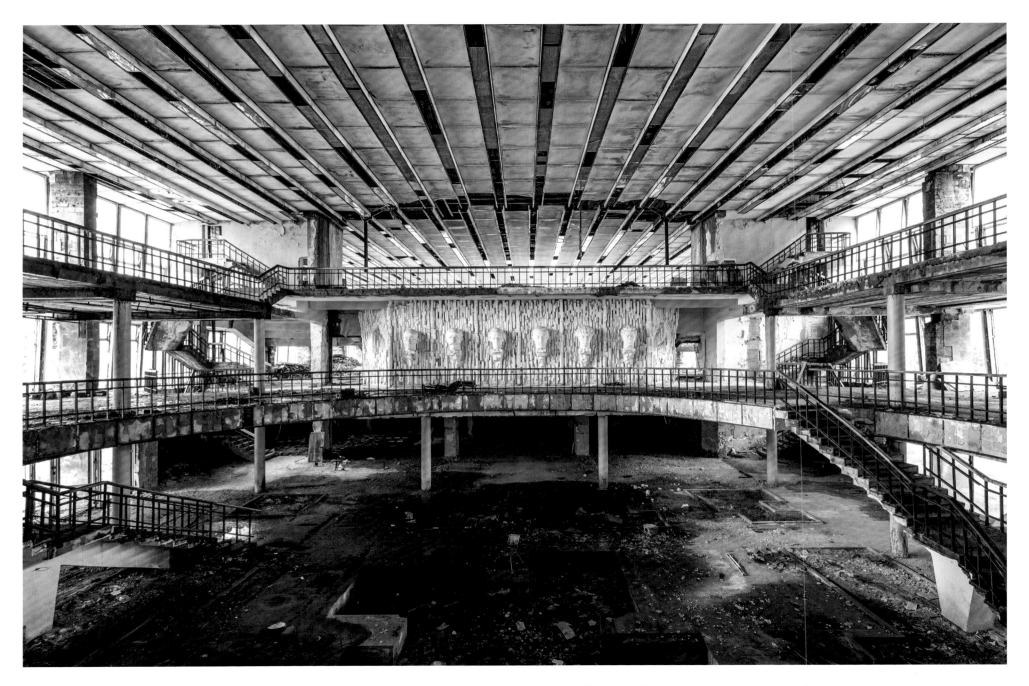

Eye-catching sports complex in a spa town, decorated with the busts of important Armenians. The establishment also contained a swimming pool and a theatre.

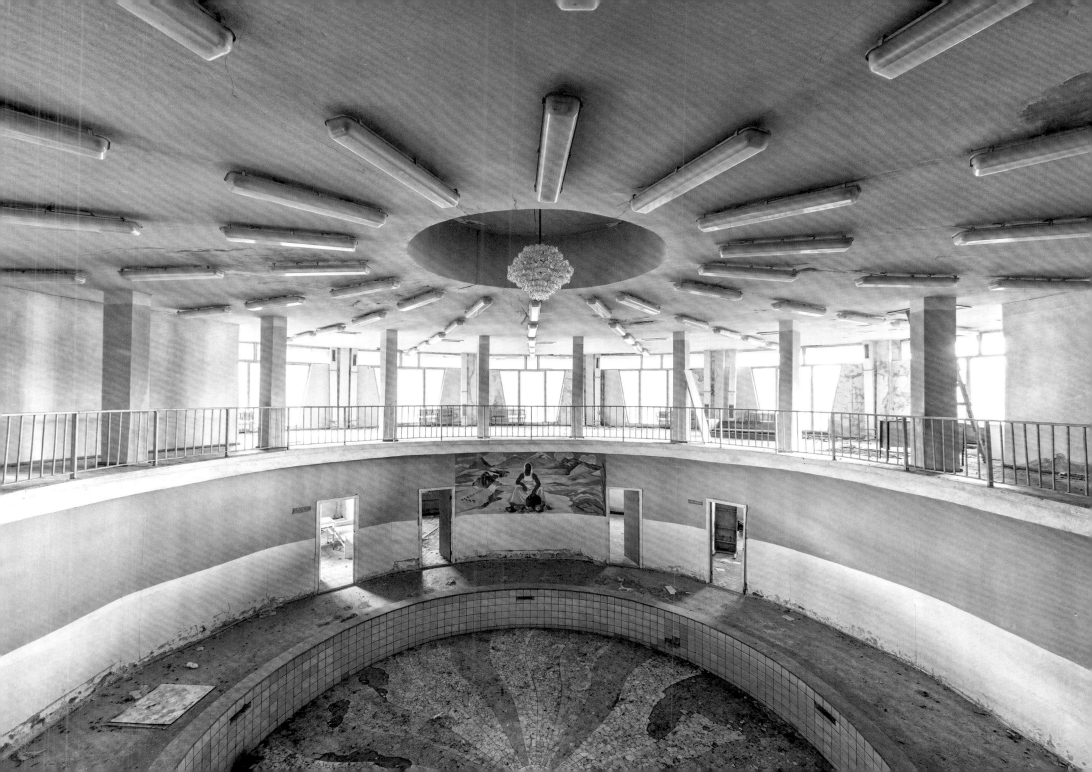

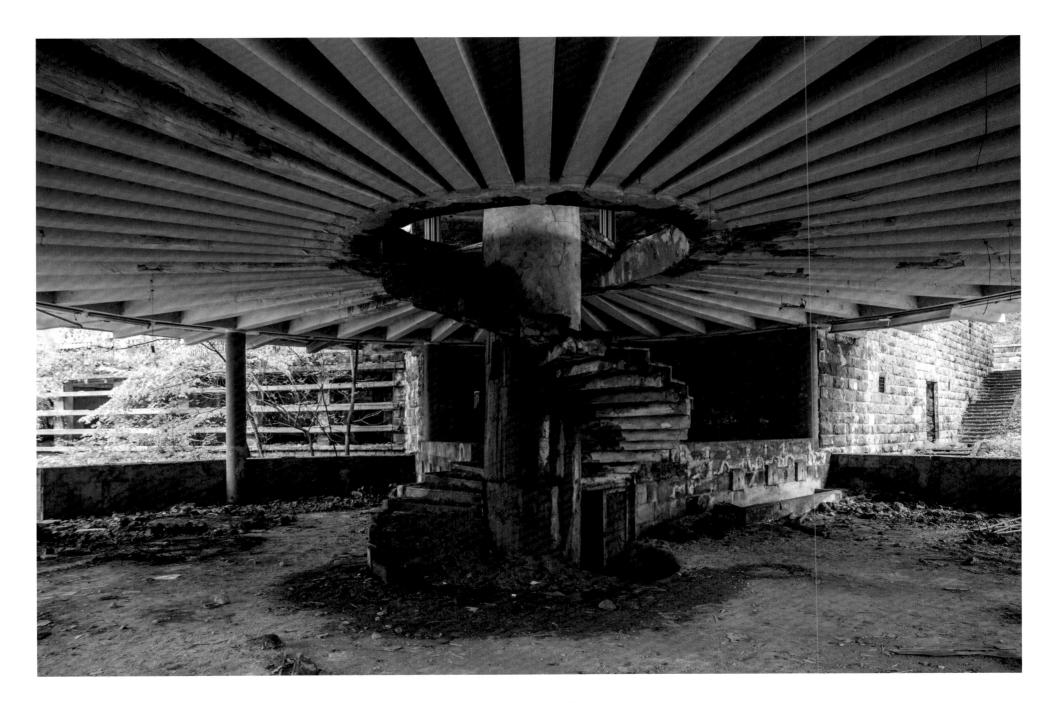

Brutalist style sanatorium in the highlands of the country. The staircase leads up to the hotel's lobby.

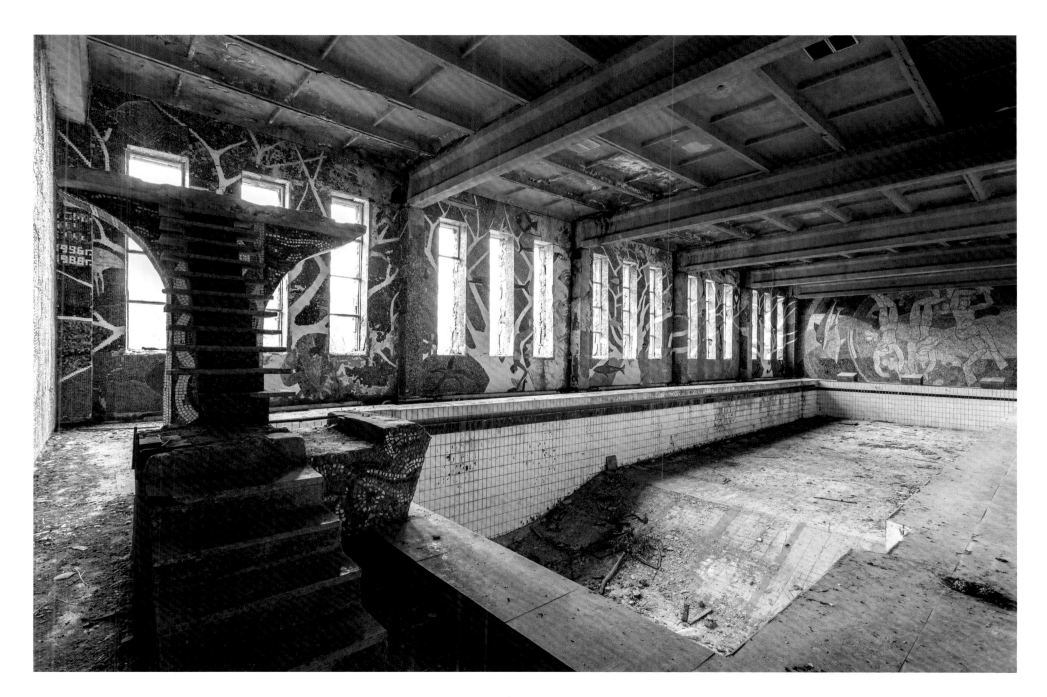

Swimming pool in a holiday camp in an area that sustained severe earthquake damage.

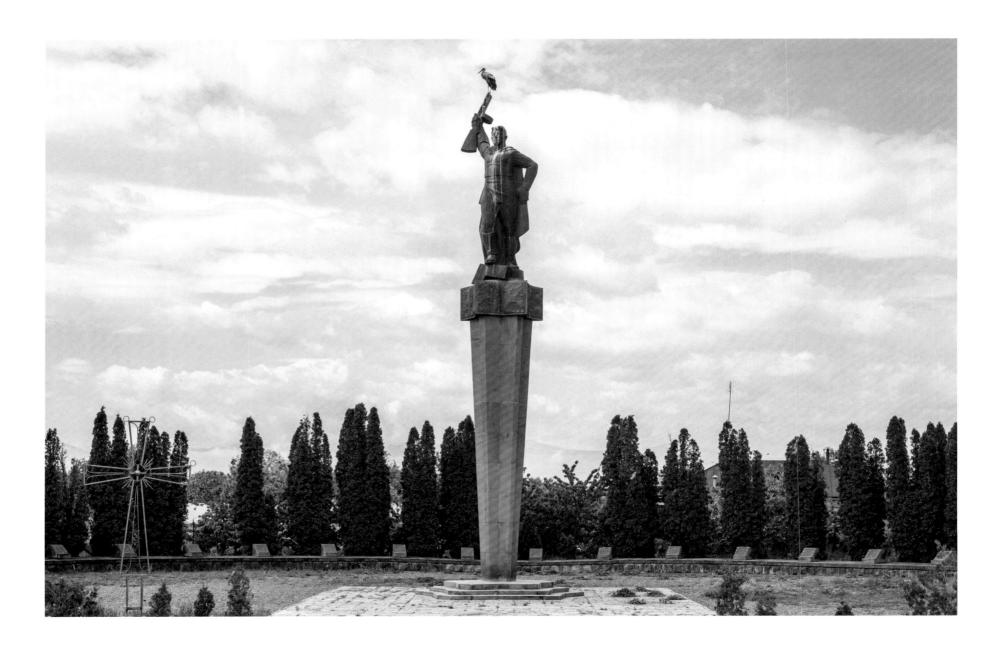

A monument to the unknown soldier is a feature of most Soviet towns. For once it is the stork's role to deliver a message of peace ...

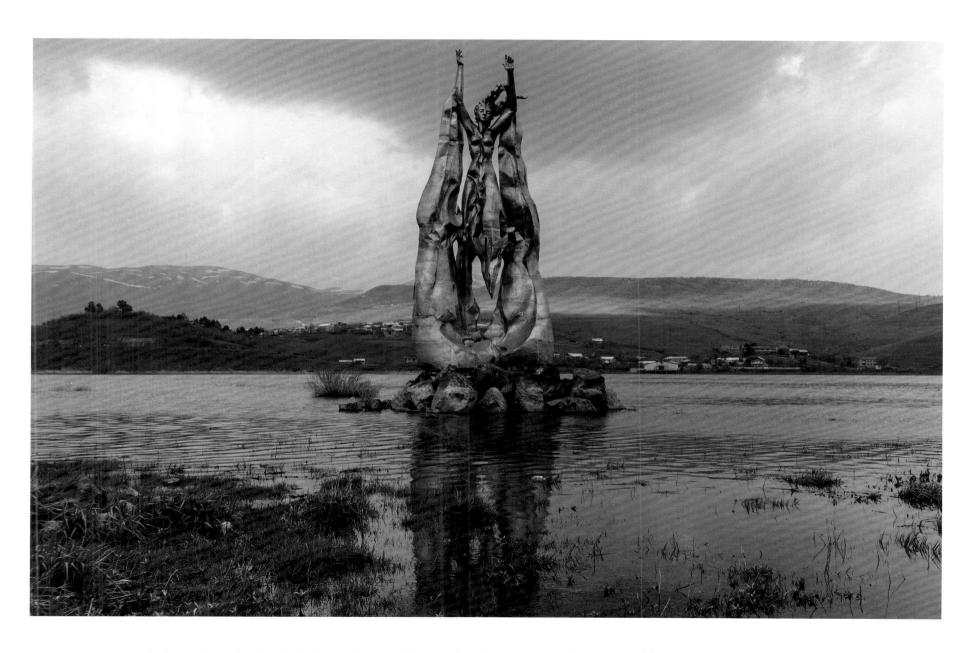

Sculpture devoted to the Motherland, a favoured theme in the different countries that comprised the Soviet Union. It is a symbol of peace and an expression of the courage, strength and sadness of the nation's children.

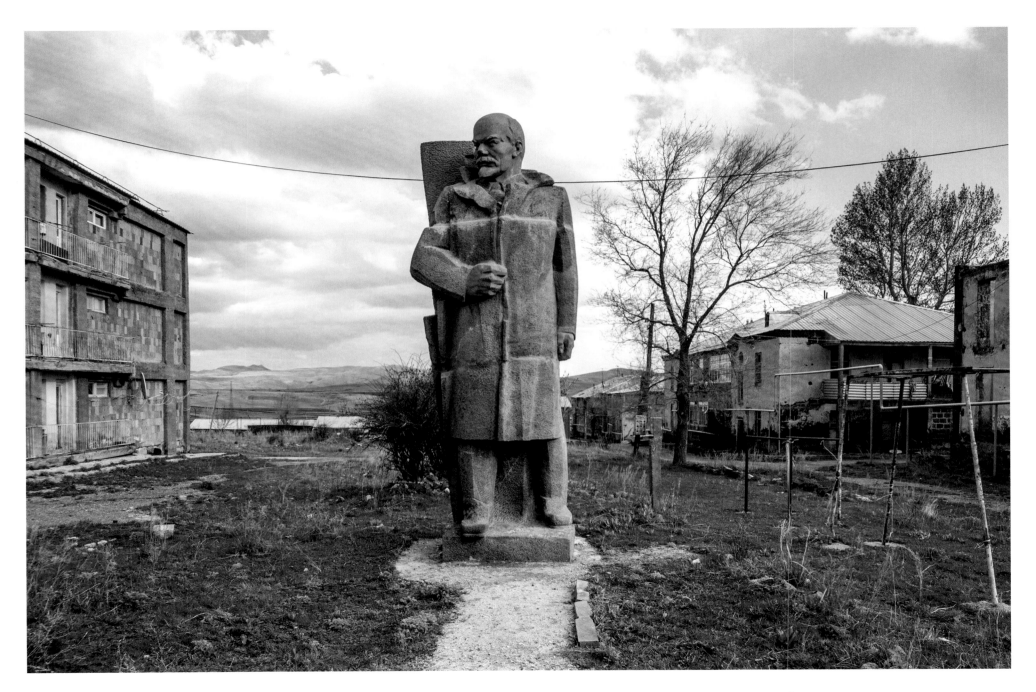

One of the rare statues of Lenin still standing in the country. The majority were toppled at the time of the collapse of the USSR.

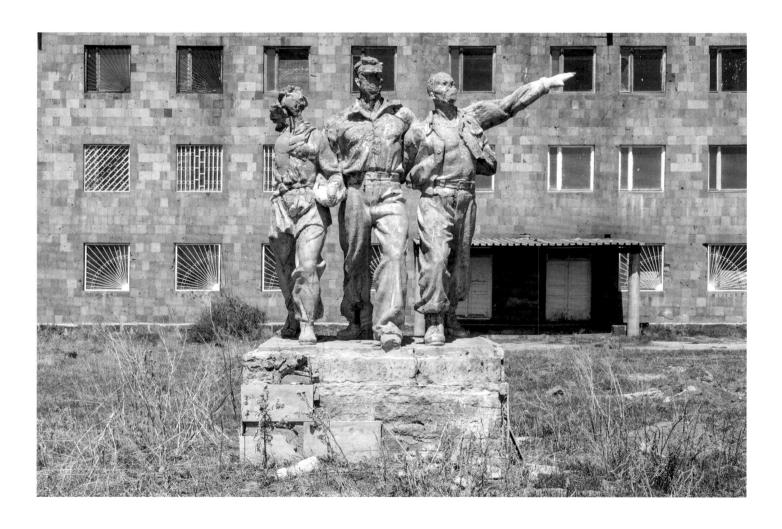

Damaged statues in front of the admin department of an abandoned glass factory. They were produced from a mould, and this model is fairly ubiquitous. At first sight it simply consists of a female *kolkhoz* worker and two labourers, but on closer inspection, you can see that one of the men is of African appearance, presumably to convey the message that the Soviet community was a stranger to discrimination.

145

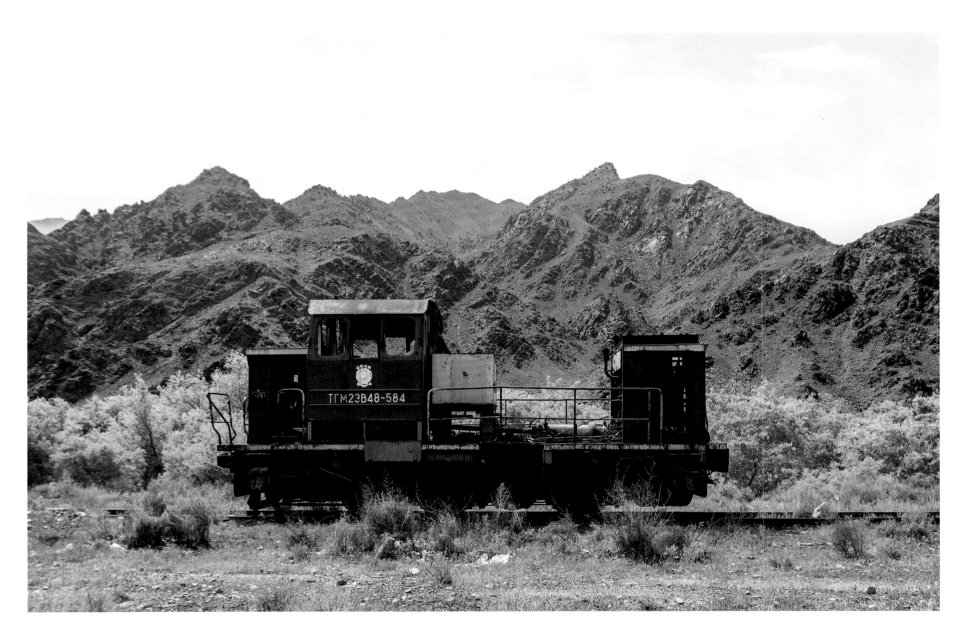

The last station in the country with any Soviet trains. It is the end of the line for this Armenian CCCP locomotive. Towering behind it are the Iranian mountains, which long marked out a clear border between the USSR and the rest of the world.

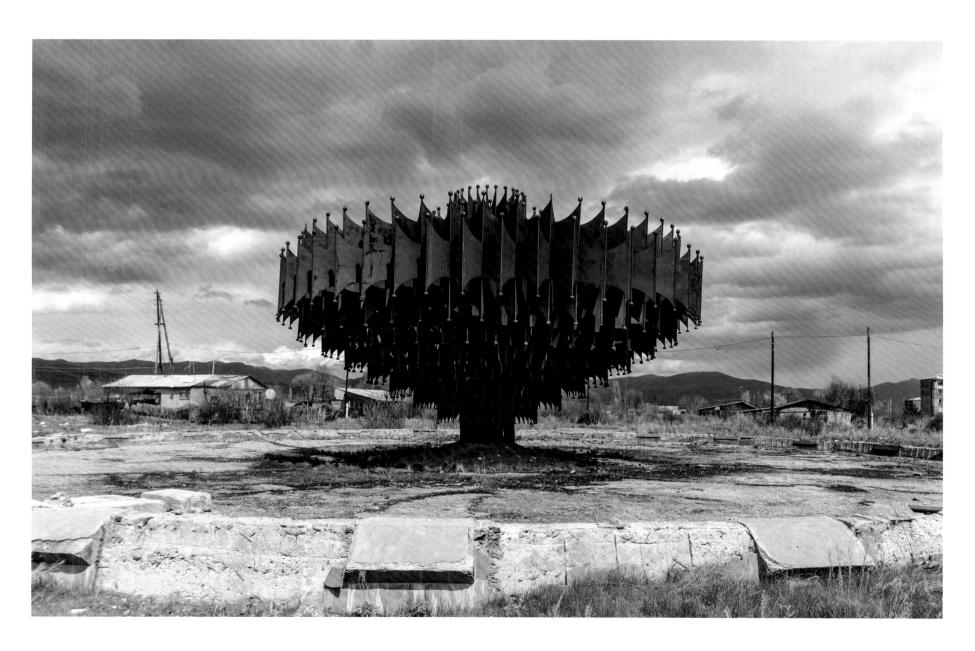

Fountain at the former technical university in Gyumri. In 1988, it was destroyed by an earthquake that resulted in nearly 50,000 deaths. For the very first time, the USSR was forced to ask for international co-operation in a bid to resolve the situation.

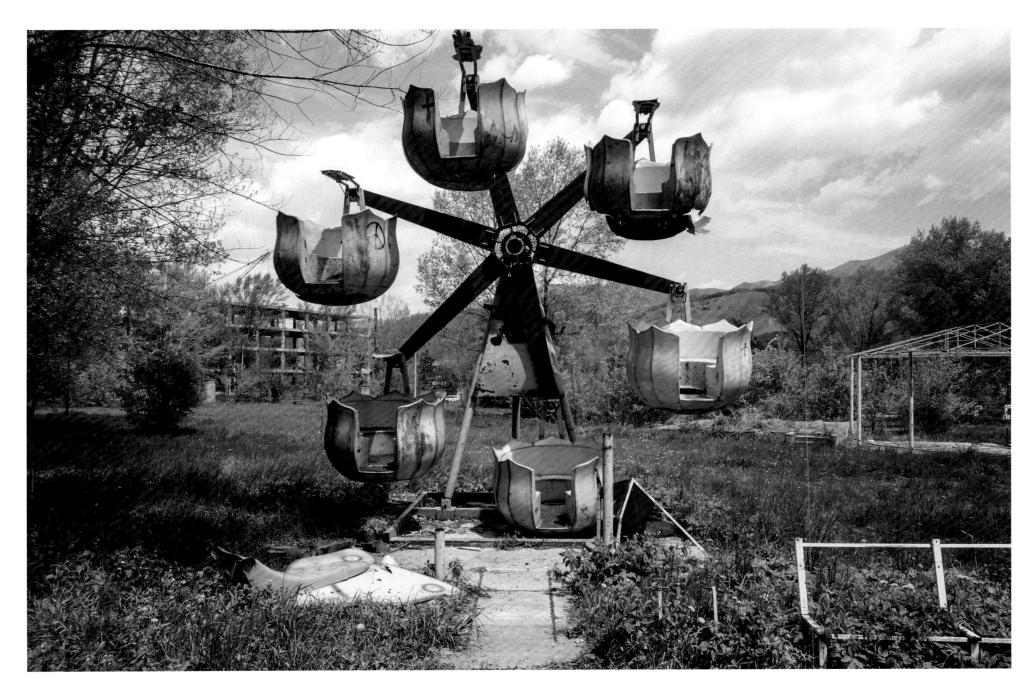

A ghost amusement park in an industrial town that has reached the end of its life.

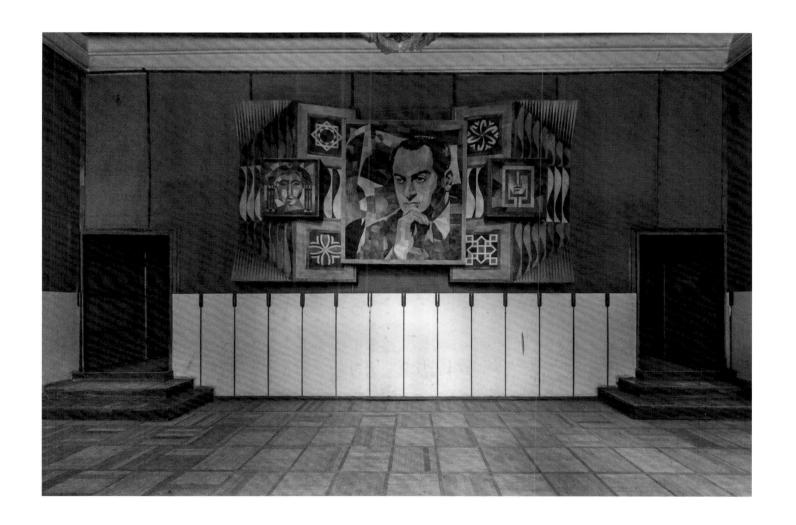

A cinema foyer with a wooden wall decoration that depicts a Soviet actor. Like everywhere else, small independent cinemas are dying out in the face of competition from modern multiplexes erected in vast commercial centres.

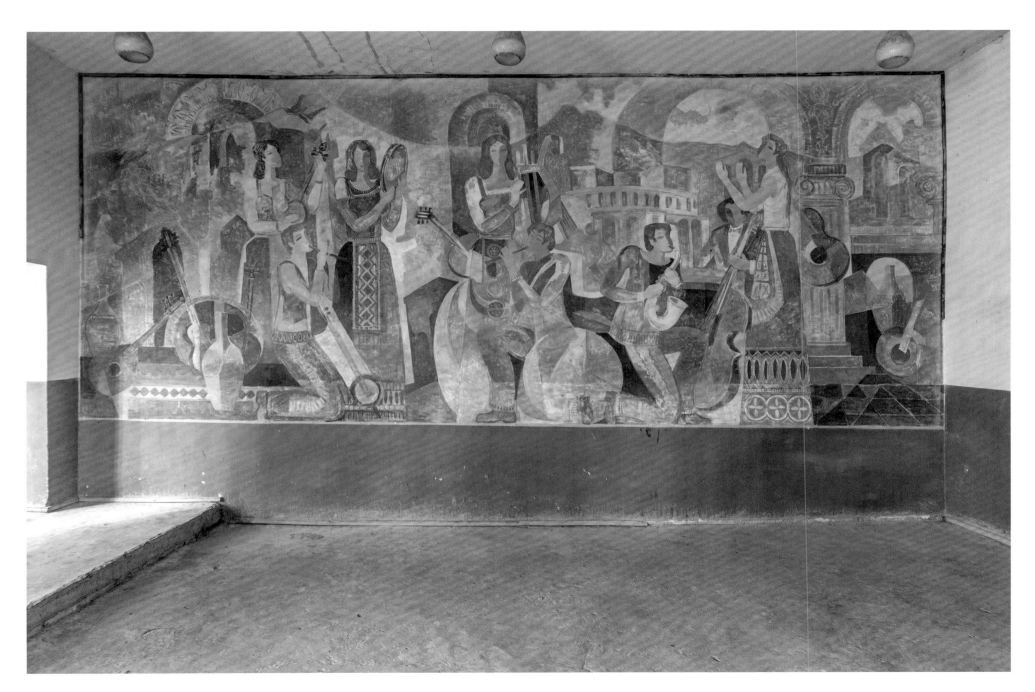

A fresco consisting of musicians against the background of the Yerevan Opera Theatre and Mount Ararat.

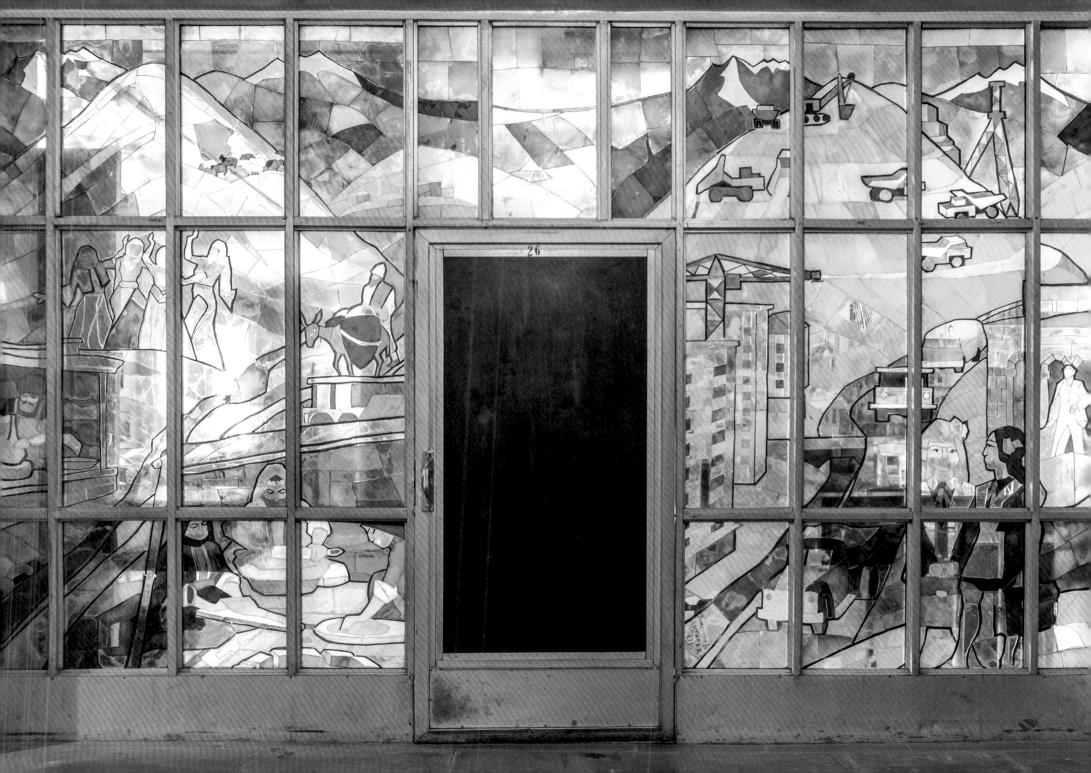

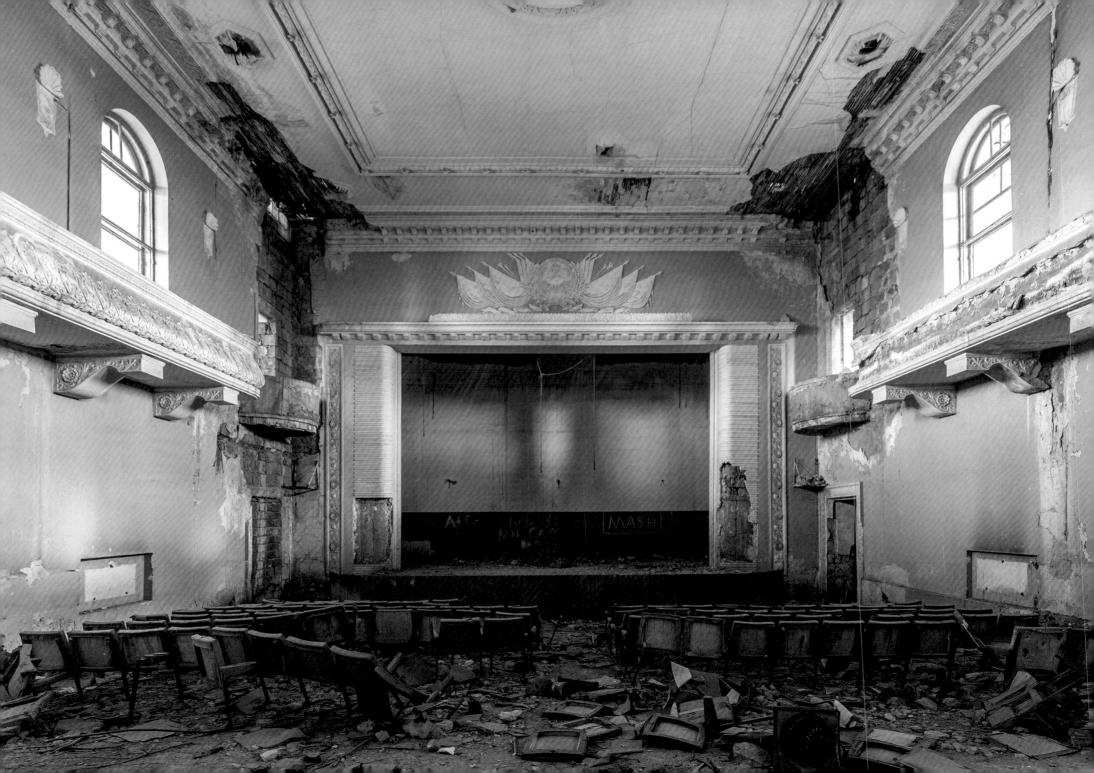

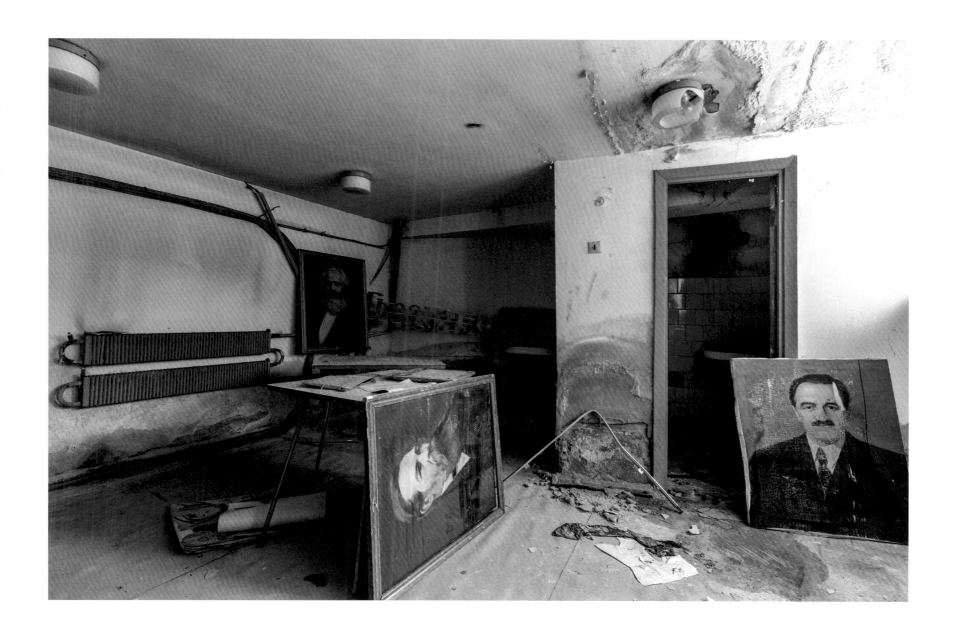

The three pictures in an Armenian university basement are of Missak Manouchian, Friedrich Engels and Karl Marx.

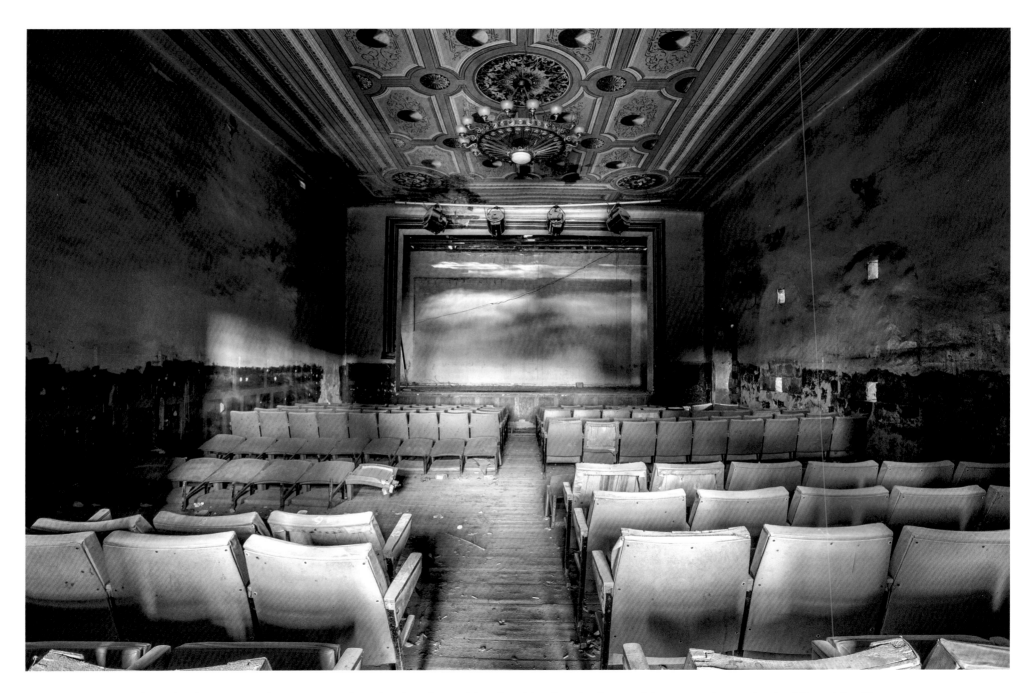

A Palace of Culture converted into a cinema then abandoned, its golden chandelier the sole element of the once widespread style of Soviet Neo-Classicism.

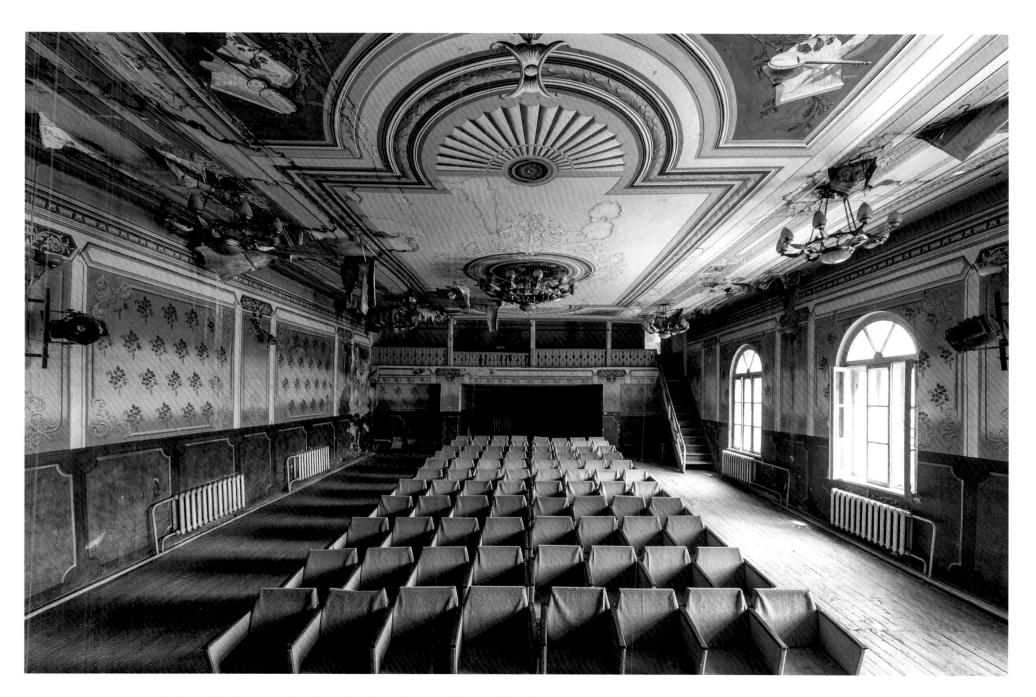

A rare example of a perfectly preserved Palace of Culture where no alterations have been carried out in an attempt to modernise it or conceal signs of dilapidation.

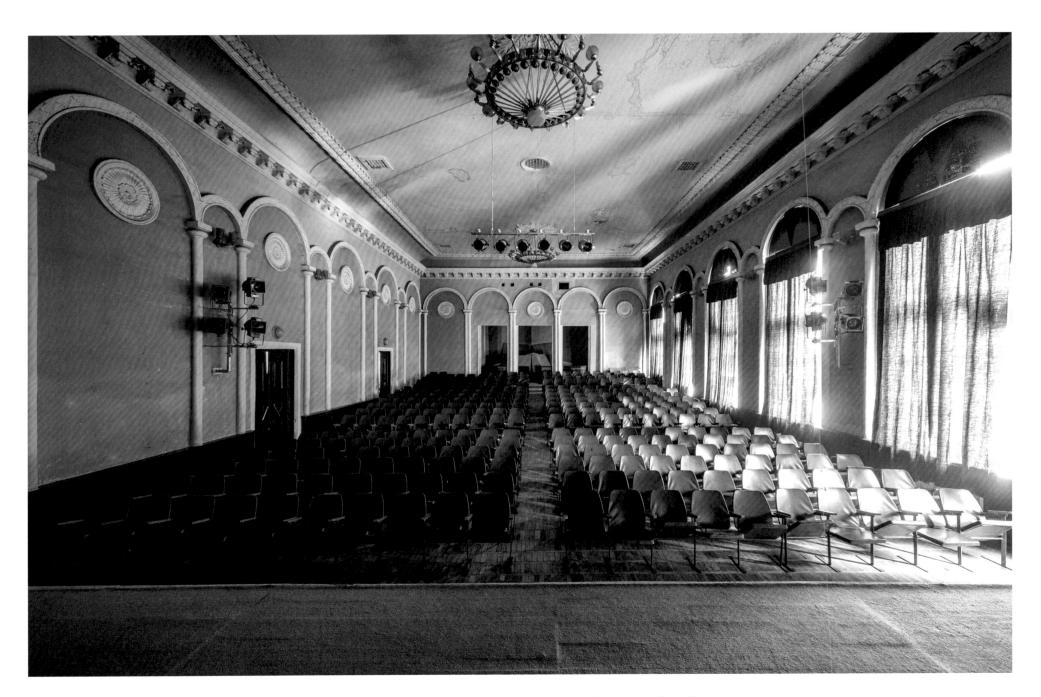

Theatre at a smelting plant in the north of the country. The plant itself is still in use.

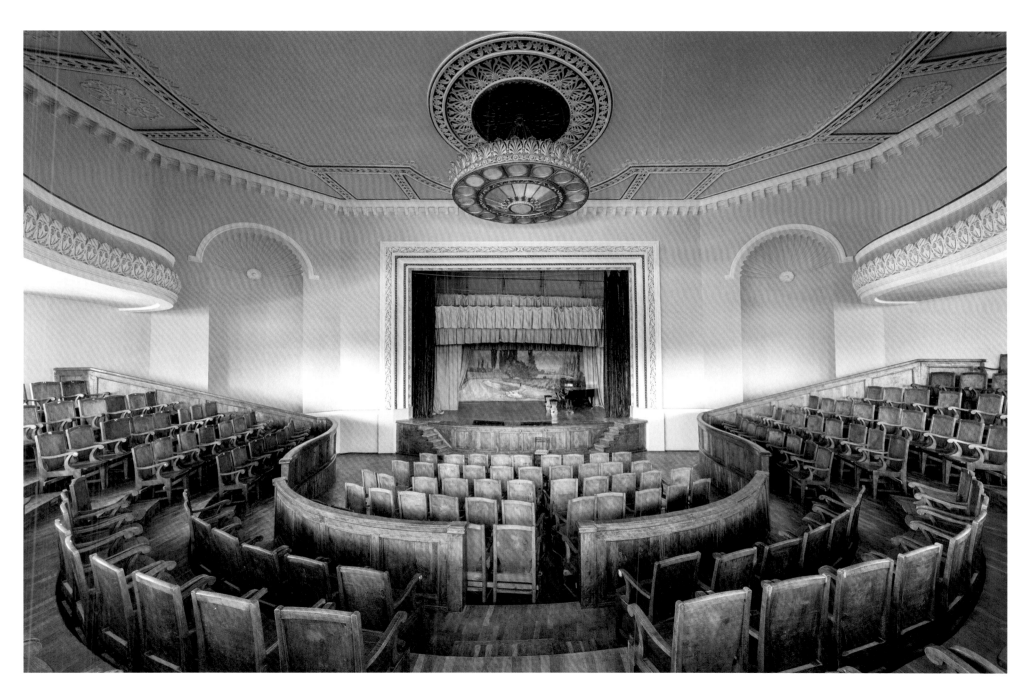

Palace of Culture in the Yerevan region that was used as an opera house. It is so well preserved that it looks like a museum piece.

# Azerbaijan

Like neighbouring Armenia, Azerbaijan's first attempt at proclaiming itself an independent republic in 1918 was quickly swept aside by Soviet influence, to be replaced in 1920 by the Azerbaijan Soviet Socialist Republic. In 1922, it became an integral part of Transcaucasia. The thorny issue of the annexation of Nagorno-Karabakh did not come to the fore again until 1988 when demonstrations in the secessionist province revived discontent, exploding into full armed conflict as soon as Azerbaijan's independence was proclaimed in 1991. Karabakh similarly sought independence, and this ended in a war in which combatants fighting on the Nagorno-Karabakh side received support from Armenia. In spite of the ceasefire signed in 1994, conflict continues to arise on a regular basis, and in 2020 the fight to gain back control of the territory resumed with ever greater intensity. Against this background of ever-present tension, an urbex photographer is rarely welcomed with open arms. Often being mistaken for a reporter, in a country where freedom of expression is severely curtailed, it is hard for a photographer to obtain the authorisation required to travel around and explore abandoned places. So sometimes the only alternative is to take advantage of a window left open in order to obtain a permanent record of an abandoned spa or a factory lying empty, silent witnesses to a story simply begging to be told.

Visits: 2015 – 2017

A small spinning mill on the brink of collapse. In other parts of the building, including the changing rooms and the canteen, production documents lie abandoned on site.

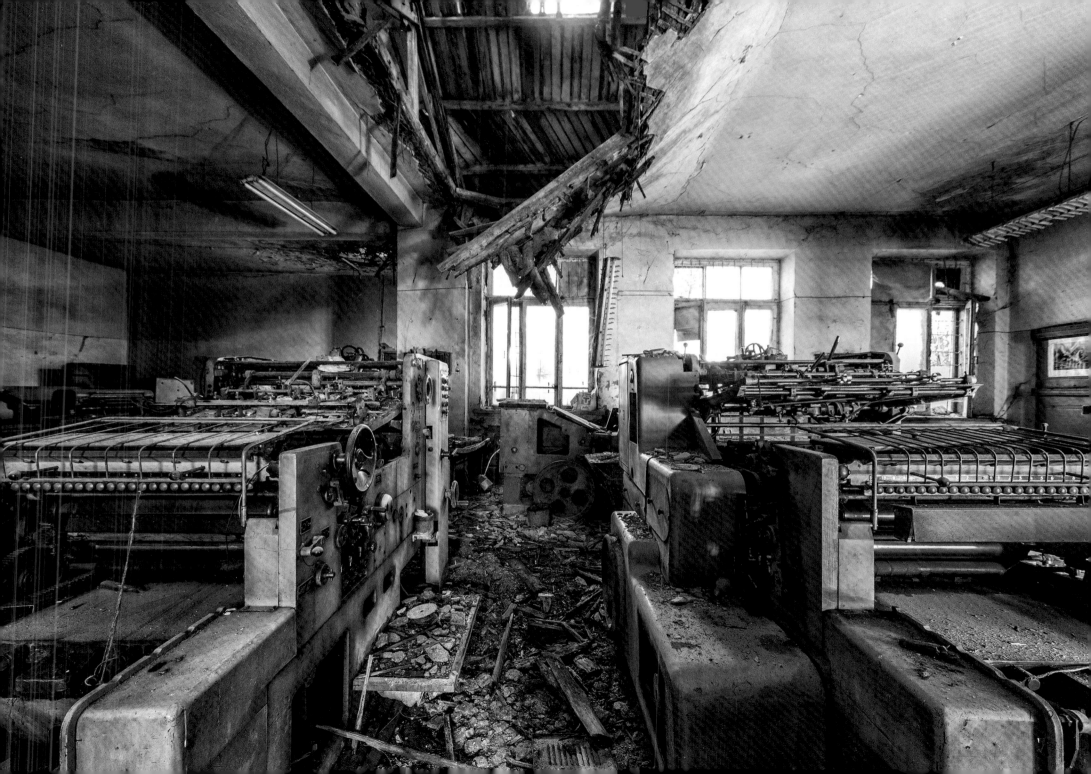

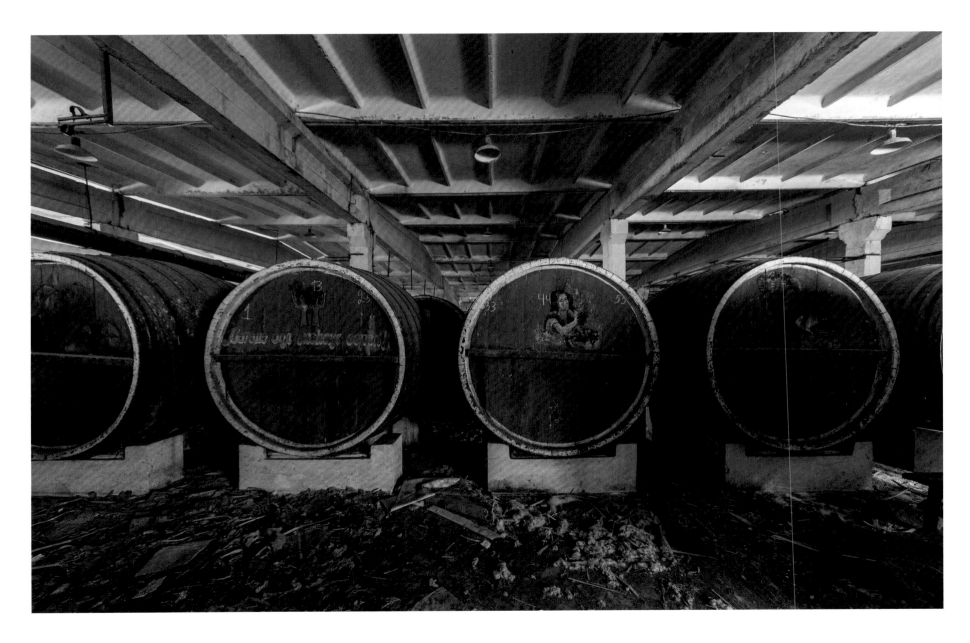

Former winery. These warehouses once contained about a hundred barrels but when the site was converted to agricultural production the cellars fell into disuse.

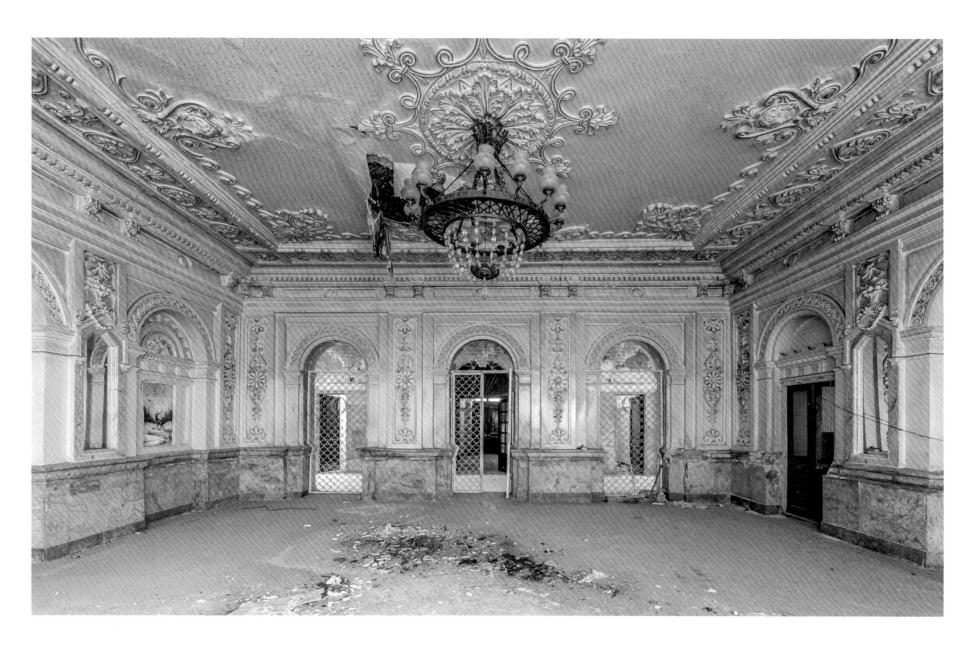

Magnificent function room in the Fantasia hamam in Baku, built in 1886. It is situated in a thriving area of the city where many of the old buildings are being demolished. Its future remains uncertain.

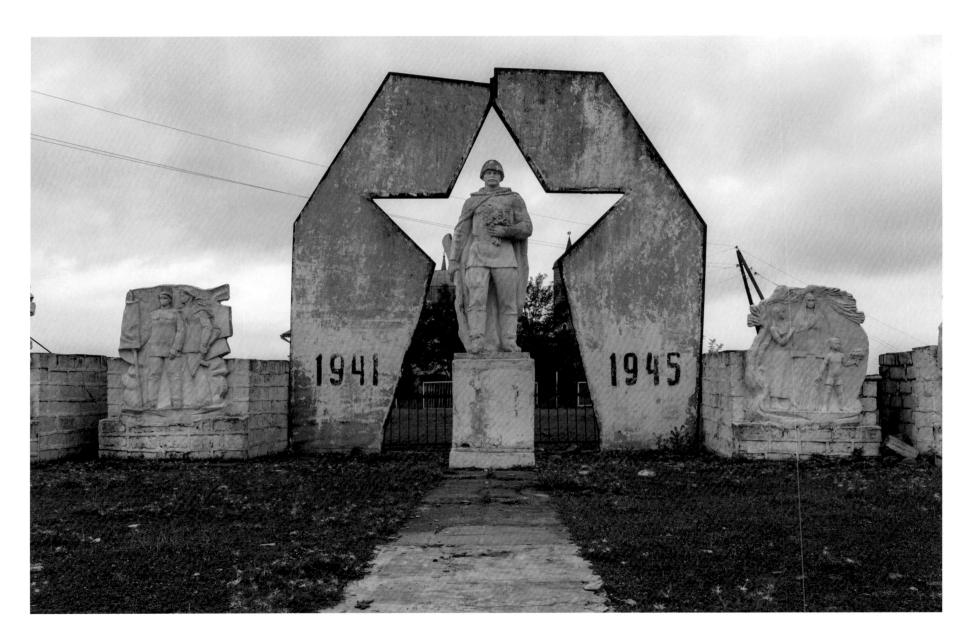

Monument commemorating heroes who died in the Great Patriotic War against Germany from 1941 to 1945. The reliefs symbolise

their courage and pride in serving the motherland.

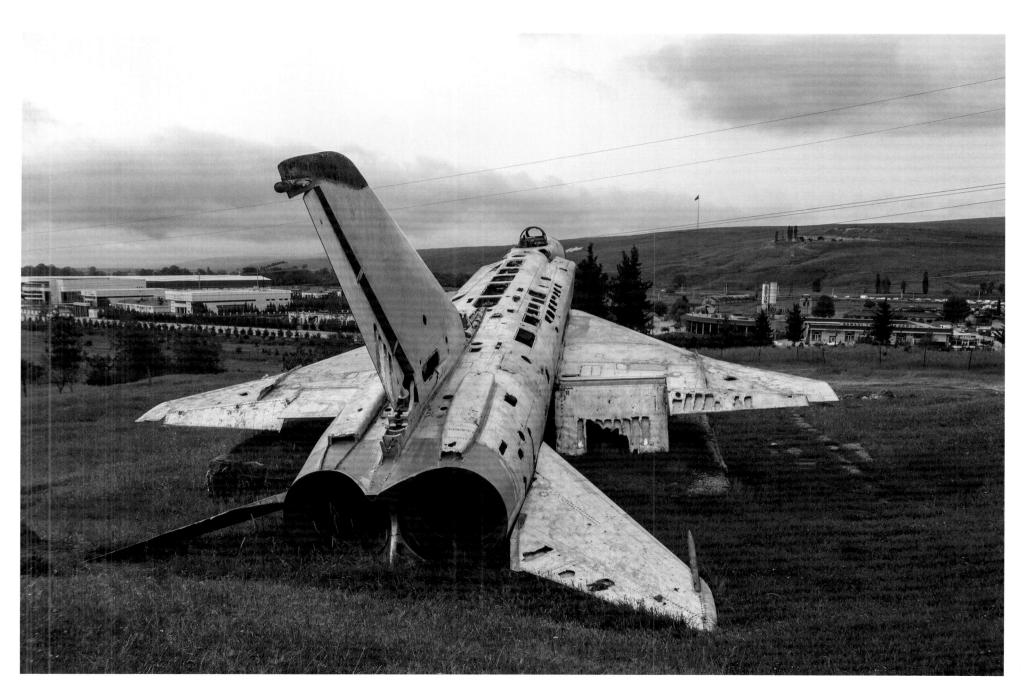

Former Mig fighter plane used during the Soviet era. Many planes of this type are displayed in the middle of roundabouts or in the vicinity of memorials.

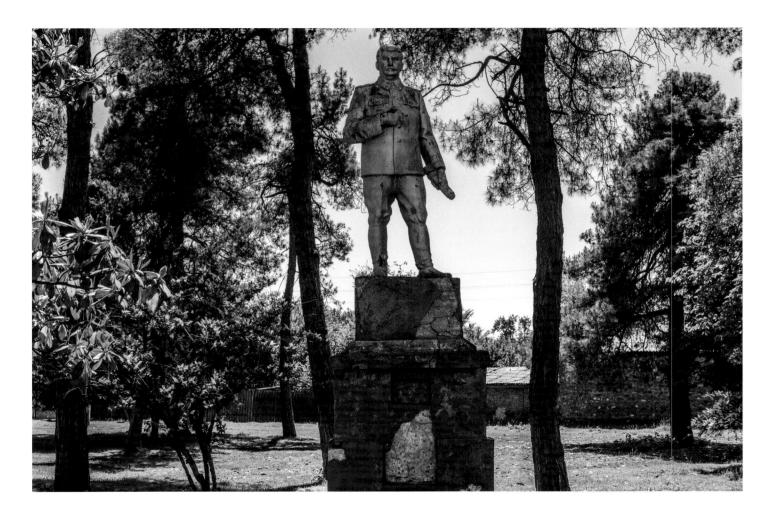

A very rare example of a statue of Stalin since most have now been destroyed in Azerbaijan as well as elsewhere. Its presence is explained by a special characteristic of the village in which it stands: the majority of the villagers are Georgians like Stalin, so this statue remains as an expression of Georgian identity, even though it is in a country whose heart is set on erasing traces of its Soviet past.

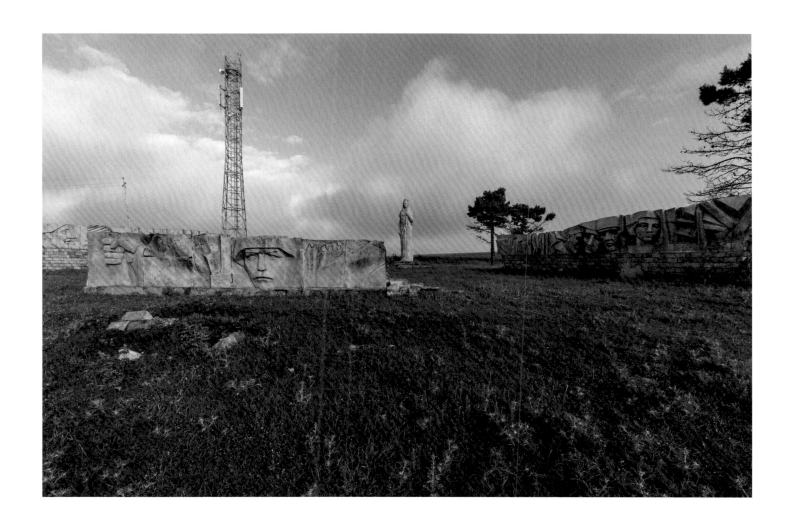

Monument to the dead, dedicated to the soldiers killed in the conflict with Nagorno-Karabakh in which the latter, supported by Armenia, fought against the central power of Azerbaijan. It was difficult to get photos of this monument due to the presence of some highly suspicious people who made their presence felt as lookouts, aggressively stalking any Armenian journalists.

165

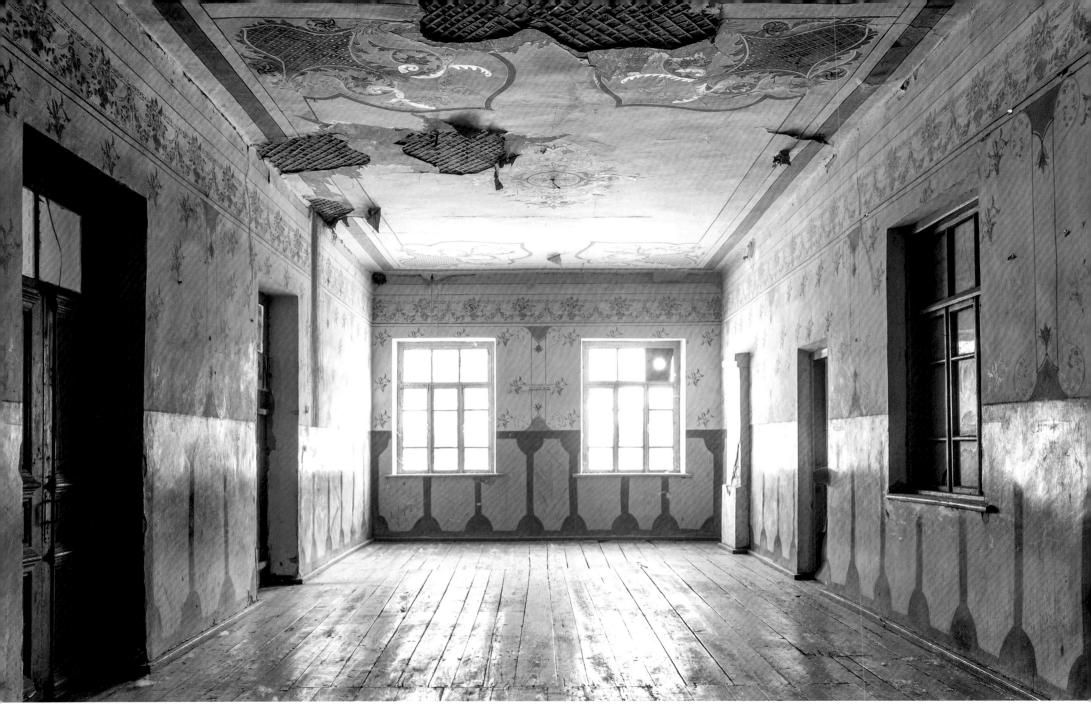

Palace of Culture in a village near the Armenian border. Tourists are not made to feel welcome there, but it is worthwhile trying to get past the icy reception in order to enjoy the painted decor which must be more than fifty years old.

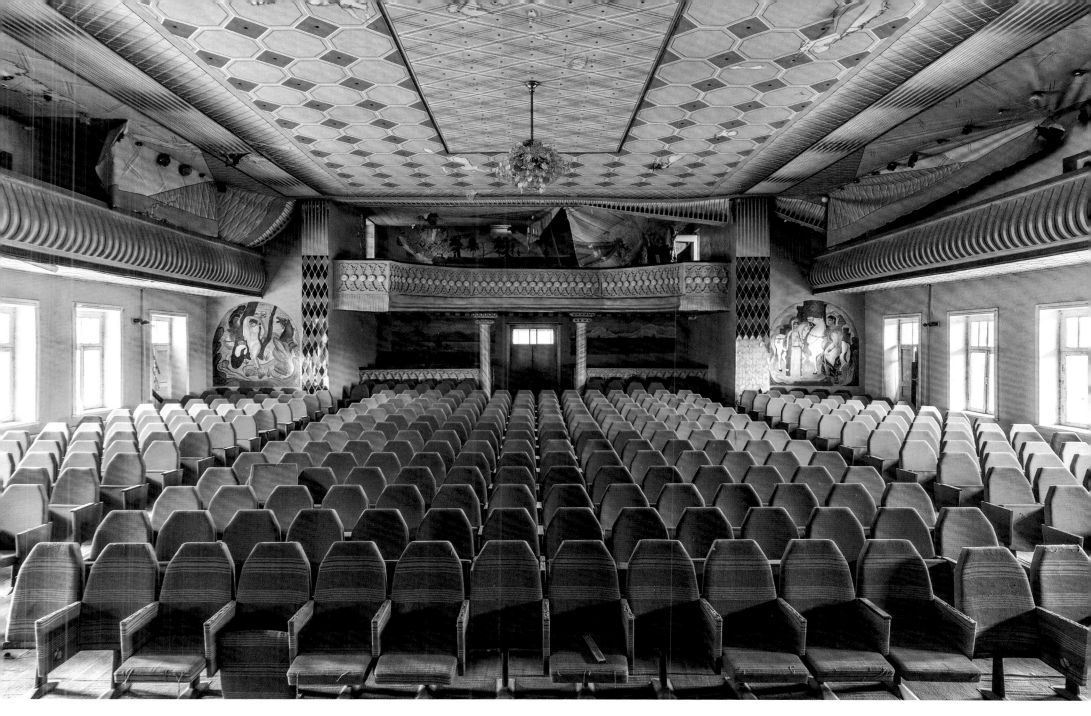

Palace of Culture in one of the last villages before the combat zone. Its excellent state of repair after lying abandoned for years, makes

it a shining example of how the Soviet Union's cultural past stoically battles against neglect.

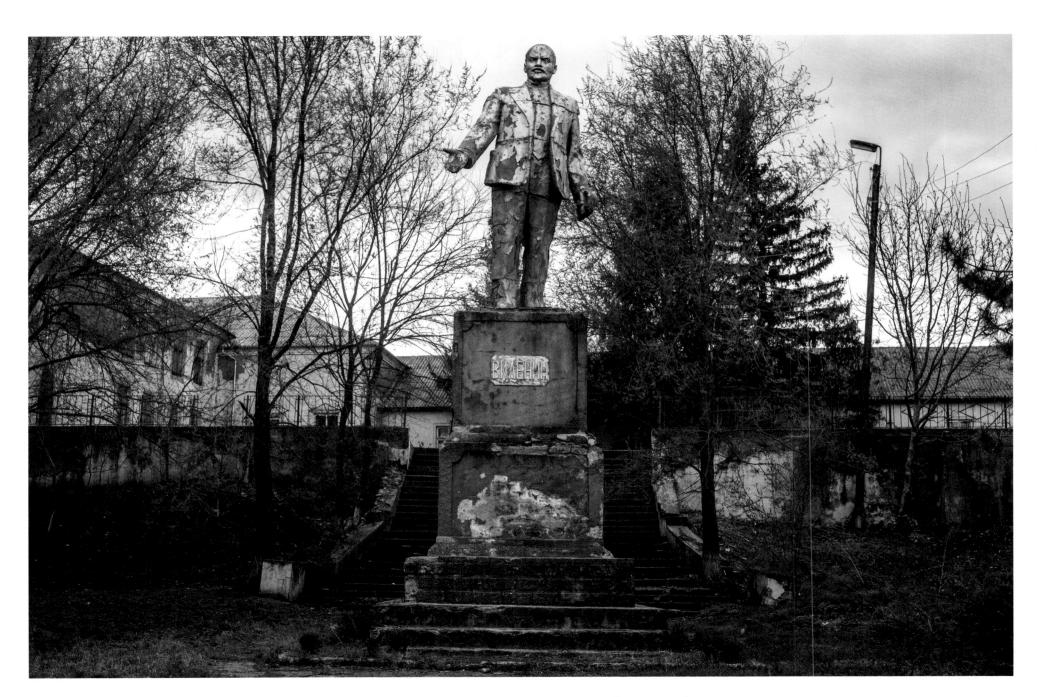

Statue of Lenin that has not been spared the ravages of time, in a village.

# AUTONOMOUS REPUBLICS
## Nagorno-Karabakh, Gagauzia, Transnistria, Nakhchivan, Abkhazia

Many areas became aligned to neighbouring countries. This was sometimes as a result of one of many conflicts, or the signing of treaties at the end of the First World War and the October Revolution, or indeed the dissolution of the USSR when its former 15 states gained their independence. The reasons for justifying these attachments range from historic affiliations and geographical borders, to regional geopolitics more generally. These territories are mostly opposed to the governments to which they are subordinated, and are fighting for independence or for association with another country.

From Abkhazia to Chechnya, from South Ossetia to Transnistria, many territories have suffered endless conflict, and the local heritage exhibits many scars which testify to this. A burnt-out mosque in Karabakh, the ruins of a parliament building in Abkhazia that still seems to echo with the sound of killings, a concert hall that has managed to escape the systematic destruction of Soviet buildings in Nakhchivan: each of these vestiges of the past tells its own part of the story of the suffering. The struggle for a separate identity pervades the very stones on the ground here, yet from time to time the sense of conflict can unexpectedly fade, giving way to a fleeting moment of serenity.

Visits: 2015 – 2016 – 2017 – 2018

# Nagorno-Karabakh

Nagorno-Karabakh is a region in Transcaucasia situated between Azerbaijan and the southern part of Armenia. During the Soviet period it was an integral part of Azerbaijan. As soon as Azerbaijan declared its independence from the USSR, the Nagorno-Karabakh region, with its mainly Armenian population, claimed autonomy from Azerbaijan. This provoked a major conflict between the two new nations, resulting in over 30,000 deaths since 1991 and the creation of very large numbers of refugees. Much of its territory, including the capital Stepanakert, remained on the Armenian side until 2020. Helped along by the pandemic and many other global issues simmering in the background, conflict flared up once again, and Azerbaijan, with the support of the Turkish army, seized back part of the region.

Ruined mosque in the city of Shusha, retaken by the Azeris in 2020. Prior to that, the building had been situated in the Armenian territory of Nagorno-Karabakh with its Orthodox Christian majority, which would explain why it has fallen into such a state of neglect.

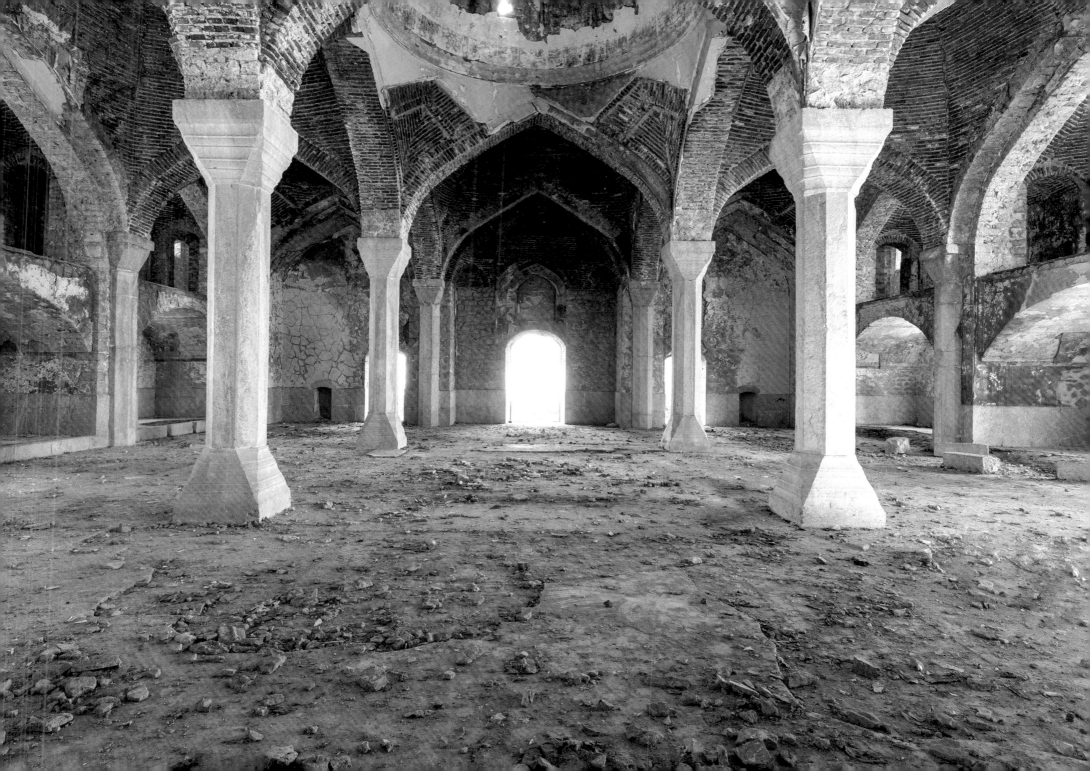

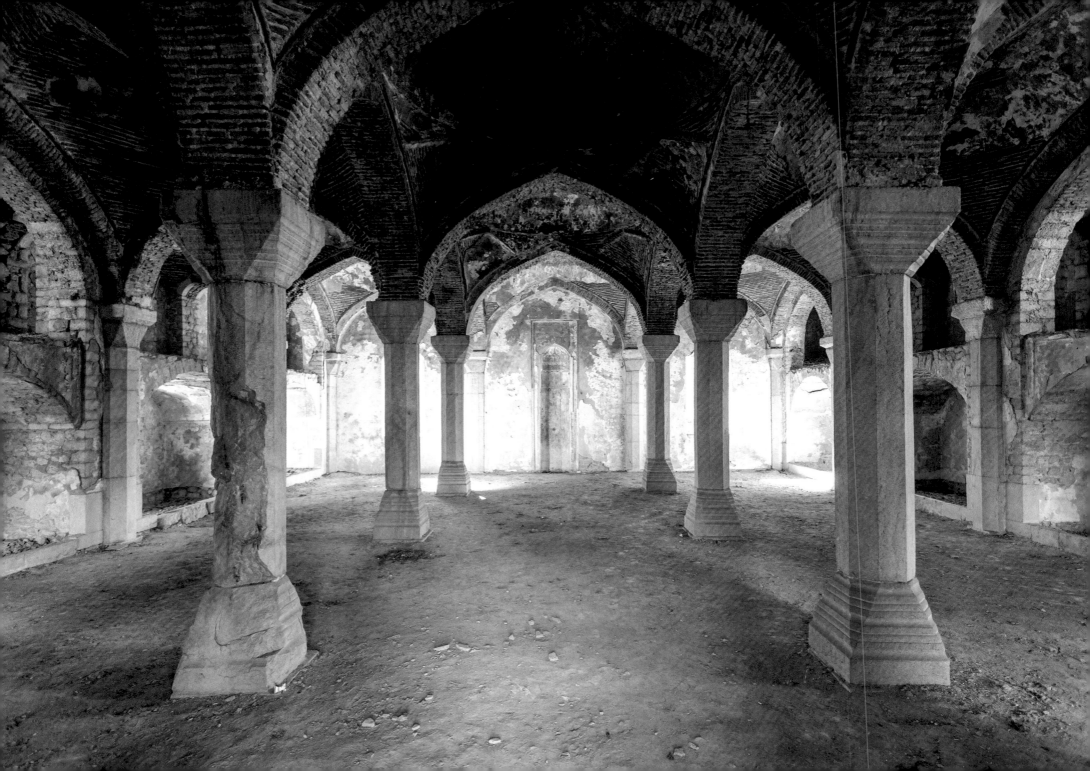

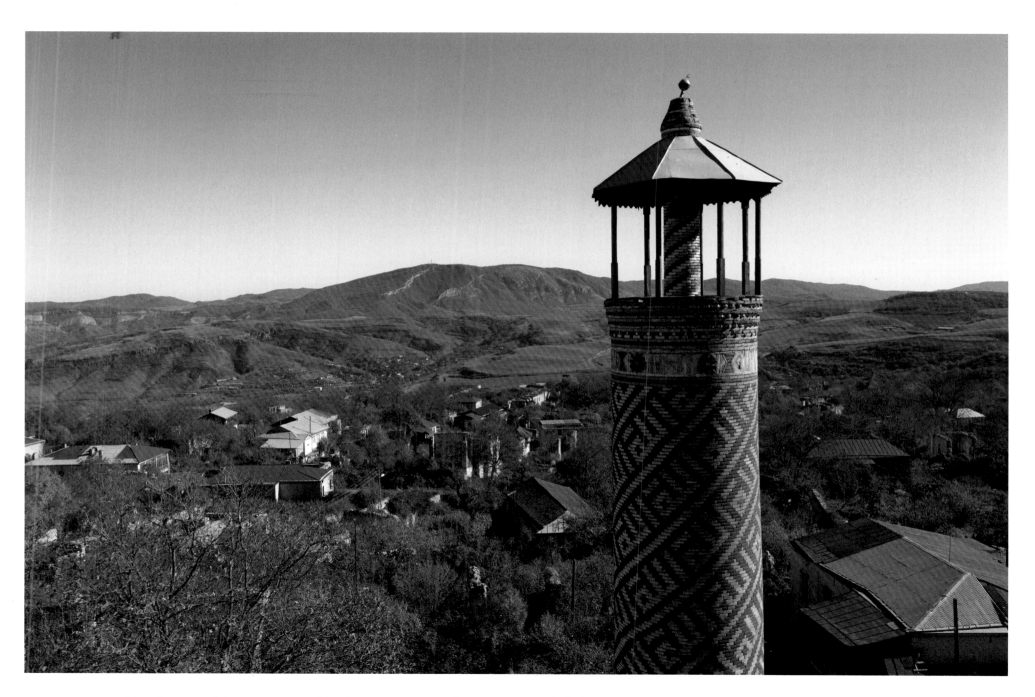

View from one of the two minarets of the Great Mosque extending over the city of Shusha, whose cathedral was destroyed by Azeri strikes in 2020.

Monument to the dead of the Second World War depicting a soldier, a sailor and an airman. The bullet damage sustained in more recent fighting emphasises with dramatic effect the *raison d'être* of this kind of memorial.

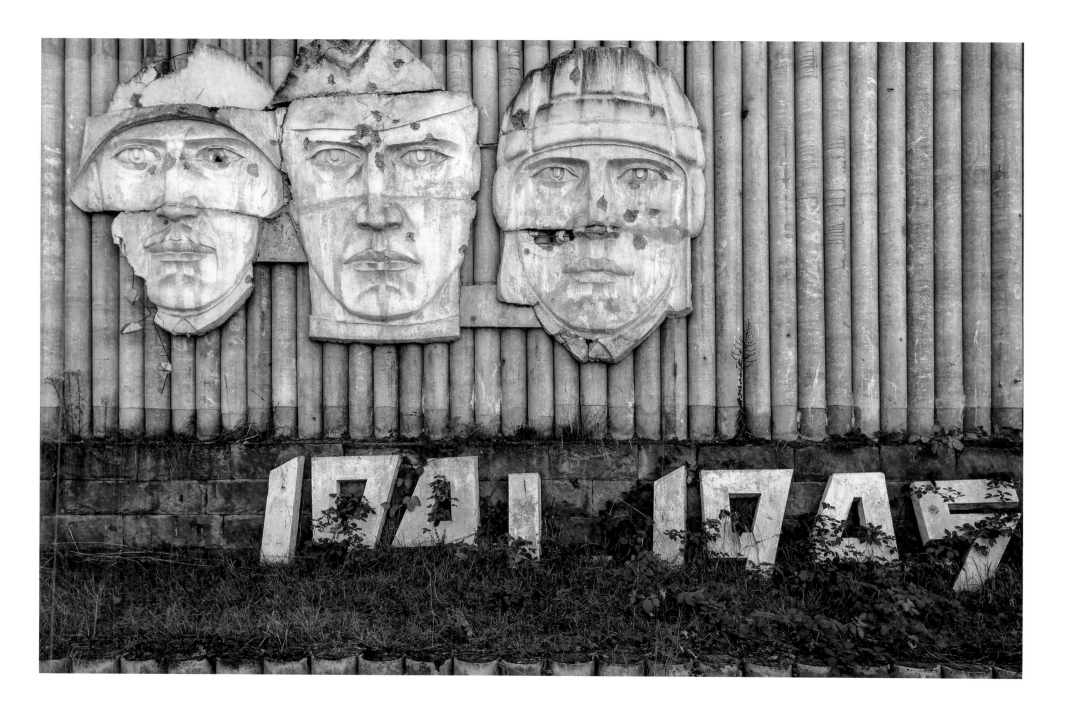

# Gagauzia

Gagauzia is a semi-autonomous republic situated within the territory of Moldova. Its mainly Turkic-speaking population originally came from Bulgaria, settling in this area in the 19th century.

Monument to the unknown soldier in a small practically deserted village.

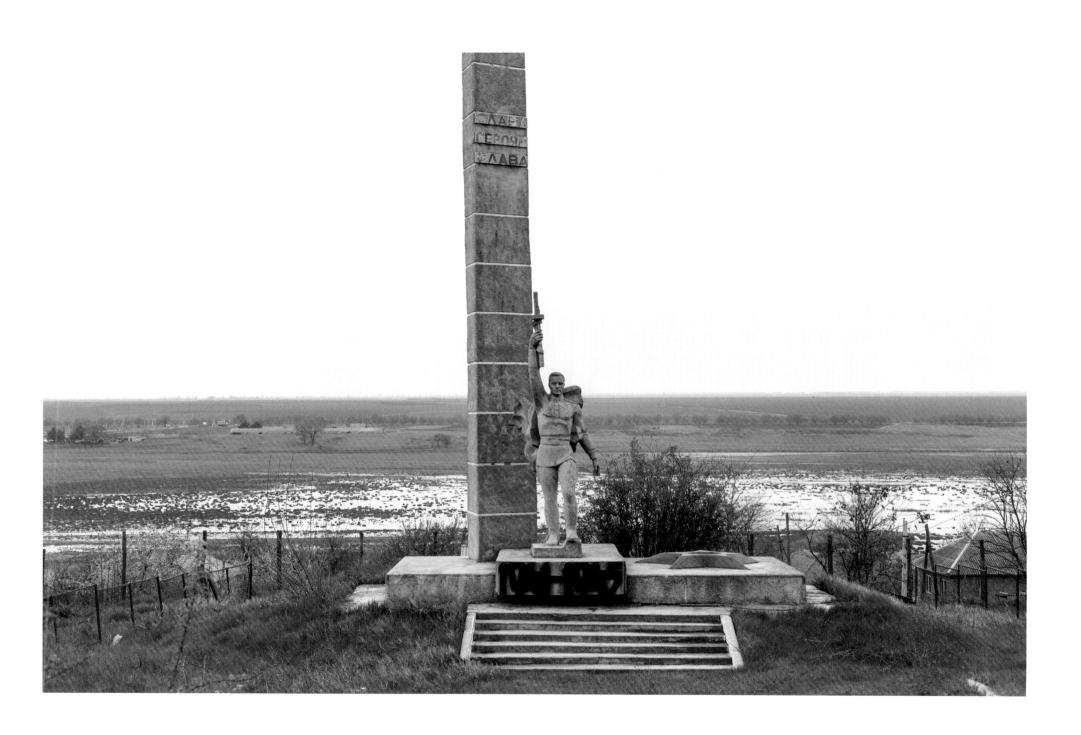

# Transnistria

The Republic of Transnistria effectively became an independent state following the disintegration of the USSR in 1991. It is not, however, recognised by the UN. Visiting this region, which clings to its Soviet past, is a bit like going back in time in search of the USSR.

This mosaic work is a particularly powerful celebration of the October Revolution, symbolised by a man throwing off his shackles and offering his heart to the motherland. It is rare to find mosaics like these in the former USSR, most such reminders of Soviet days were destroyed during one or another of the various waves of decommunisation. But in Transnistria, where nostalgia for the Soviet past remains particularly alive, it is possible to find some surviving jewels.

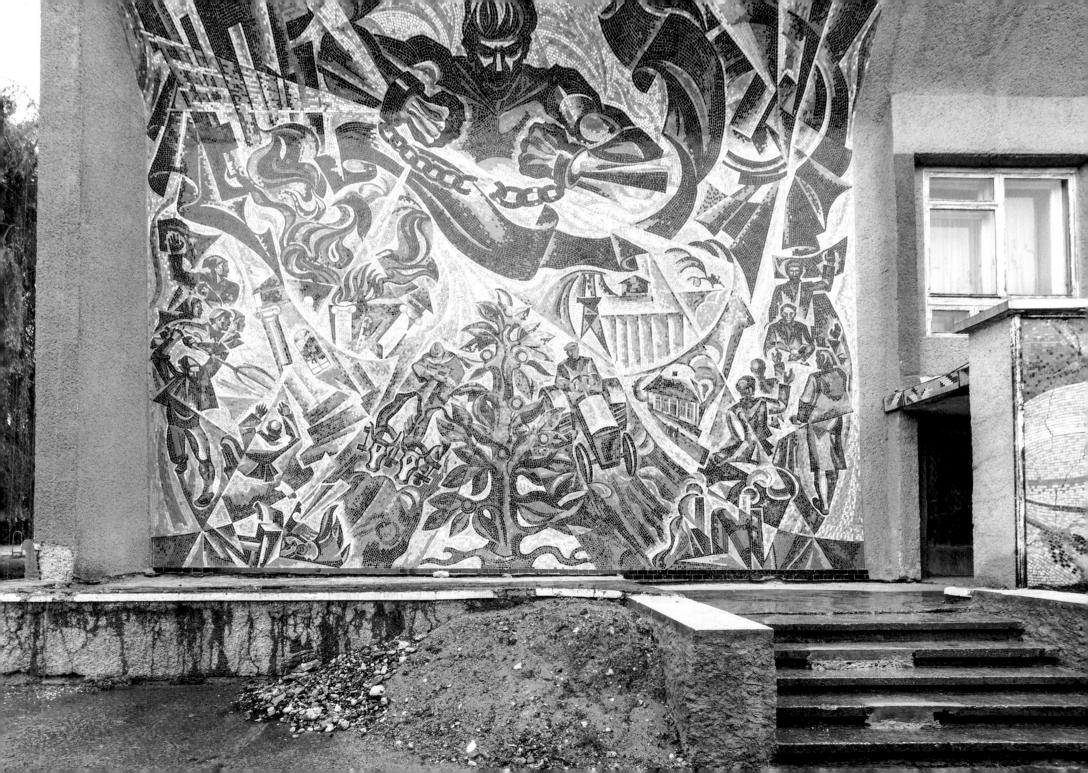

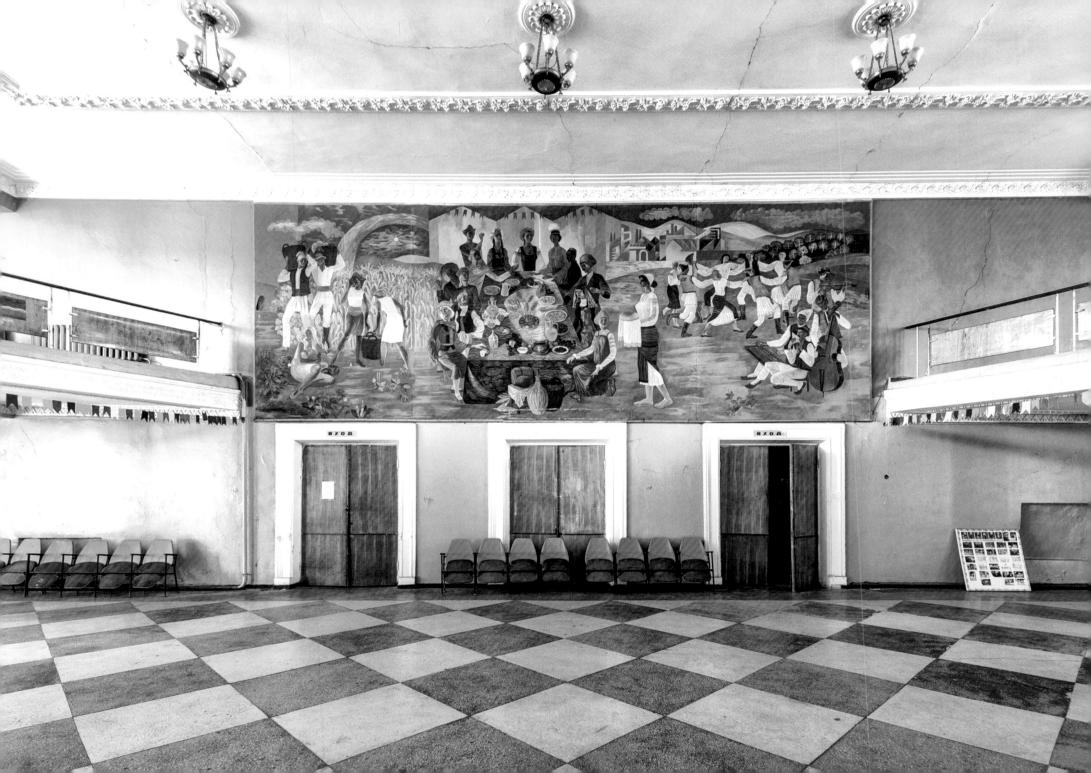

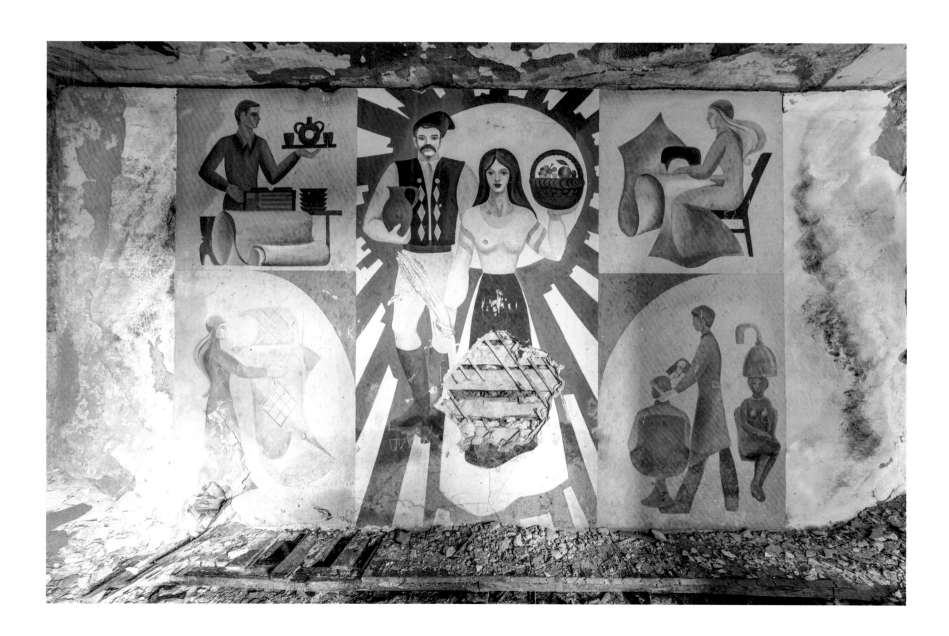

This traditional fresco is all that remains of a Palace of Culture.

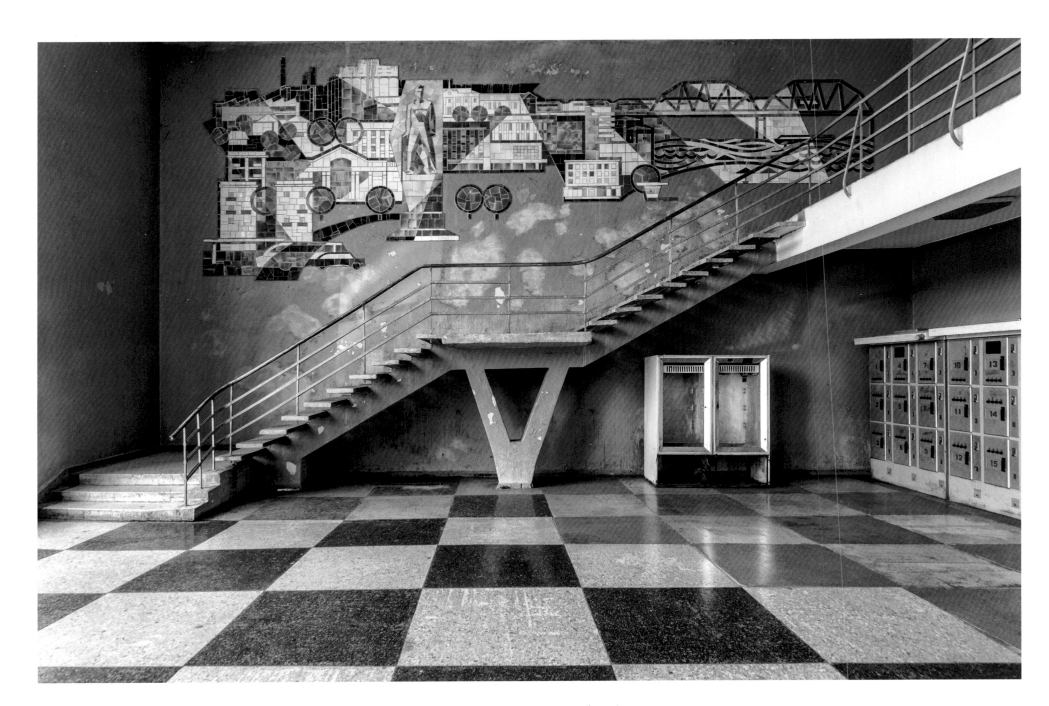

Bus station at Bender in a style dating from the 1970s.

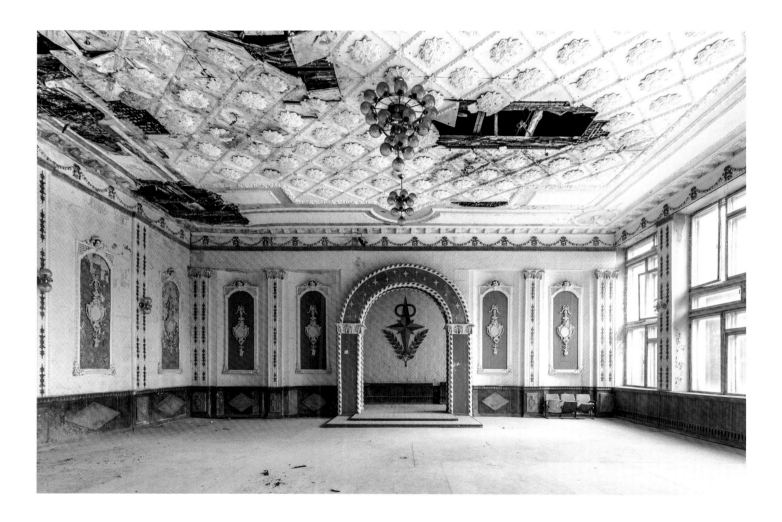

A somewhat rare example of a wedding hall. Now that religion is once again permitted following the collapse of the USSR, weddings are often celebrated in places of worship rather than in civic buildings like this one. Although the hall in this small village is in a poor state of repair, it has so far avoided demolition.

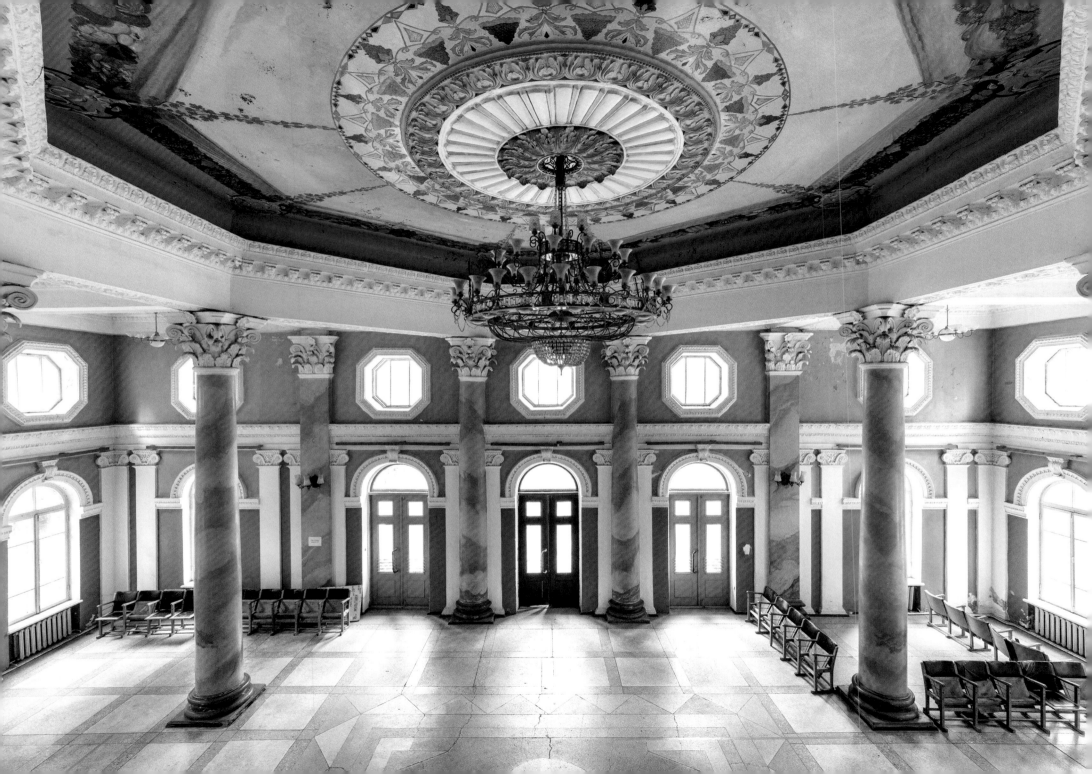

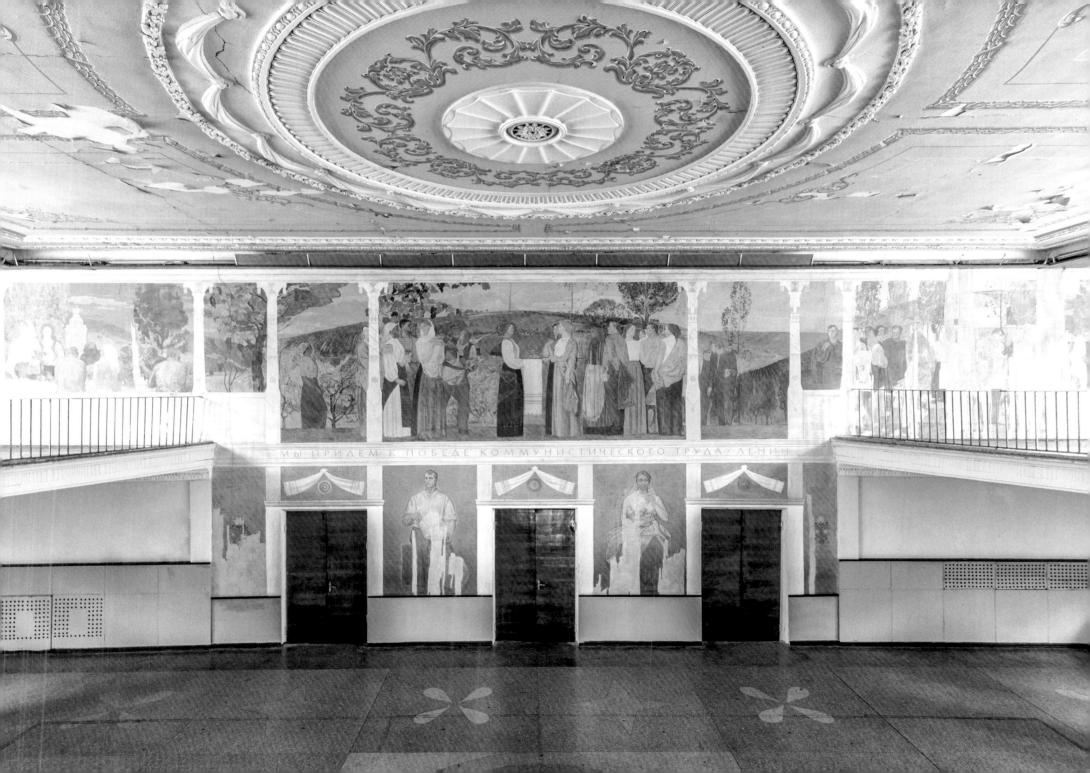

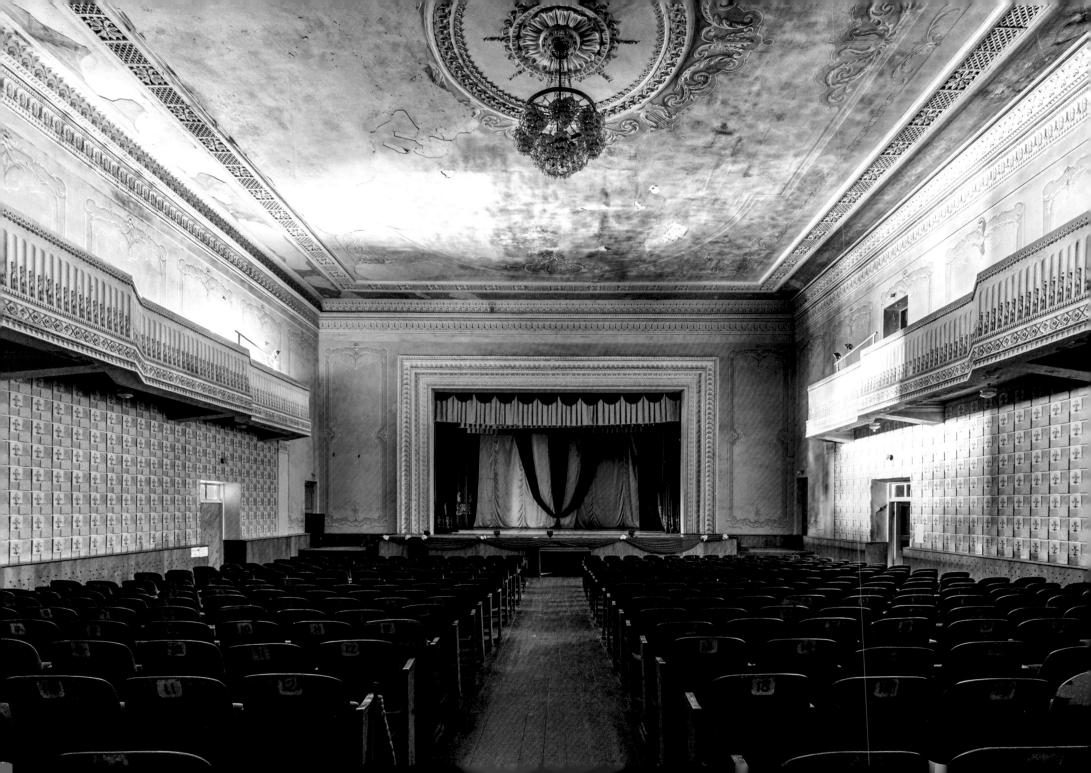

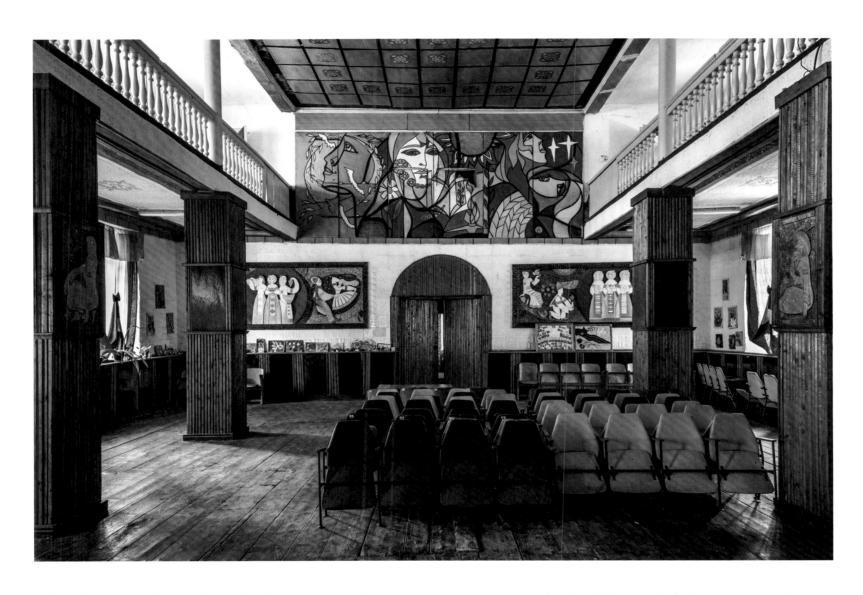

Palace of Culture in a former Lutheran church. It was converted into a civic building at the time when the USSR banned all religious practices, depriving people of German origin of their place of worship. The layout of the building reveals the ghostly outline of what was once a church.

# Nakhchivan

Nakhchivan, formerly a province of Armenia, is today one of the autonomous republics of the Caucasus, officially an autonomous part of Azerbaijan. This region, with its complex history and its proximity to Iran, Turkey, but in particular Armenia, has often been fraught with tension. This in turn has led to the destruction of many historic gems, such as the cemetery containing the largest number of khachkars (Armenian steles in the shape of a cross) in Nakhchivan, as well as churches and other sites linking this land with Armenia.

Theatre adjoining a disused hospital. It is rare to find any remains of the Soviet past in this republic which has been completely rebuilt, each new generation leaving its own mark on history.

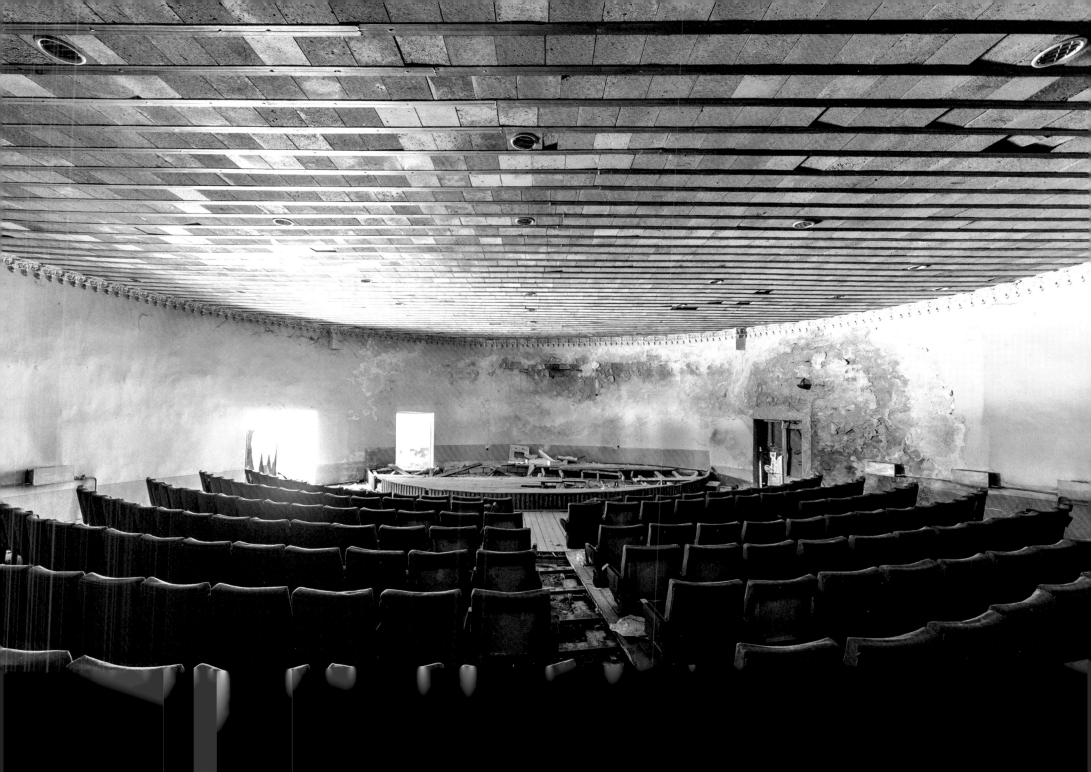

# Abkhazia

The autonomous republic of Abkhazia that stretches along the Black Sea coast between Russia and Georgia, claimed independence from the latter in 1992. Officially it is still considered part of Georgia. The push for independence resulted in extremely violent armed conflict in 1992-1993 in which 30,000 lost their lives and 300,000 were displaced..

The former parliament building of the Republic of Abkhazia in Sukhumi was destroyed by fire during the civil war, resulting in the deaths of several hundreds of people. Today this building is a shell of its former self and is used as a public toilet.

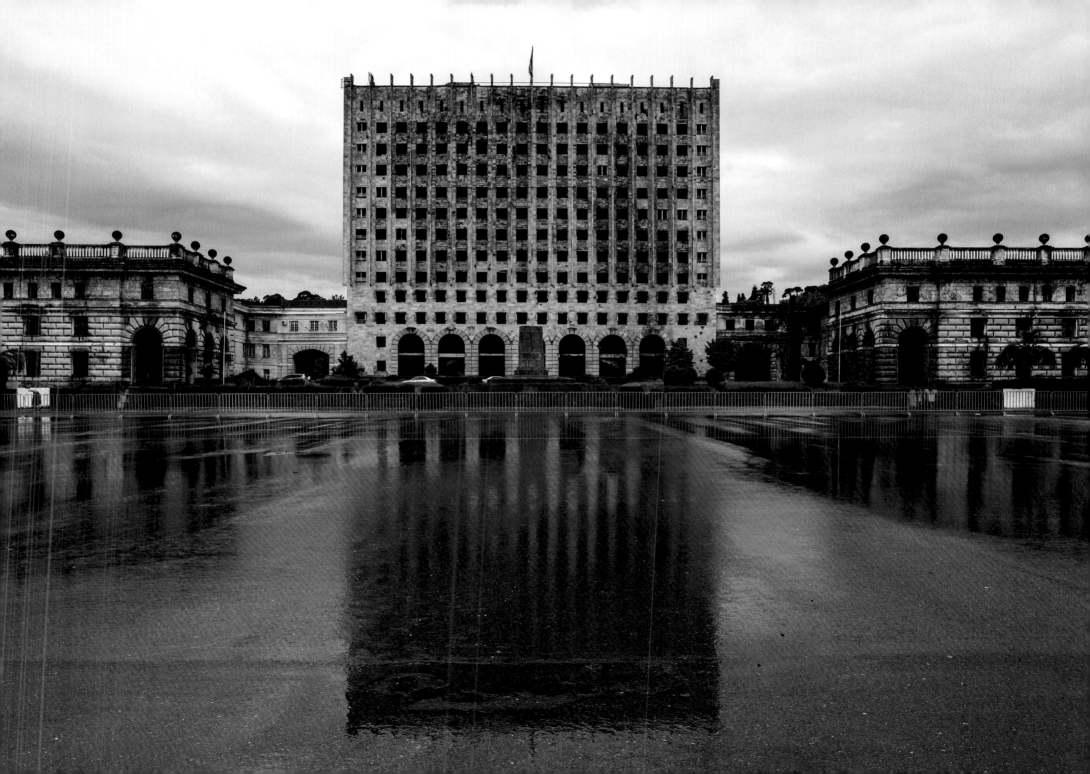

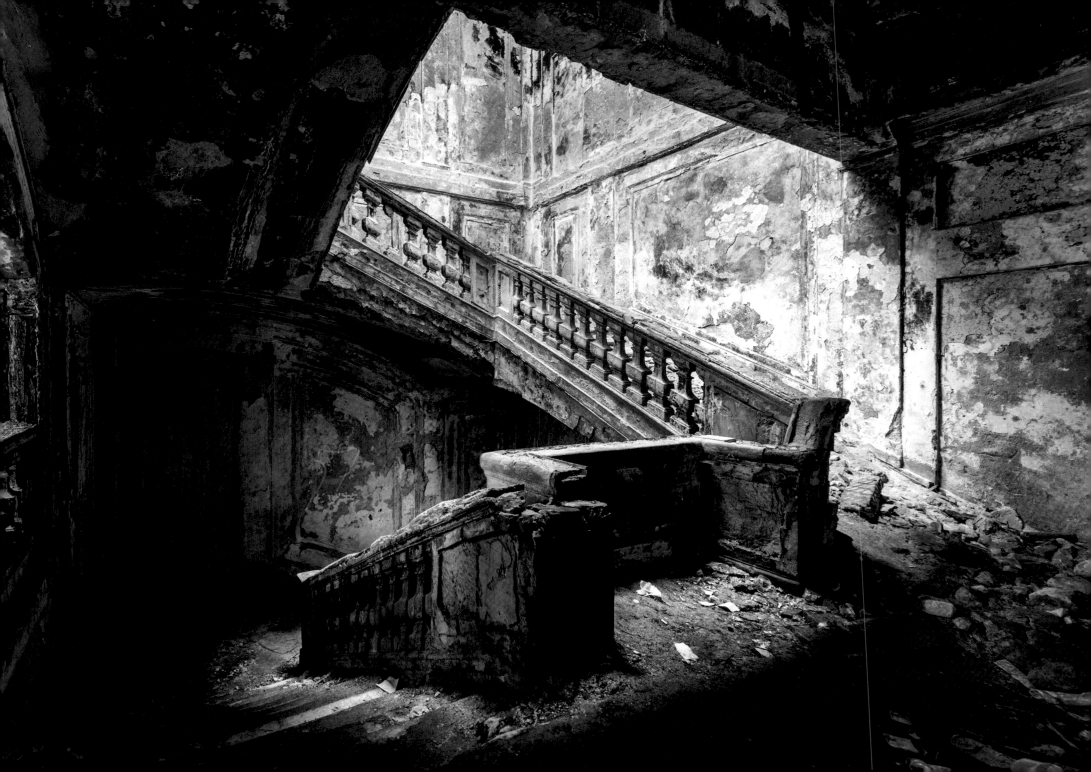

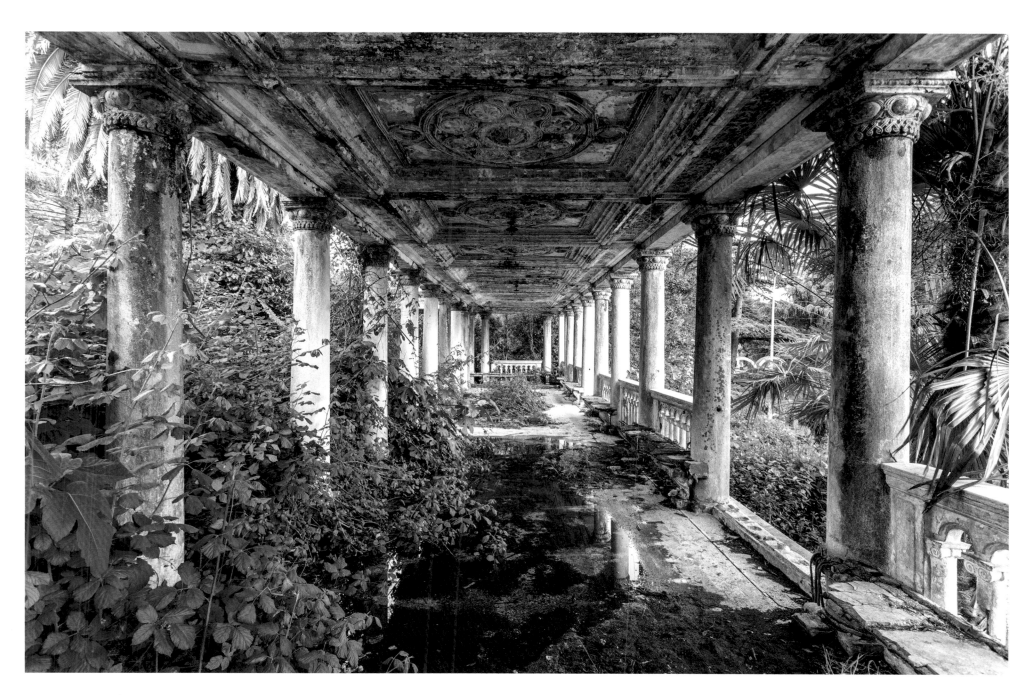

One of Abkhazia's many abandoned railway stations, here in Gagra. The Sochi (Russia)-Tbilisi (Georgia) line that ran through here has never been brought back into service.

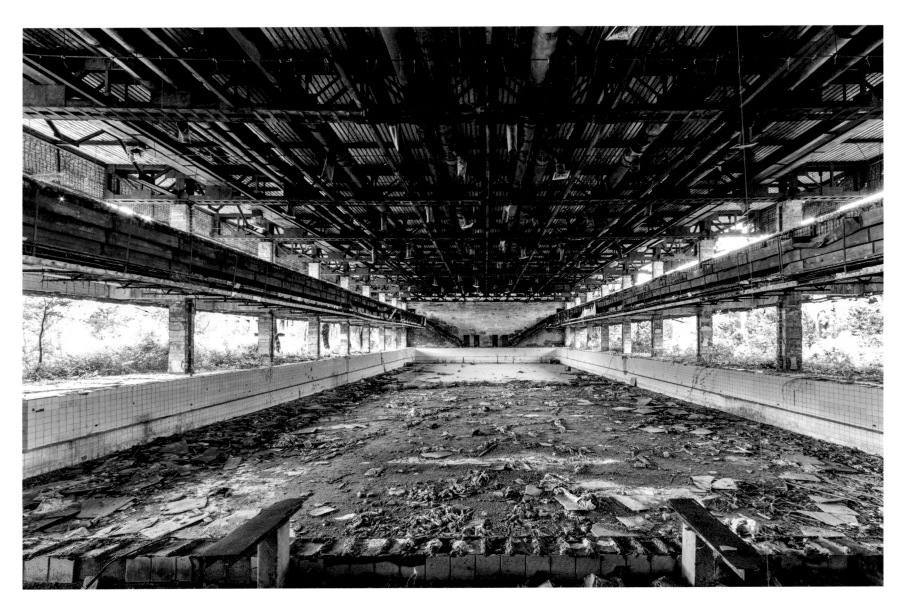

Olympic sports complex used as a training space for athletes from the Soviet Union in the 1970s and 1980s. It contains a large swimming pool, a theatre and a hotel.

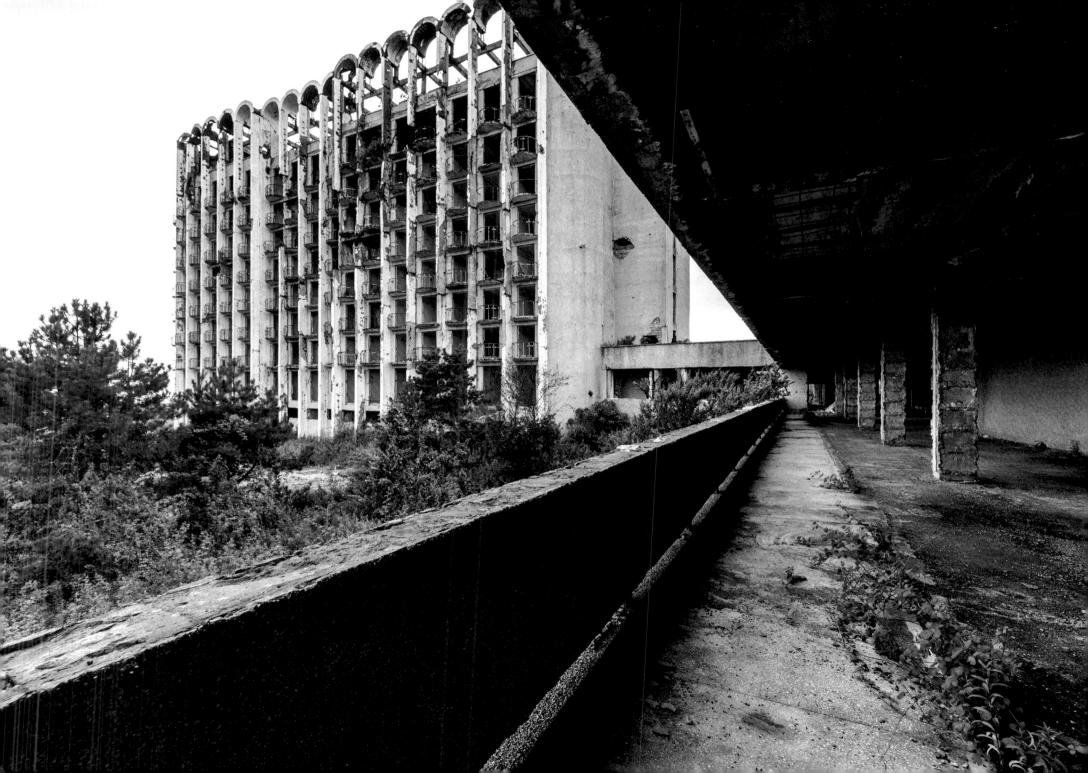

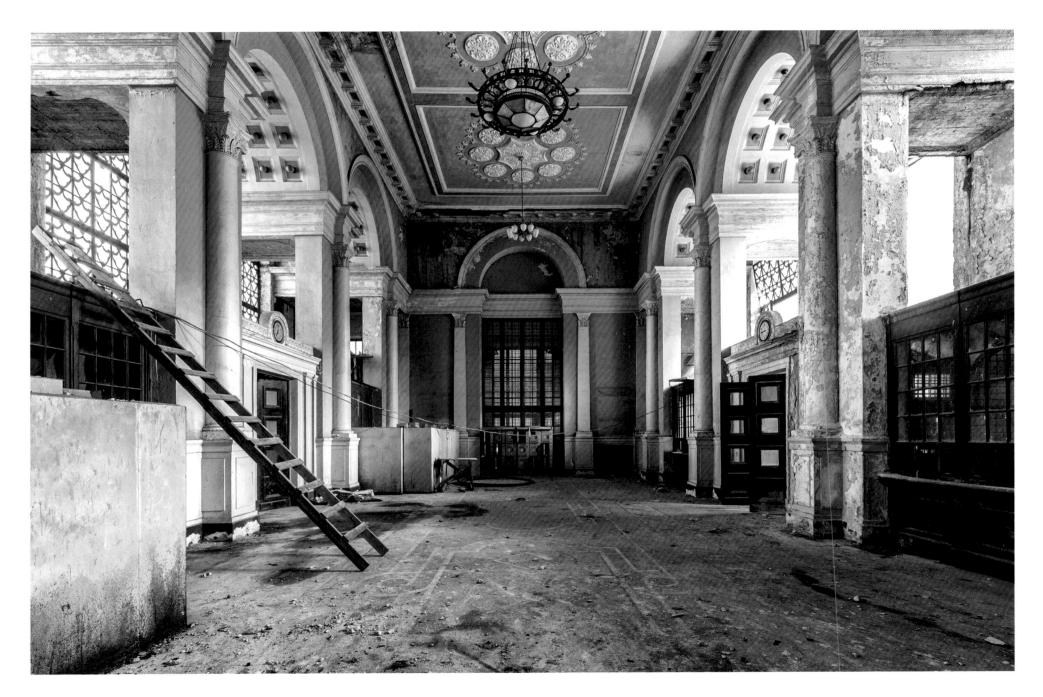

Hall in a second station in Gagra, a reminder of the Stalin years.

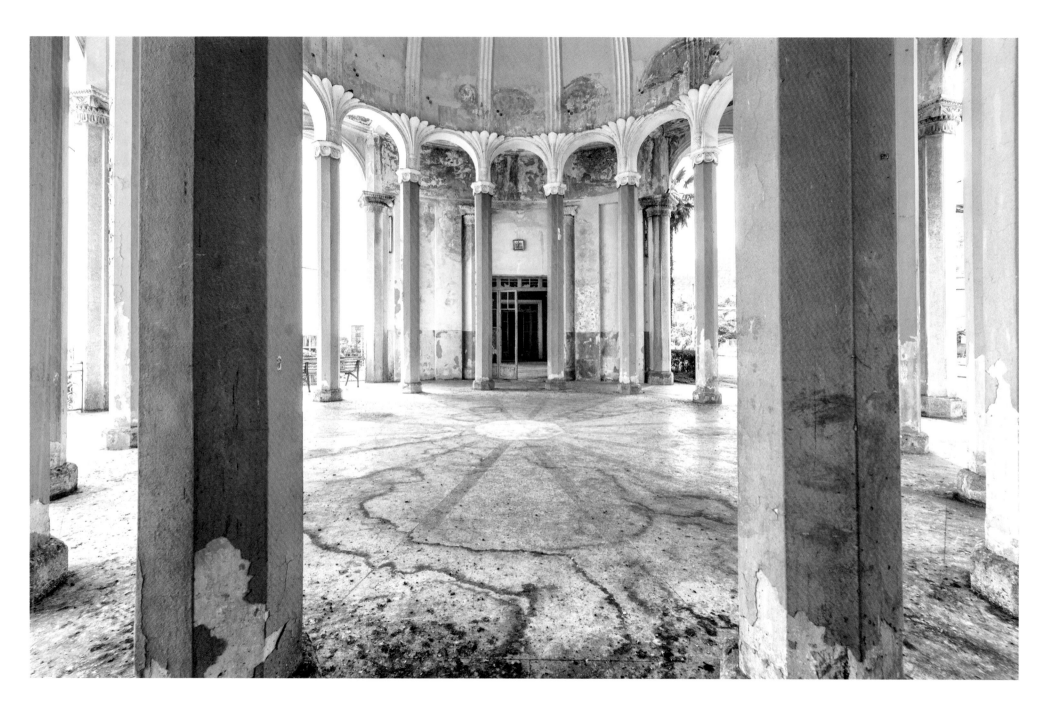

Station at New Athos, a spa town that boasts a magnificent Orthodox monastery.

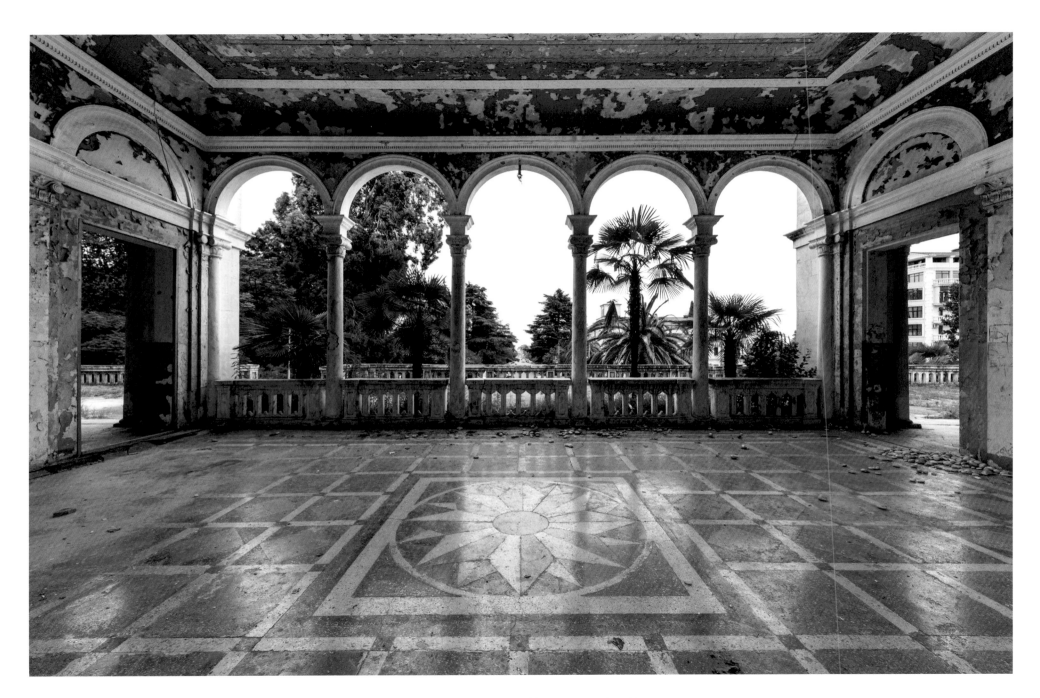

One of the stations in the Abkhazian capital, Sukhumi.

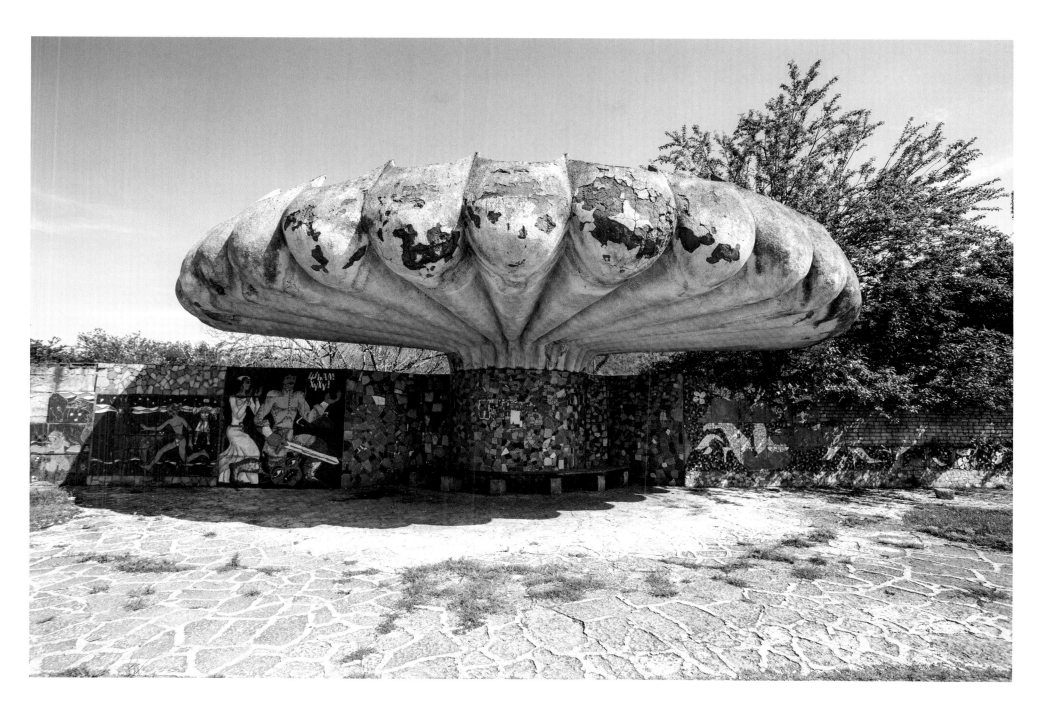

Bus shelter of remarkable proportions.

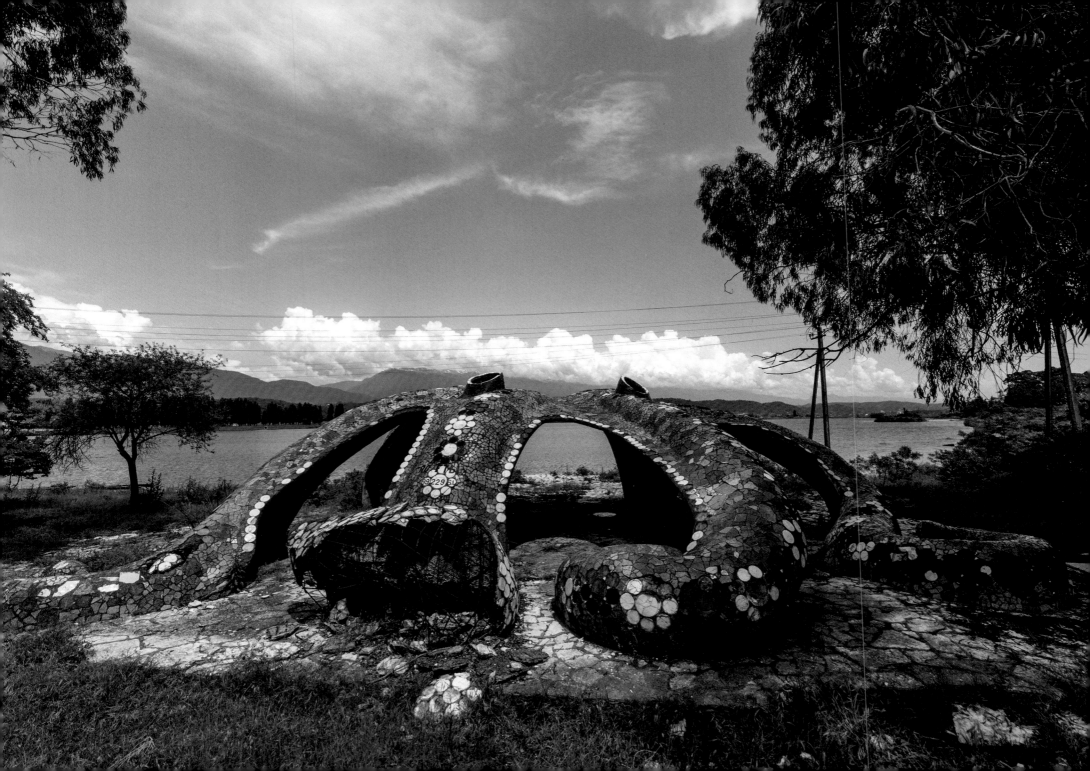

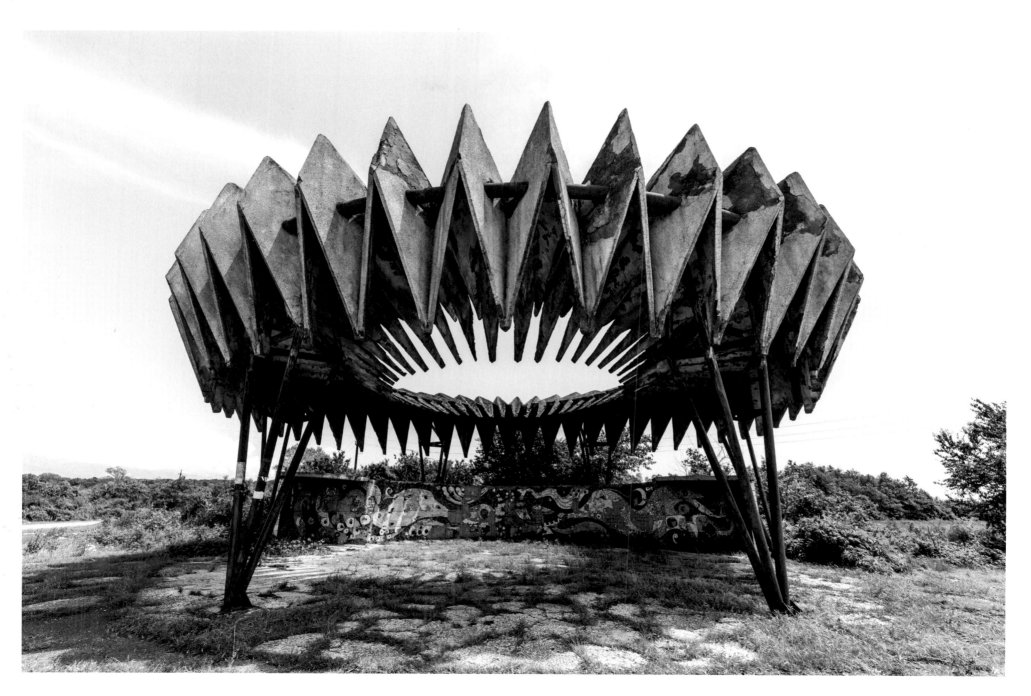

An eye-catching bus stop in the Brutalist style. Nowadays it is only the cows hanging out nearby that derive any sort of excitement from it.

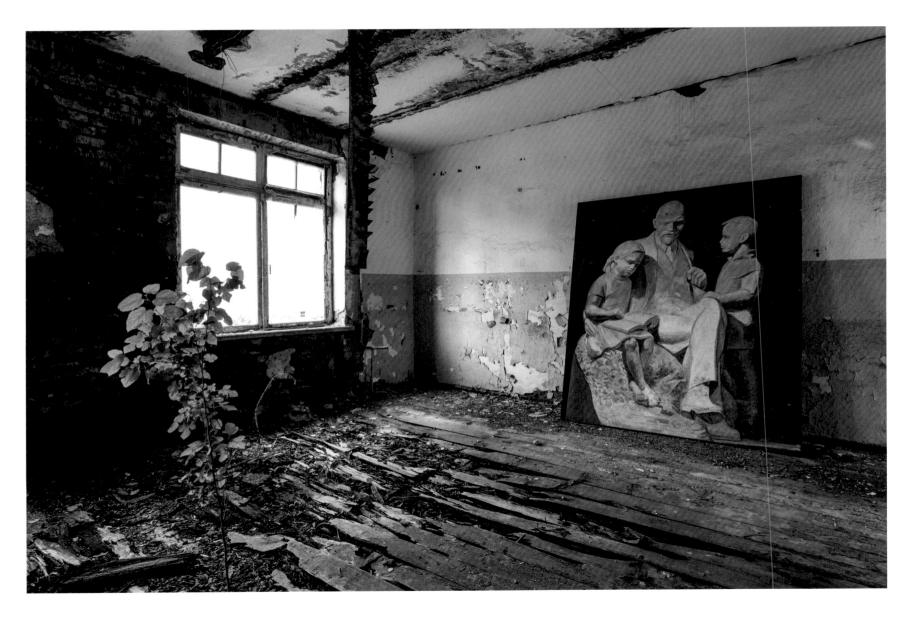

The ruined remains of a school, like many others in the region. Schools for Georgians were for the most part ransacked. All that remains here is an idealised picture of Lenin delivering lessons to school children.

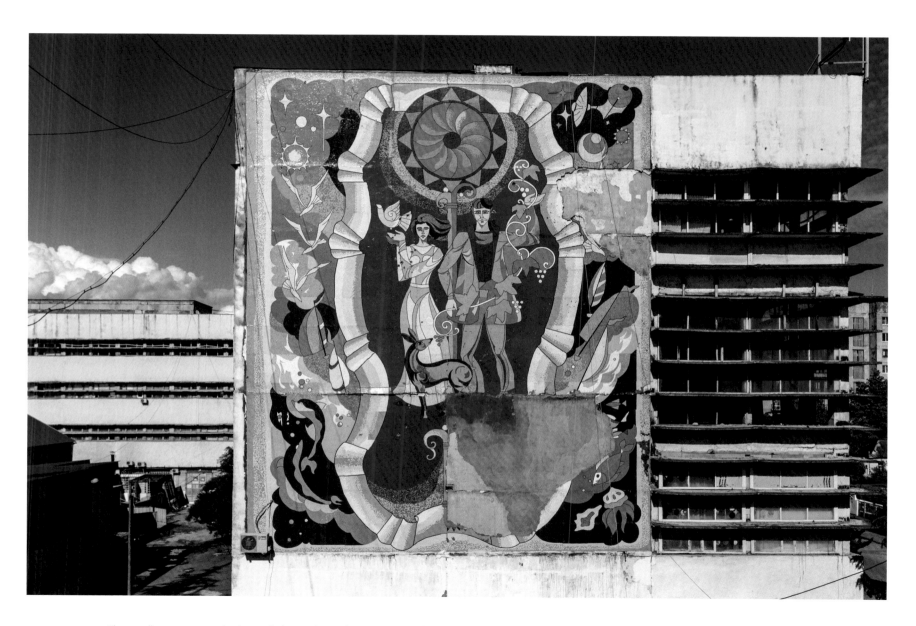

This wall painting symbolises all the sadness that armed conflicts bring. The woman releasing the dove of peace is riddled with bullet holes, no doubt fired from the floor from which this photo was taken.

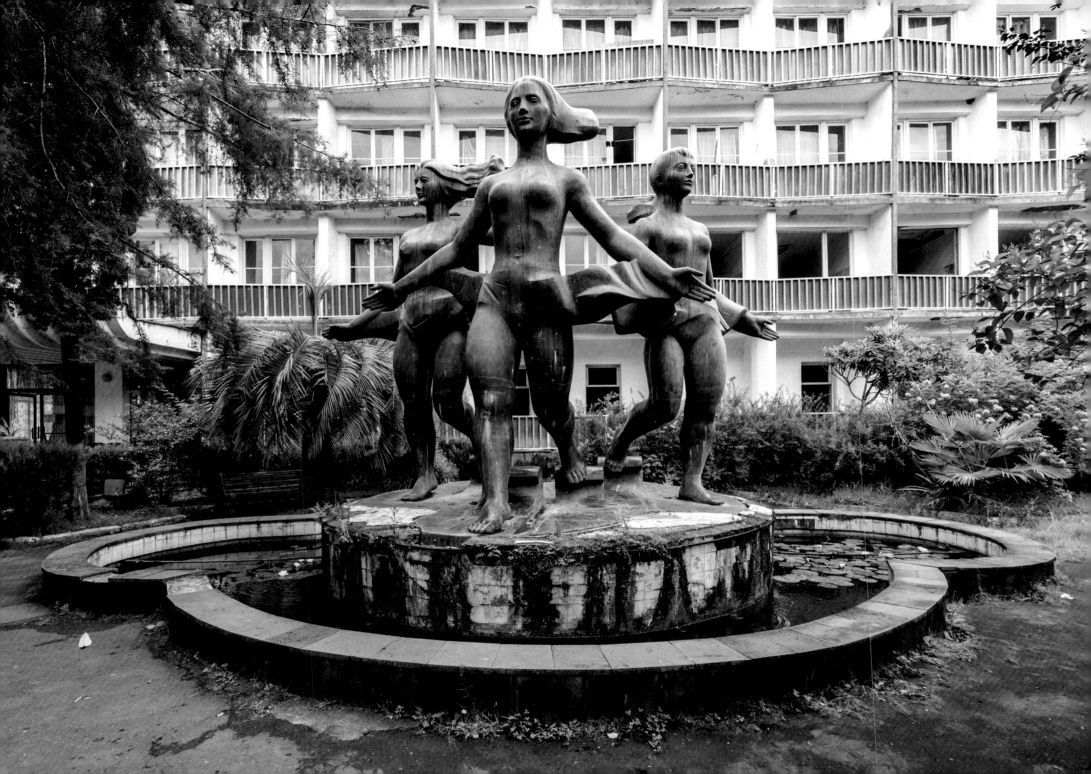

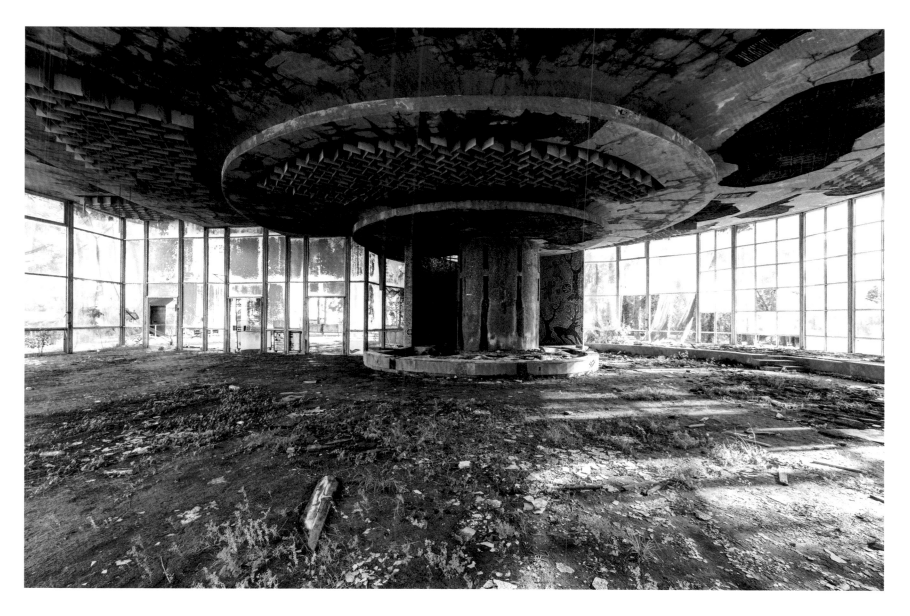

Brutalist style bar and restaurant with a night club in Pitsunda, a seaside resort enjoying a hint of an economic upturn thanks to an influx of Russian tourists.

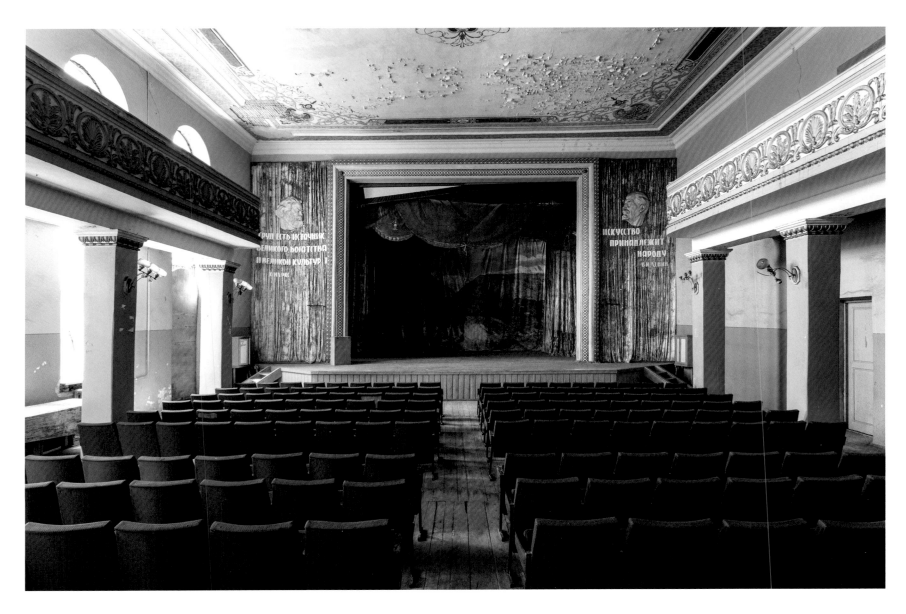

All the propaganda has survived intact in this Palace of Culture: Karl Marx to the left of the stage with his quotation "Work is the source of wealth and all culture", and Lenin on the right with "Art belongs to the people".

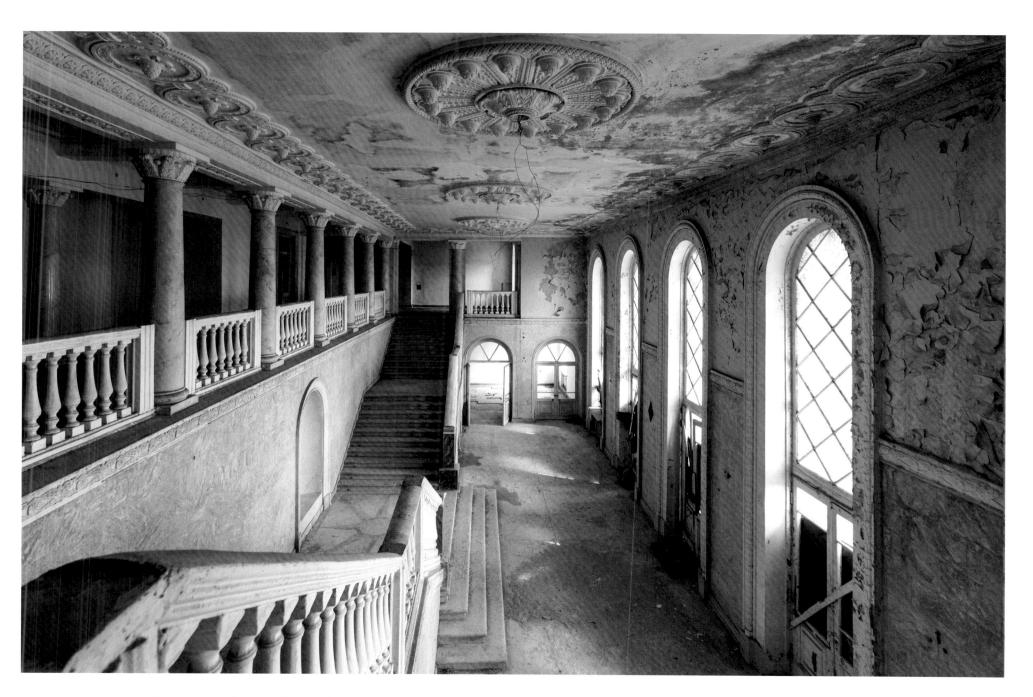

Sanatorium in Gagra, whose idyllic surroundings and hot-water springs acted as a magnet for the many visitors arriving by pleasure boat.

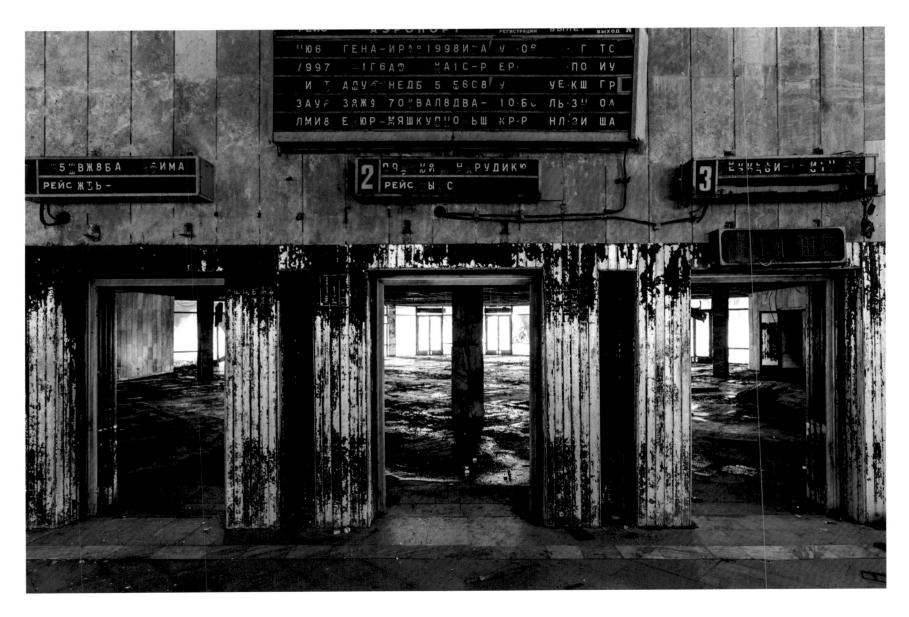

Sukhumi Airport was built in the 1950s. It has lain empty since 1993, having played its role in the armed conflict. The independence forces here shot down no fewer than four Tupolev passenger planes resulting in 150 deaths. These included civilians travelling in a plane hit by mortar fire while in full flight.

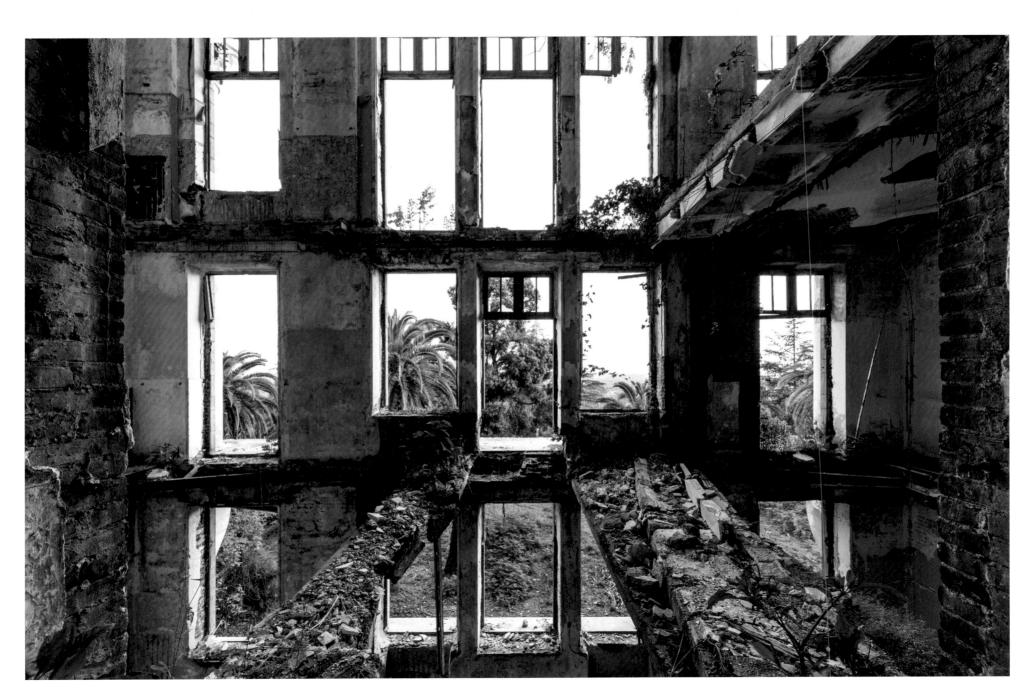

This view from an upper floor in a ruined sanatorium came as a pleasant surprise.

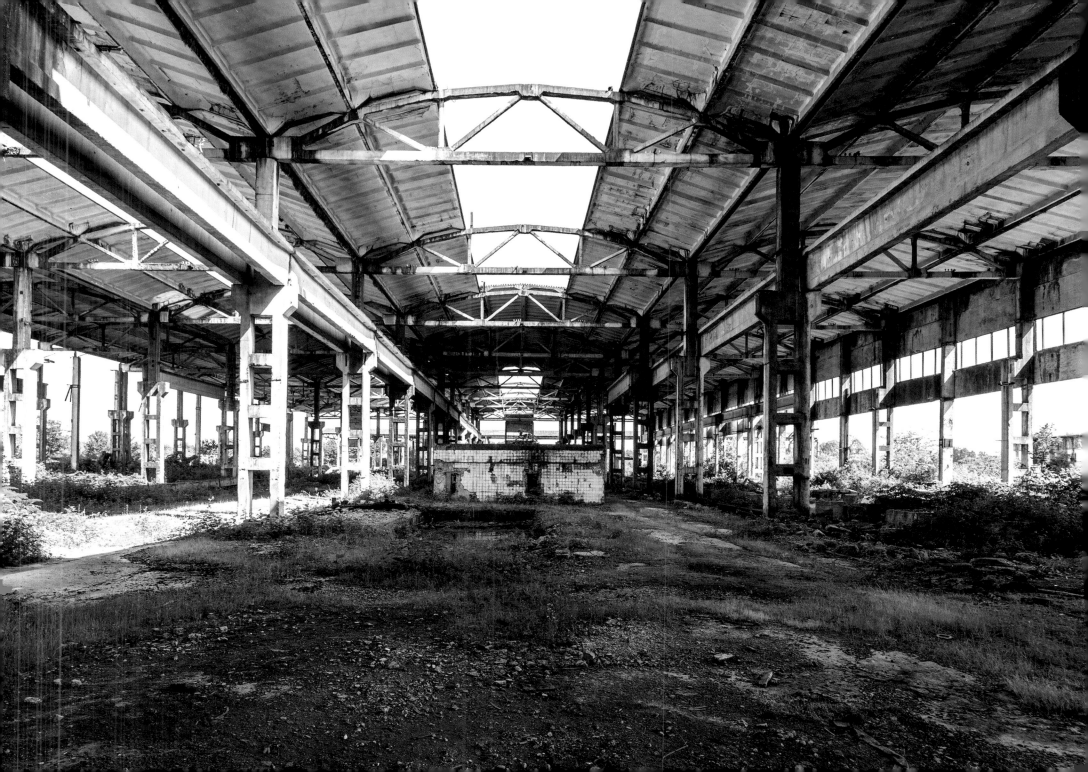

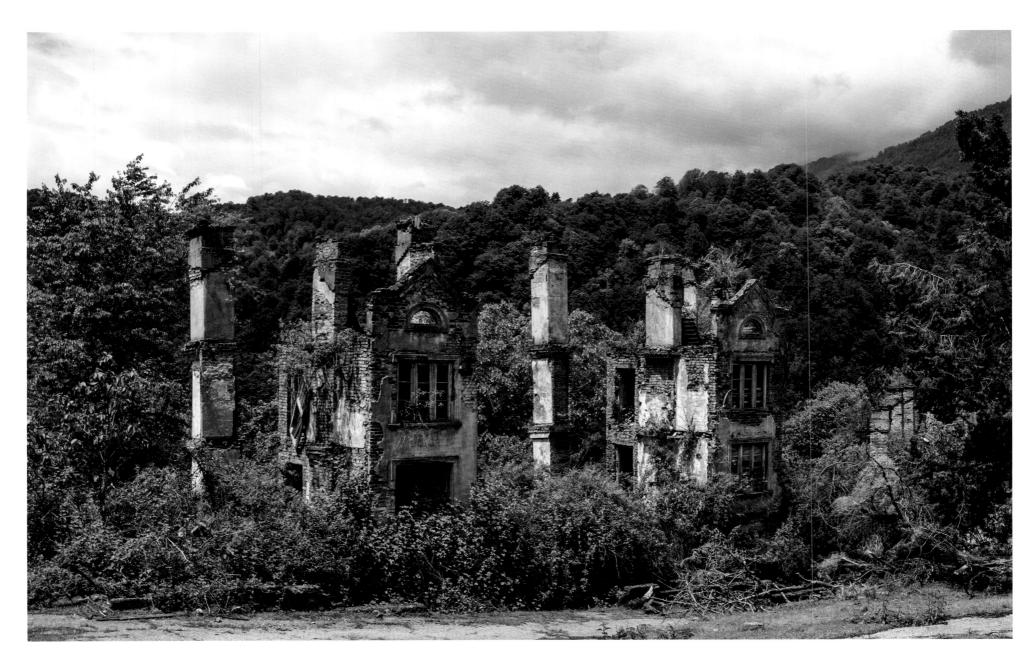

The mining town of Akarmara, built by German prisoners after the Second World War, was ravaged by the fighting for independence. Only about ten people still live here, in rather insalubrious living conditions.

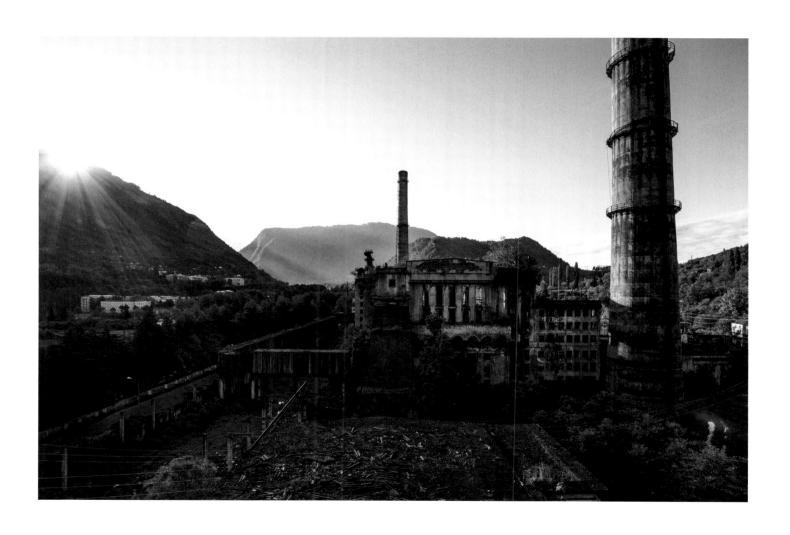

Boilers at the power station in Tkvarcheli. It was bombed during the siege by the Georgian army that lasted over 400 days leaving 17,000 dead. Gun stocks and cases of ammunition were found lying around in the warehouse from which this photo was taken. A sniper must have stood in this very spot some 30 years earlier.

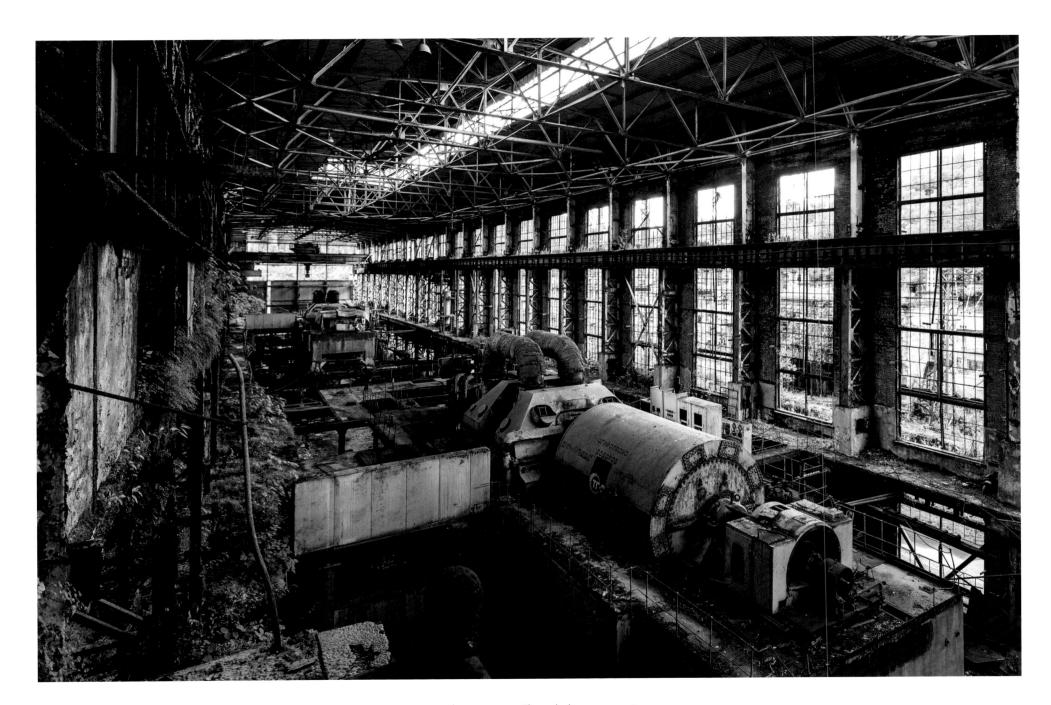

Large turbine room in Tkvarcheli power station.

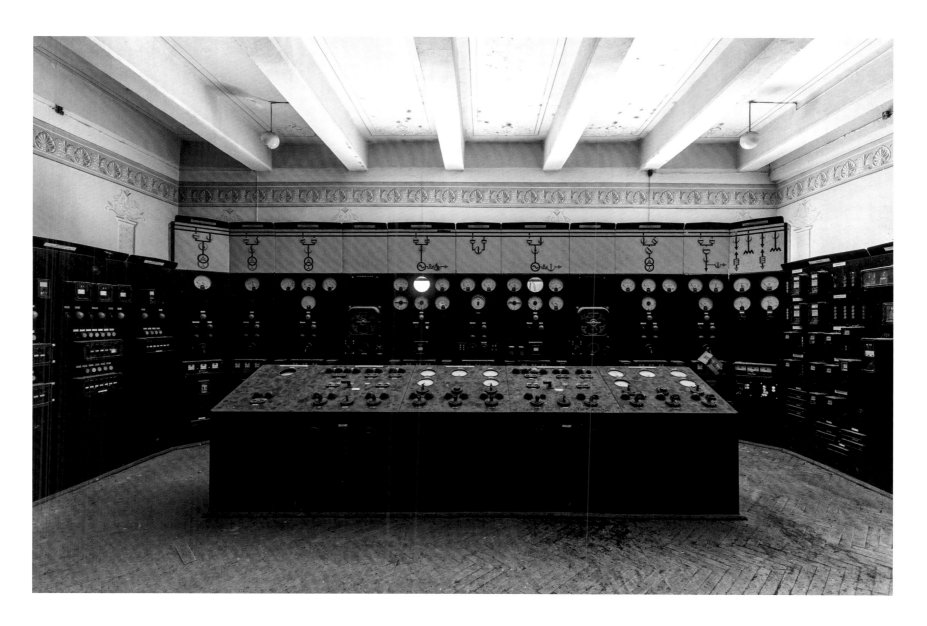

Control room of a hydropower plant near the Chechen border. We had to walk more than 15 kilometres to get here. Surprisingly, it was a rather pleasant hike.

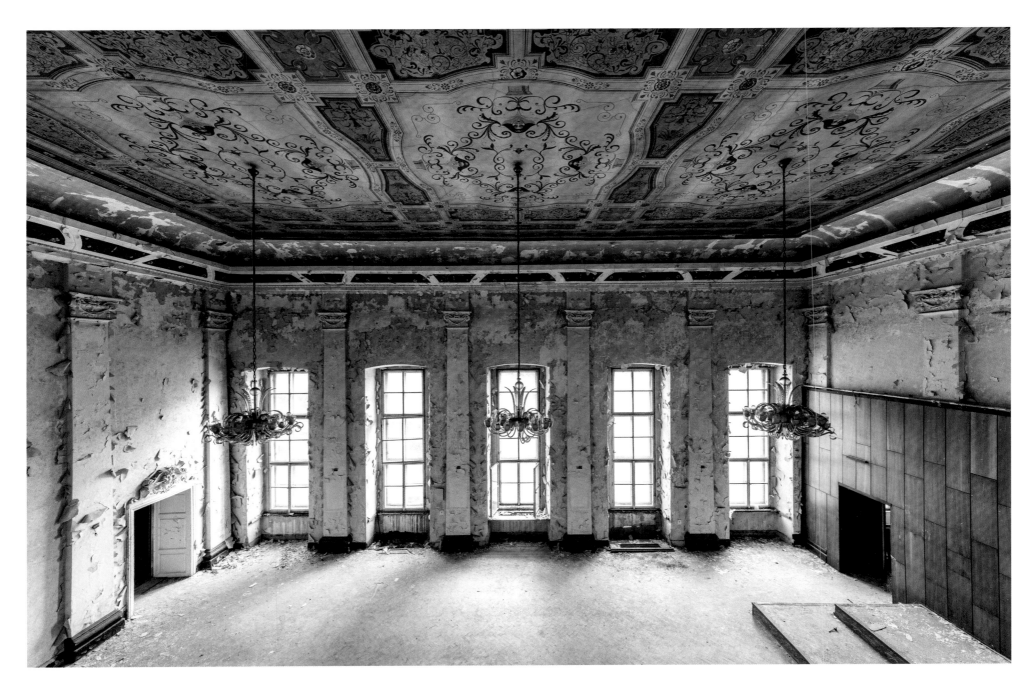

Ballroom reserved for Russian officers in the Czech Republic. The site is currently under restoration.

# EASTERN BLOC
## Romania, Former East Germany (GDR), Hungary, Czech Republic, Bulgaria

Many countries like the GDR, Bulgaria, Romania and Hungary, while not actually being part of the USSR, nevertheless supported the ideology of communism or accepted in some way the influence of their colossal neighbour. For this reason, a good part of Central Europe lived under military control for many decades, in anticipation of the potential threat of any new declaration of war. Sometimes Soviet influence extended beyond the borders of Europe too, amongst allies such as Cuba, sharing the same ideology, or countries that relied on counter-pressure from the USSR to help free them from another power's domination. This explains the large numbers of statues and mosaics depicting Lenin to be found in countries like Angola or Mozambique which enjoyed the support of the USSR in gaining independence and escaping their status as colonies.

However, in Europe the legacy of communism is often viewed less positively. In post-Ceauşescu Romania, reminders of communism are few and far between, with most buildings recalling those dark days having been destroyed or vandalised. In Germany you sometimes have to walk for hours to ferret out frescos or posters buried in the inner depths of some disused barracks. At the same time, however, more and more heritage conservation organisations are appearing, working to preserve the remains of a time in history which, although painful, it may well be dangerous to forget.

Visits: 2013 – 2015 – 2016 – 2018

# Romania

The Romanian Communist Party rose to power in 1945. Nicolae Ceaușescu's totalitarian government finally collapsed in December 1989 following a coup. The communist regime in the country drew its inspiration largely from the practices of its Soviet neighbour. It continued to support the USSR throughout the time it was a member state of the Warsaw Pact.

Part of the station, now closed, in Hunedoara, a large industrial town which suffered many closures.

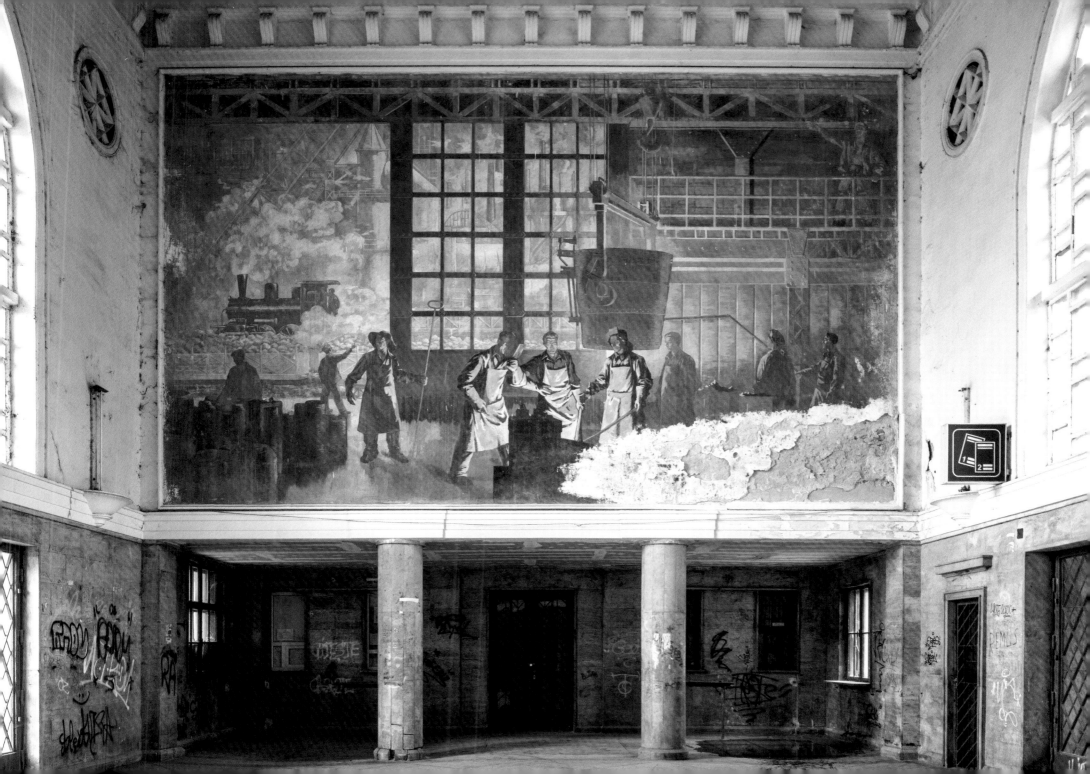

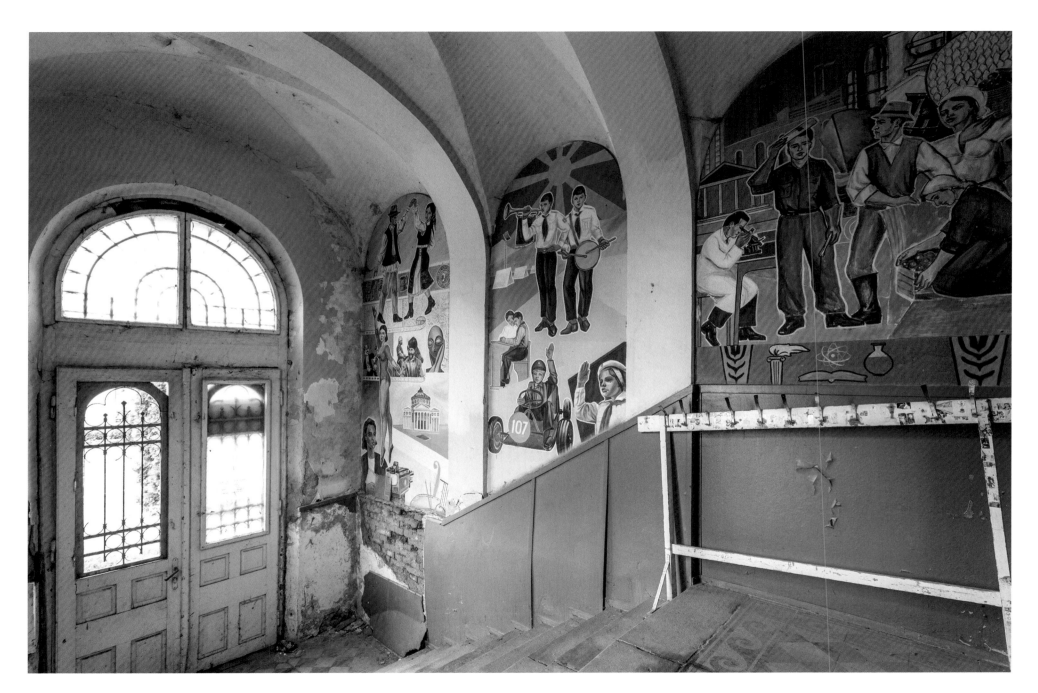

Painted on the walls of a school, these propaganda paintings are more than a match for some found in the USSR.

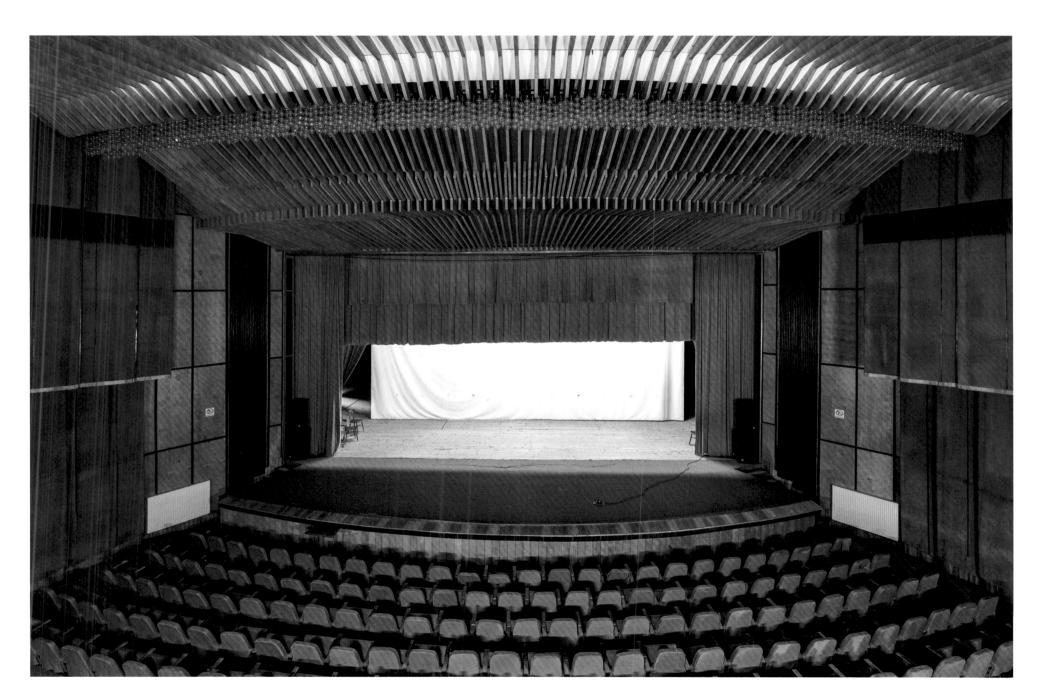

Auditorium in a Palace of Culture designed in the Futurist style which was in vogue in the 1970s.

# Former East Germany (GDR)

The German Democratic Republic was established in 1949, entering directly into the sphere of protection of the USSR, with which it shared an ideology and some other practices. The construction of the Berlin wall in 1961 simply reinforced this relationship. The GDR remained the USSR's most faithful ally in terms of foreign policy, and also provided logistical and financial support to the various operations it conducted around the world.

Holiday resort in the former German Democratic Republic.

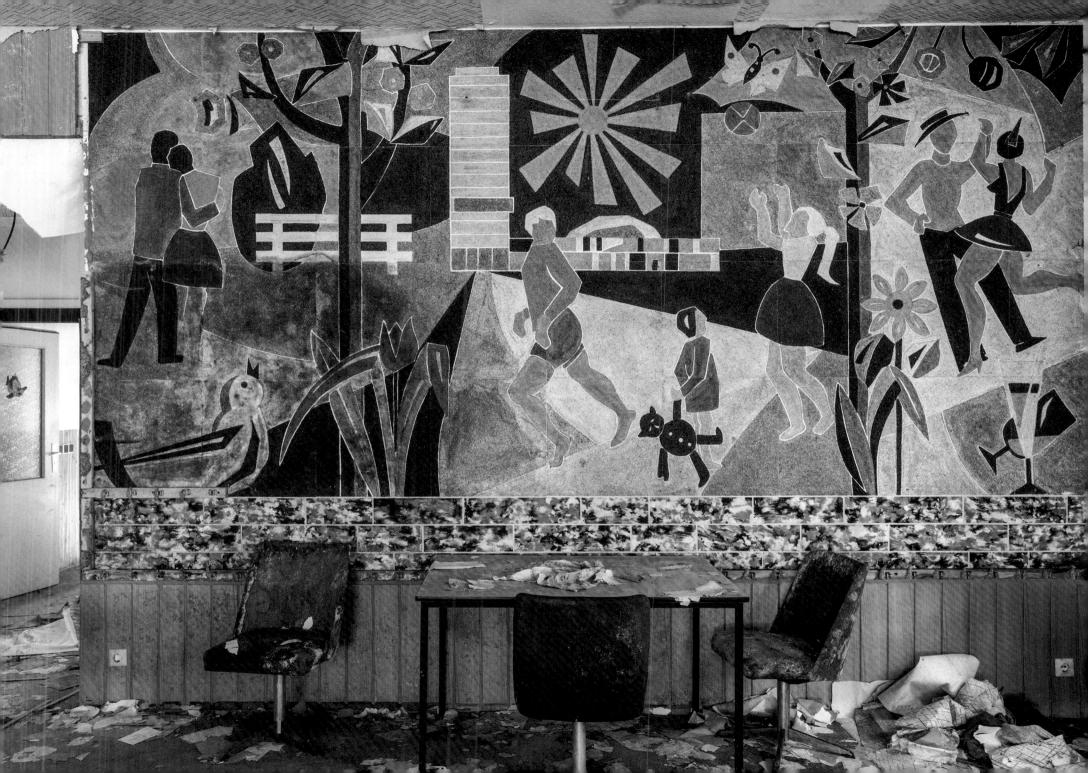

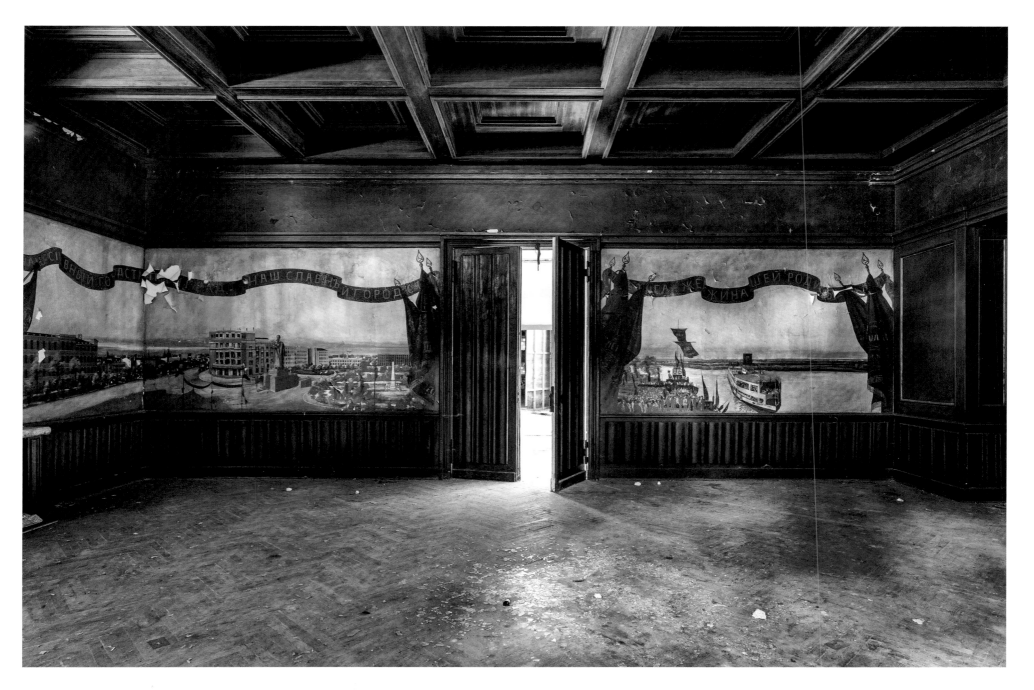

Officers' casino in the Krampnitz barracks where a portrait of Stalin can be seen despite pictures of him being very rare.

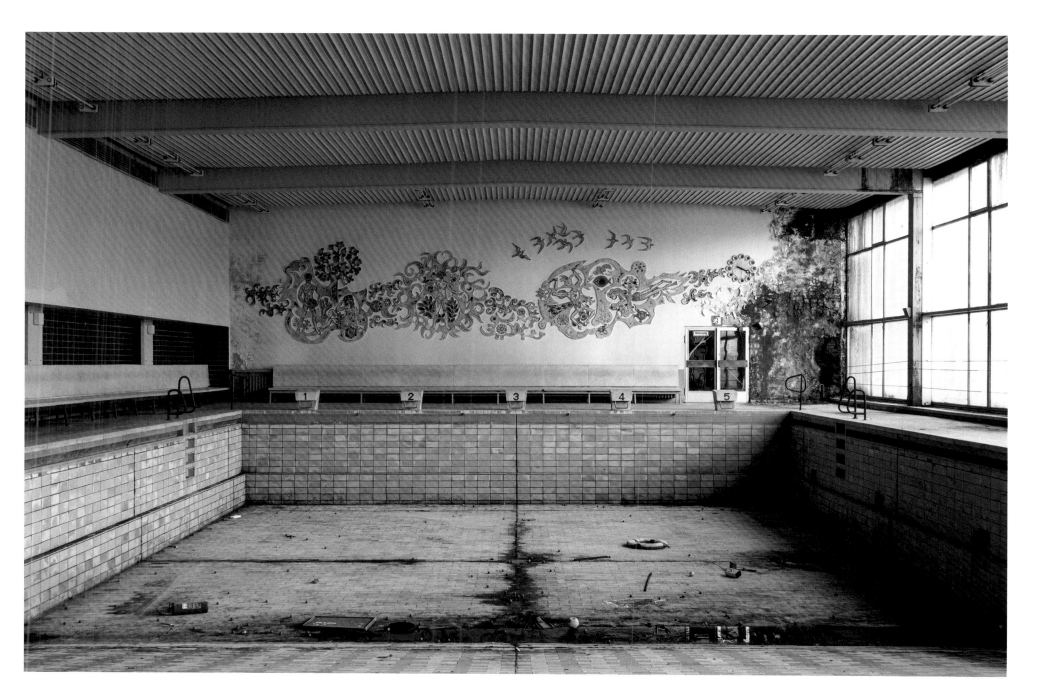

Swimming pool in a hotel in the mountains, not far from the border with the Czech Republic.

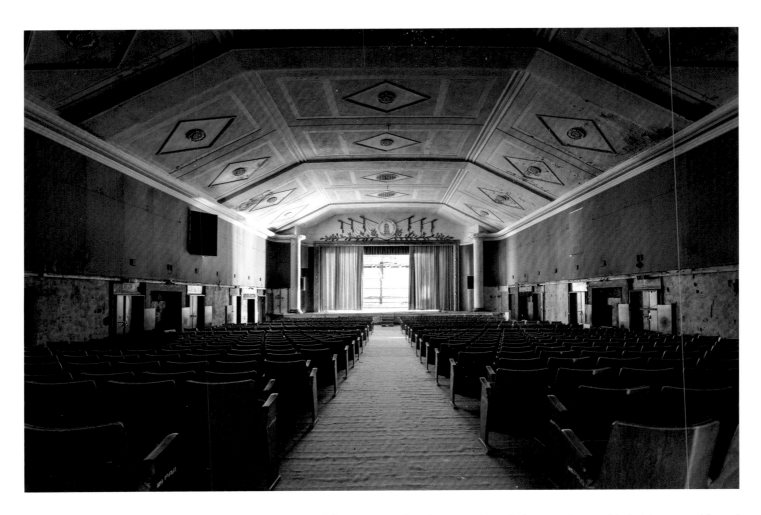

The theatre in the officers' barracks at Wünsdorf was used for staging political events. Wünsdorf was nicknamed Little Moscow – blessed with a railway line that provided a direct link to the Soviet capital, it hosted 30,000 Russian soldiers and their families, effectively making it a village with a population of 75,000. Germans were not allowed to enter.

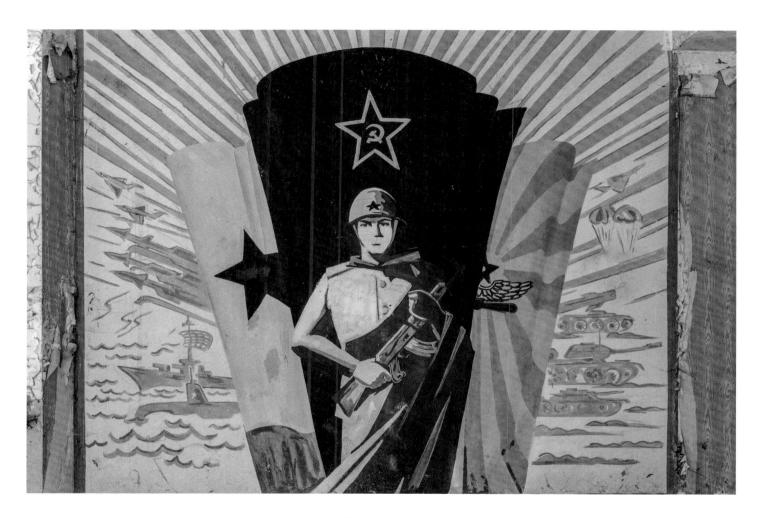

Mural at a military site that for a long time belonged to the German army. The site was particularly significant during the Third Reich when it was converted into a training camp specialising in military aviation techniques. The site later fell into the hands of the Soviets who used it as a base for armoured divisions and to host certain KGB officials, amongst other things. The site today is completely empty, despite being included in the inventory of German Historic Monuments on account of its architecture which is typical of the Nazi regime.

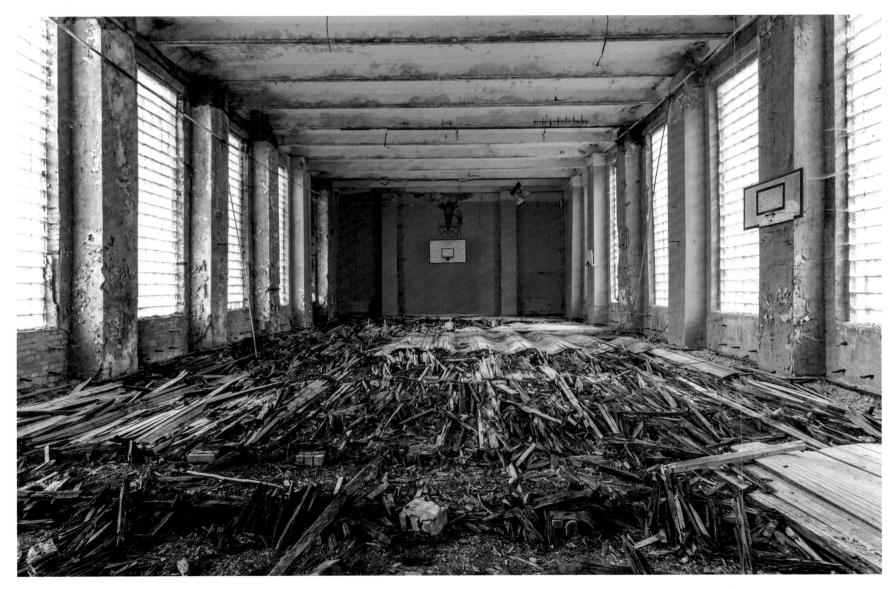

Gymnasium in the Krampnitz barracks which were used by the German army until 1937. The site was later requisitioned by the Soviet army for use by the soldiers of the 35th division of armoured fighting vehicles. These included tanks, which explains the width of the roads at the site. A town-planning initiative was launched in 2013 in an attempt to carry out restoration at the site, but to date work has not yet started.

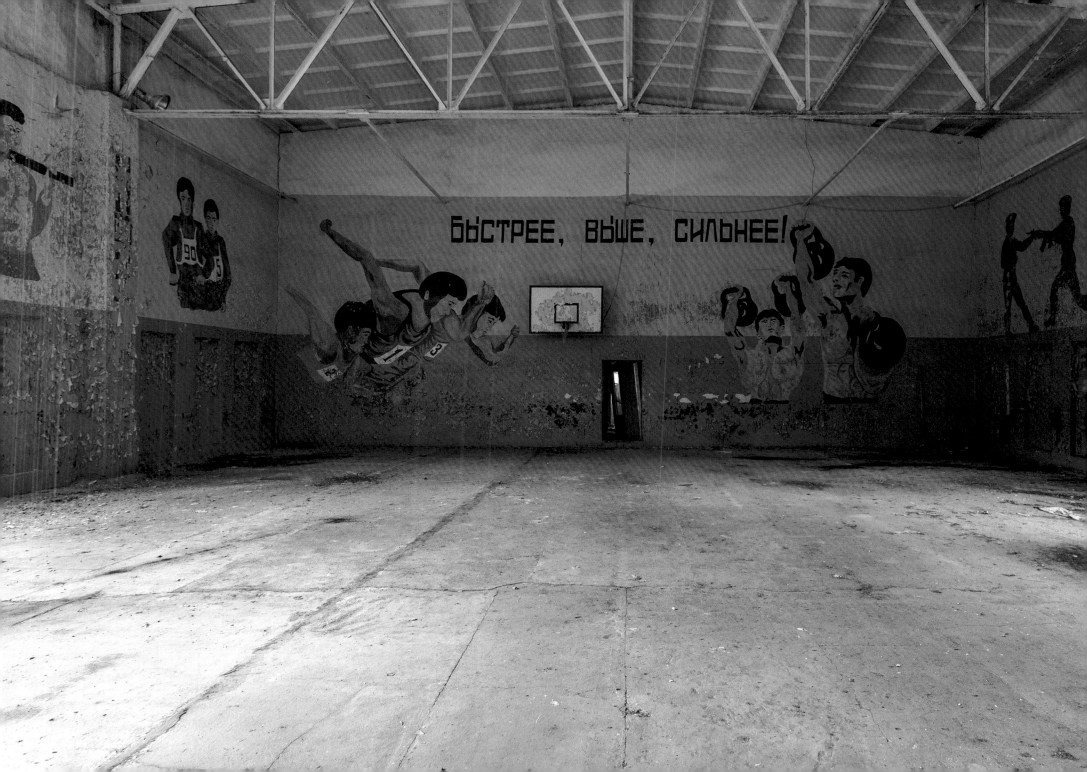

# Hungary

The Hungarian People's Republic with its communist regime was established in 1949 and remained under the control of the USSR until its break-up. Several uprisings were attempted, like that of 1956, but they were cruelly crushed.

Painting on a wall in a barracks – one of the last remaining reminders of the Red Army's presence on Hungarian soil.

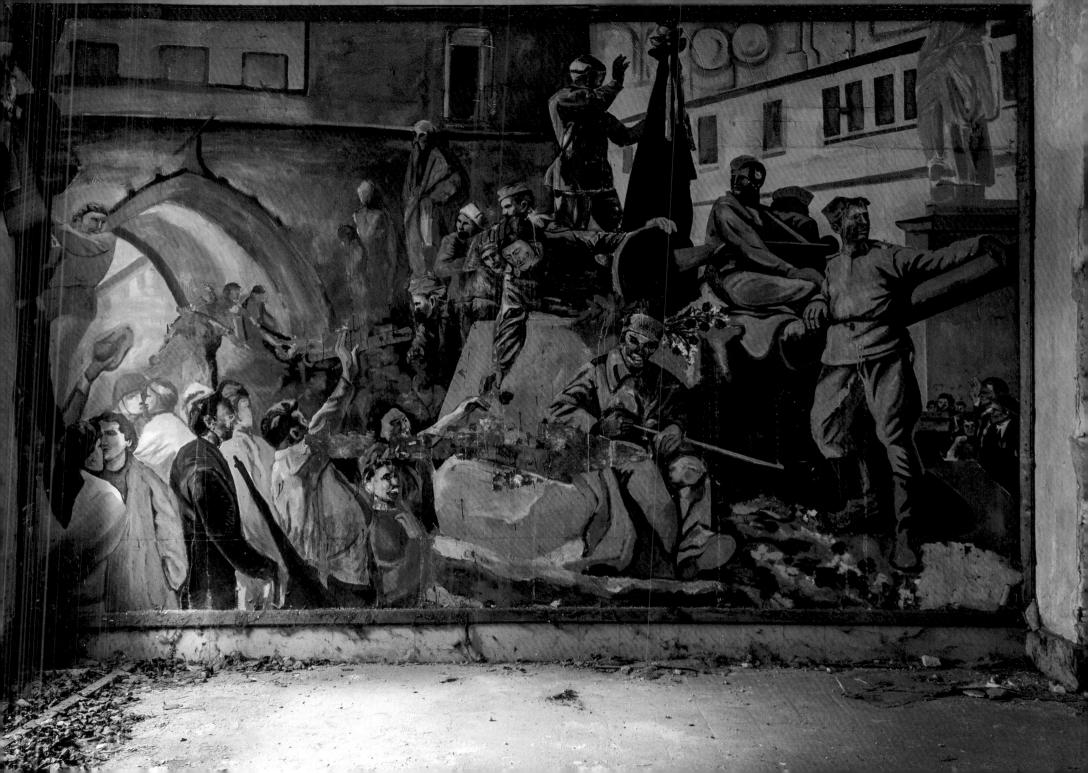

# Czech Republic

Czechoslovakia was occupied by the German army during the Second World War. Afterwards it resisted Soviet domination for a few years but, following the Czechoslovak coup d'état when the communists officially took power, it finally fell into line in 1948, thus becoming a satellite state.

Immense mural in a Palace of Culture which was reserved for officers in one of the country's large cities.

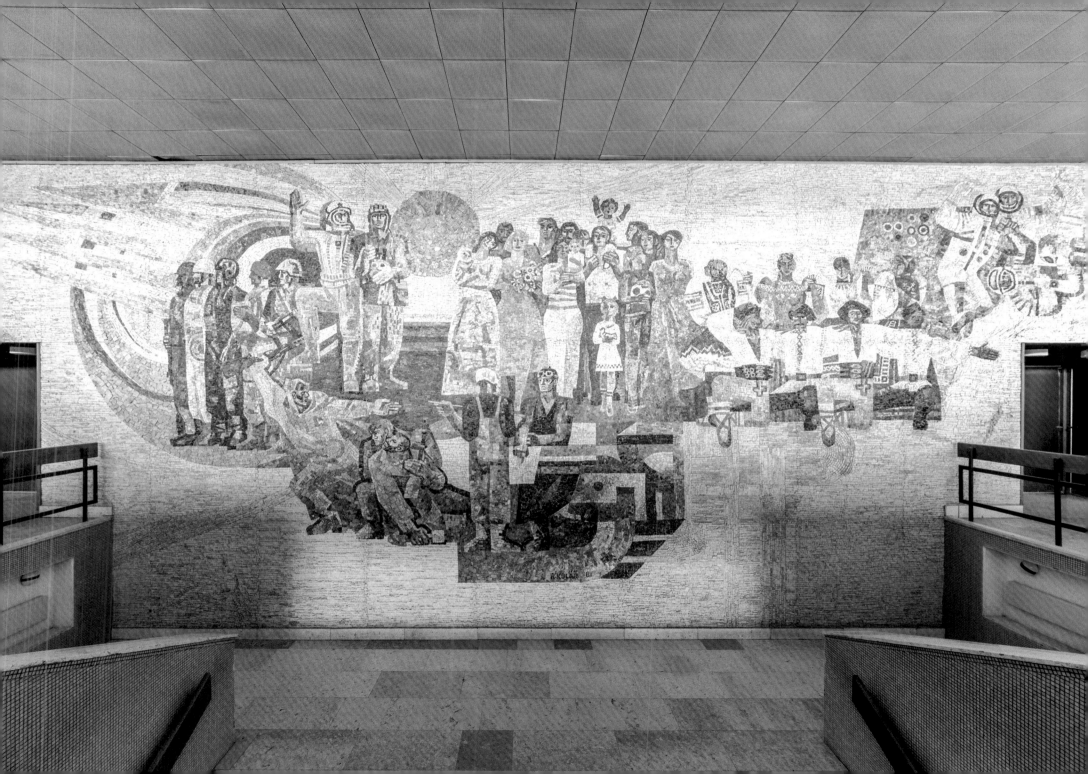

# Bulgaria

With effect from its creation in 1946, the People's Republic of Bulgaria came under Soviet influence. Stalinist principles were applied at all levels of society, and the USSR had such total trust in its satellite's loyalty, that it did not maintain any Red Army presence on Bulgarian territory.

The Buzludzha Monument. The famous Bulgarian community amphitheatre was designed by architect Georgi Stoilov and opened in 1981 but was abandoned for the last time eight years later. It stands on a hill at an altitude of 1,441 metres. The convention hall contains some amazing murals, but although their restoration has been discussed over several years, the relevant authorities have not yet taken practical steps to set the wheels in motion.

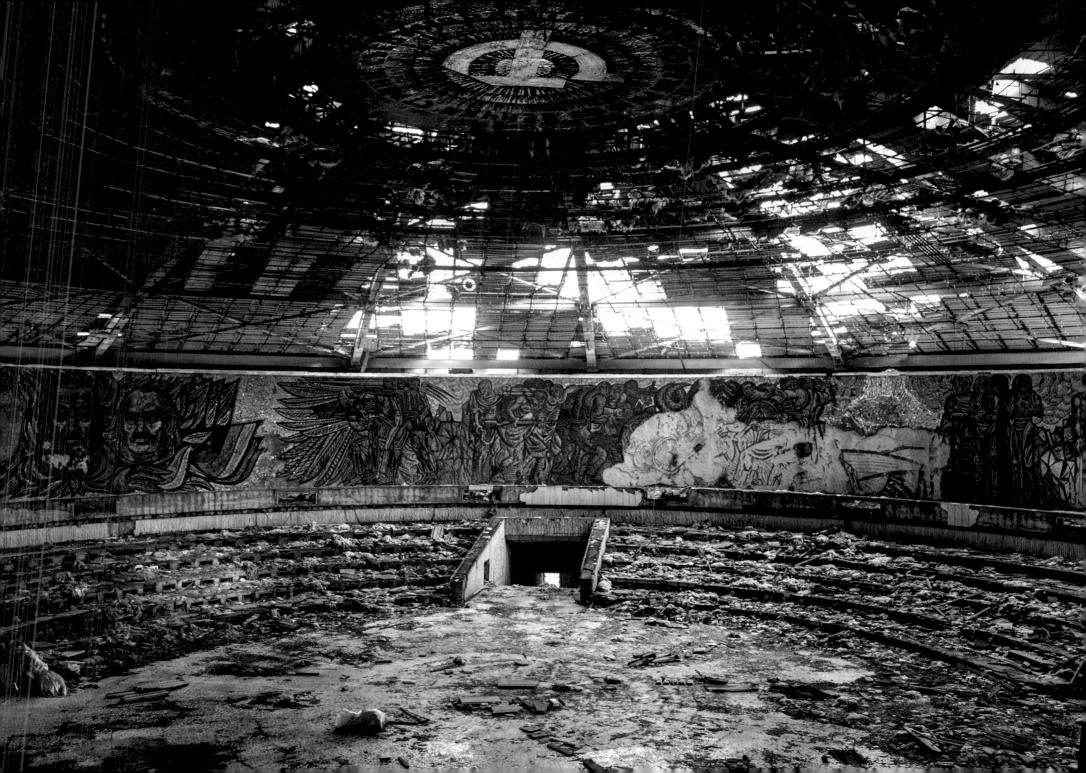

## Aknowledgments

I would like to thank all those who helped me discover these places – the owners, town mayors, and nearby residents – as well as my friends who shared these moments with me and supported me through the difficult times, when the conditions of exploration were at their toughest. Thanks to David, Martin, Raf, Chloé, Aurelien and all those who pushed me to finish this project.

# About the author

Terence Abela has spent nine years travelling across the former USSR unearthing fragments from its past. His love of history, of photographing relics of the past and discovering the unknown, have combined to create this work. Driven by a desire to preserve the heritage abandoned by states that lurch between the threat of nationalism, dictatorship, wars and the will to invent a new history for themselves, he appeals to us through his pictures to protect these mementos which are at risk of disappearing in the not too distant future.

# About Jonglez Publishing

*Thomas Jonglez*

It was September 1995 and Thomas Jonglez was in Peshawar, the northern Pakistani city 20 kilometres from the tribal zone he was to visit a few days later. It occurred to him that he should record the hidden aspects of his native city, Paris, which he knew so well. During his seven-month trip back home from Beijing, the countries he crossed took in Tibet (entering clandestinely, hidden under blankets in an overnight bus), Iran and Kurdistan. He never took a plane but travelled by boat, train or bus, hitchhiking, cycling, on horseback or on foot, reaching Paris just in time to celebrate Christmas with the family.

On his return, he spent two fantastic years wandering the streets of the capital to gather material for his first "secret guide", written with a friend. For the next seven years he worked in the steel industry until the passion for discovery overtook him. He launched Jonglez Publishing in 2003 and moved to Venice three years later.

In 2013, in search of new adventures, the family left Venice and spent six months travelling to Brazil, via North Korea, Micronesia, the Solomon Islands, Easter Island, Peru and Bolivia.

After seven years in Rio de Janeiro, he now lives in Berlin with his wife and three children.

Jonglez Publishing produces a range of titles in nine languages, released in 40 countries.

# Also available

## Photo books

Abandoned America
Abandoned Asylums
Abandoned Australia
Abandoned churches – Unclaimed places of worship
Abandoned cinemas of the world
Abandoned France
Abandoned Italy
Abandoned Japan
Abandoned Lebanon
Abandoned Spain
After the Final Curtain – The Fall of the American Movie Theater
After the Final Curtain – America's Abandoned Theaters
Baikonur – Vestiges of the Soviet Space Programme
Chernobyl's Atomic Legacy
Forbidden Places
Forbidden Places - Vol.2
Forbidden Places - Vol.3
Forgotten Heritage
Oblivion
Unusual wines
Venice deserted

## "Soul of" guides

Soul of Athens - A guide to 30 exceptional experiences
Soul of Kyoto - A guide to 30 exceptional experiences
Soul of Lisbon - A guide to 30 exceptional experiences
Soul of Los Angeles - A guide to 30 exceptional experiences
Soul of Marrakesh - A guide to 30 exceptional experiences
Soul of New York - A guide to 30 exceptional experiencess
Soul of Rome - A guide to 30 exceptional experiencess
Soul of Tokyo - A guide to 30 exceptional experiences
Soul of Venice - A guide to 30 exceptional experiences

## "Secret" guides

New York Hidden bars & restaurants
Secret Amsterdam
Secret Bali
Secret Barcelona
Secret Belfast
Secret Berlin
Secret Brighton - An unusual guide
Secret Brooklyn
Secret Brussels
Secret Buenos Aires
Secret Campania
Secret Cape Town
Secret Copenhagen
Secret Dublin - An unusual guide
Secret Edinburgh - An unusual guide
Secret Florence
Secret French Riviera
Secret Geneva
Secret Glasgow
Secret Granada
Secret Helsinki
Secret Istanbul
Secret Johannesburg
Secret Lisbon
Secret Liverpool - An unusual guide
Secret London - An unusual guide
Secret London - Unusual bars & restaurants
Secret Madrid
Secret Mexico City
Secret Milan
Secret Montreal - An unusual guide
Secret Naples
Secret New Orleans
Secret New York - An unusual guide
Secret New York - Curious activities

Secret Paris
Secret Prague
Secret Provence
Secret Rio
Secret Rome
Secret Singapore
Secret Sussex - An unusual guide
Secret Tokyo
Secret Tuscany
Secret Venice
Secret Vienna
Secret Washington D.C.

**Layout:** Emmanuelle Willard Toulemonde – **Translation:** Lyall Pratt – **Editing:** Sigrid Newman – **Proofreading:** Kimberly Bess – **Publishing:** Clémence Mathé

© JONGLEZ 2021
Registration of copyright: September 2021 – Edition: 01
ISBN: 978-2-36195-510-6
Printed in Slovakia by Polygraf